Culture and Art

Culture and Art

Culture and Art

An Anthology

Edited by

Lars Aagaard-Mogensen

ECLIPSE BOOKS

Nyborg: F. Løkkes Forlag

Atlantic Highlands, N.J.: Humanities Press

1976

This edition first published
in the U.S.A. in 1976 by
Humanities Press Inc.
Atlantic Highlands, N.J. 07716

Library of Congress Cataloging in Publication Data
Main entry under title:

CULTURE AND ART.

(Eclipse books)
1. Aesthetics — Addresses, essays, lectures.
2. Art — Philosophy — Addresses, essays, lectures.
I. Aaagaard-Mogensen, Lars, 1944 -
BH39.C84 1976 111.8'5 75-45455
ISBN 0-391-00539-1

ISBN 8785074128

Printed in Denmark
Midtfyns Bogtryk, Ringe
Design: Fini Løkke

Contents:

ACKNOWLEDGMENT is gratefully made to the following publishers and editors for permission to include:

Arthur C. Danto »The Artworld«, *Journal of Philosophy* (1964): 571-84.

George Dickie »What Is Art?«. Reprinted from George Dickie: *Art and the Aesthetic.* Copyright © 1974 by Cornell University. Used by permission of Cornell University Press.

Joseph Margolis »Works of Art as Physically Embodied and Culturally Emergent Entities«, *The British Journal of Aesthetics* (1974): 187-96.

Leonard B. Meyer »Forgery and the Anthropology of Art«, from his *Music, the Arts and Ideas,* © 1967 by The University of Chicago. Used with permission from The University of Chicago Press.

The editor also wish to express his gratitude to Knud Højgaards Fond, Danmark-Amerika Fondet, and the United States Educational Foundation in Denmark, for support in periods where the anthology was prepared.

...to my parents

> In order to get clear about aesthetic words
> you have to describe ways of living.
>
> L. Wittgenstein

When you say 'art and culture' it often appears as if some important conjunction is posed. A conjunction between two things which one must make immense efforts to grasp in merely the slightest way. Actually this customary separation may have hindered valuable thinking. At least it is one tenet of the trains of thought presented in this collection that, rather than art being independently contributing to human culture, it conversely is constituted culturally. On the one hand, the »culturally institutive« arttheory gains much plausibility from its expedient applicability to contemporary art. On the other, it bears a detectable urge toward what we might call — on analogy with the self-understanding philosophy is sometimes said to have accomplished in this century — æstetics' self-understanding. This paradox in its possible impact may well prove to be the theory's force.

Where there's a world — of philosophy, of art, of trade, &c. — a 'demimonde' soon tags along. If one should suggest an area this material doesn't explore, it might be such artful ways of life. Should it however be deep enough to avoid itself belonging to this shadowy existence, it may face some serene *floruit* in our æsthetic culture.

As any anthology, this one is incomplete — lots of fine material remain beyond it.[1] Even the present lenght incurred some cuts, for which a gentle hand was applied — may the contributors see them that way as well. They have been cooperative, for which I'm as grateful as I am to those who let me see writings the volume couldn't hold. Apart from Arthur Danto's, all pieces appear either freshly (10) or revised some way or other (3). What the book not contains of criticism and comment, it is wished it may extract from its readers. To whose benefit and judgment it is now handed over.

L. Aa-M.

[1] I particularly regret being unable to include R. Rhees »Art and Philosophy«, Without answers, London 1969, and W. B. Gallie »Art as an Essentially Contested Concept«, Phil Quart (1956). (Abbreviations accord, whereever applicable, with the Philosopher's Index). Another useful piece, also bibliographically, is M. C. Albrecth »Art as an Institution«, American Sociological Review (1968).

Arthur Danto

The Artworld

Hamlet:
 Do you see nothing there?
The Queen:
 Nothing at all; yet all that is I see.

Shakespeare: Hamlet, Act III, Scene IV

Hamlet and Socrates, though in praise and deprecation respectively, spoke of art as a mirror held up to nature. As with many disagreements in attitude, this one has a factual basis. Socrates saw mirrors as but reflecting what we can already see; so art, insofar as mirrorlike, yields idle accurate duplications of the appearances of things, and is of no cognitive benefit whatever. Hamlet, more acutely, recognized a remarkable feature of reflecting surfaces, namely that they show us what we could not otherwise perceive — our own face and form — and so art, insofar as it is mirrorlike, reveals us to ourselves, and is, even by socratic criteria, of some cognitive utility after all. As a philosopher, however, I find Socrates' discussion defective on other, perhaps less profound grounds than these. If a mirror-image of o is indeed an imitation of o, then, if art is imitation, mirror-images are art. But in fact mirroring objects no more is art than returning weapons to a madman is justice; and reference to mirrorings would be just the sly sort of counterinstance we would expect Socrates to bring forward in rebuttal of the theory he instead uses them to illustrate. If that theory requires us to class *these* as art, it thereby shows its inadequacy: »is an imitation« will not do as a sufficient condition for »is art«. Yet, perhaps because artists *were* engaged in imitation, in Socrates' time and after, the insufficiency of the theory was not noticed until the invention of photography. Once rejected as a sufficient condition, mimesis was quickly discarded as even a necessary one; and since the achievement of Kandinsky, mimetic features have been relegated to the periphery of critical concern, so much so that some works survive in spite of possessing those virtues, excellence in which was once celebrated as the essence of art, narrowly escaping demotion to mere illustrations.

It is, of course, indispensable in socratic discussion that all participants be masters of the concept up for analysis, since the aim is to match a real defining expression to a term in active use, and the test for adequacy presumably consists in showing that the former analyzes and applies to all and only those things of which the latter is true. The popular disclaimer notwithstanding, then, Socrates' auditors purportedly knew what art was as well as what they liked; and a theory of art, regarded here as a real definition of 'Art', is accordingly not to be of

9

great use in helping men to recognize instances of its application. Their antecedent ability to do this is precisely what the adequacy of the theory is to be tested against, the problem being only to make explicit what they already know. It is *our* use of the term that the theory allegedly means to capture, but we are supposed able, in the words of a recent writer, »to separate those objects which are works of art from those which are not, because . . . we know how correctly to use the word 'art' and to apply the phrase 'work of art'.« Theories, on this account, are somewhat like mirrorimages on Socrates' account, showing forth what we already know, wordy reflections of the actual linguistic practice we are masters in.

But telling artworks from other things is not so simple a matter, even for native speakers, and these days one might not be aware he was on artistic terrain without an artistic theory to tell him so. And part of the reason for this lies in the fact that terrain is constituted artistic in virtue of artistic theories, so that one use of theories, in addition to helping us discriminate art from the rest, consists in making art possible. Glaucon and the others could hardly have known what was art and what not: otherwise they would never have been taken in by mirror-images.

I. Suppose one thinks of the discovery of a whole new class of artworks as something analogous to the discovery of a whole new class of facts anywhere, viz., as something for theoreticians to explain. In science, as elsewhere, we often accommodate new facts to old theories via auxiliary hypotheses, a pardonable enough conservatism when the theory in question is deemed too valuable to be jettisoned all at once. Now the Imitation Theory of Art (IT) is, if one but thinks it through, an exceedingly powerful theory, explaining a great many phenomena connected with the causation and evaluation of artworks, bringing a surprising unity into a complex domain. Moreover, it is a simple matter to shore it up against many purported counterinstances by such auxiliary hypotheses as that the artist who deviates from mimeticity is perverse, inept, or mad. Ineptitude, chicanery, or folly are, in fact, testable predications. Suppose, then, tests reveal that these hypotheses fail to hold, that the theory, now beyond repair, must be replaced. And a new theory is worked out, capturing what it can of the old theory's competence, together with the heretofore recalcitrant facts. One might, thinking along these lines, represent certain episodes in the history of art as not dissimilar to certain episodes in the history of science, where a conceptual revolution is being effected and where refusal to countenance certain facts, while in part due to prejudice, inertia, and self-interest, is due also to the fact that a well-established, or at least widely credited theory is being threatened in such a way that all coherence goes.

Some such episode transpired with the advent of post-impressionist paintings. In terms of the prevailing artistic theory (IT),

it was impossible to accept these as art unless inept art: otherwise they could be discounted as hoaxes, self-advertisements, or the visual counterparts of madmen's ravings. So to get them accepted *as* art, on a footing with the *Transfiguration* (not to speak of a Landseer stag), required not so much a revolution in taste as a theoretical revision of rather considerable proportions, involving not only the artistic enfranchisement of these objects, but an emphasis upon newly significant features of accepted artworks, so that quite different accounts of their status as artworks would now have to be given. As a result of the new theory's acceptance, not only were post-impressionist paintings taken up as art, but numbers of objects (masks, weapons, etc.) were transferred from anthropological museums (and heterogeneous other places) to *musées des beaux arts*, though, as we would expect from the fact that a criterion for the acceptance of a new theory is that it account for whatever the older one did, nothing had to be transferred out of the *musée des beaux arts* — even if there were internal rearrangements as between storage rooms and exhibition space. Countless native speakers hung upon suburban mantelpieces innumerable replicas of paradigm cases for teaching the expression 'work of art' that would have sent their Edwardian forebears into linguistic apoplexy.

To be sure, I distort by speaking of a theory: historically, there were several, all, interestingly enough, more or less defined in terms of the IT. Art-historical complexities must yield before the exigencies of logical exposition, and I shall speak as though there were one replacing theory, partially compensating for historical falsity by choosing one which was actually enunciated. According to it, the artists in question were to be understood not as unsuccessfully imitating real forms but as successfully creating new ones, quite as real as the forms which the older art had been thought, in its best examples, to be creditably imitating. Art, after all, had long since been thought of as creative (Vasari says that God was the first artist), and the post-impressionists were to be explained as genuinely creative, aiming, in Roger Fry's words, »not at illusion but reality.« This theory (RT) furnished a whole new mode of looking at painting, old and new. Indeed, one might almost interpret the crude drawing in Van Gogh and Cézanne, the dislocation of form from contour in Rouault and Dufy, the arbitrary use of color planes in Gauguin and the Fauves, as so many ways of drawing attention to the fact that these were *non-imitations,* specifically intended not to deceive. Logically, this would be roughly like printing »Not Legal Tender« across a brilliantly counterfeited dollar bill, the resulting object (counterfeit *cum* inscription) rendered incapable of deceiving anyone. It is not an illusory dollar bill, but then, just because it is non-illusory it does not automatically become a real dollar bill either. It rather occupies a freshly opened area between real objcts and real facsimiles of real objects: it is a non-facsimile, if one requires a word, and

a new contribution to the world. Thus, Van Gogh's *Potato Eaters*, as a consequence of certain unmistakable distortions, turns out to be a non-facsimile of real life potato eaters; and inasmuch as these are not facsimiles of potato eaters Van Gogh's picture, as a non-imitation, had as much right to be called a real object as did its putative subjects. By means of this theory (RT), artworks re-entered the thick of things from which socratic theory (IT) had sought to evict them: if no *more* real than what carpenters wrought, they were at least no *less* real. The Post-Impressionist won a victory in ontology.

It is in terms of RT that we must understand the artworks around us today. Thus Roy Lichtenstein paints comic-strip panels, though ten or twelve feet high. These are reasonably faithful projections onto a gigantesque scale of the homely frames from the daily tabloid, but it is precisely the scale that counts. A skilled engraver might incise *The Virgin and the Chancellor Rollin* on a pinhead, and it would be recognizable as such to the keen of sight, but an engraving of a Barnett Newman on a similar scale would be a blob, disappearing in the reduction. A *photograph* of a Lichtenstein is indiscernible from a photograph of a counterpart panel from *Steve Canyon;* but the photograph fails to capture the scale, and hence is as inaccurate a reproduction as a black-and-white engraving of Botticelli, scale being essential here as color there. Lichtensteins, then, are not imitations but *new entities,* as giant whelks would be. Jasper Johns, by contrast, paints objects with respect to which questions of scale are irrelevant. Yet his objects cannot be imitations, for they have the remarkable property that any intended copy of a member of this class of objects is automatically a member of the class itself, so that these objects are logically inimitable. Thus, a copy of a numeral just *is* that numeral: a painting of 3 is a 3 made of paint. Johns, in addition, paints targets, flags, and maps. Finally, in what I hope are not unwitting footnotes to Plato, two of our pioneers — Robert Rauschenberg and Claes Oldenburg — have made genuine beds.

Rauschenberg's bed hangs on a wall, and is streaked with some desultory housepaint. Oldenburg's bed is a rhomboid, narrower at one end than the other, with what one might speak of as a built-in perspective: ideal for small bedrooms. As beds, these sell at singularly inflated prices, but one *could* sleep in either of them: Rauschenberg has expressed the fear that someone might just climb into his bed and fall asleep. Imagine, now, a certain Testadura — a plain speaker and noted philistine — who is not aware that these are art, and who takes them to be reality simple and pure. He attributes the paintstreaks on Rauschenberg's bed to the slovenliness of the owner, and the bias in the Oldenburg bed to the ineptitude of the builder or the whimsy, perhaps, of whoever had it »custom-made.« These would be mistakes, but mistakes of rather an odd kind, and not terribly different from that made by the stunned birds who

pecked the sham grapes of Zeuxis. They mistook art for reality, and so has Testadura. But it was meant to *be* reality, according to RT. Can one have mistaken reality for reality? How shall we describe Testadura's error? What, after all, prevents Oldenburg's creation from being a misshapen bed? This is equivalent to asking what makes it art, and with this query we enter a domain of conceptual inquiry where native speakers are poor guides: *they* are lost themselves.

II. To mistake an artwork for a real object is no great feat when an artwork is the real object one mistakes it for. The problem is how to avoid such errors, or to remove them once they are made. The artwork is a bed, and not a bed-illusion; so there is nothing like the traumatic encounter against a flat surface that brought it home to the birds of Zeuxis that they had been duped. Except for the guard cautioning Testadura not to sleep on the artworks, he might never have discovered that this was an artwork and not a bed; and since, after all, one cannot discover that a bed is not a bed, how is Testadura to realize that he has made an error? A certain sort of explanation is required, for the error here is a curiously philosophical one, rather like, if we may assume as correct some well-known views of P. F. Strawson, mistaking a person for a material body when the truth is that a person *is* a material body in the sense that a whole class of predicates, sensibly applicable to material bodies, are sensibly, and by appeal to no different criteria, applicable to persons. So you cannot *discover* that a person is not a material body.

We begin by explaining, perhaps, that the paintstreaks are not to be explained away, that they are *part* of the object, so the object is not a mere bed with—as it happens—streaks of paint spilled over it, but a complex object fabricated out of a bed and some paintstreaks: a paint-bed. Similarly, a person is not a material body with—as it happens—some thoughts superadded, but is a complex entity made up of a body and some conscious states: a conscious-body. Persons, like artworks, must then be taken as irreducible to *parts* of themselves, and are in that sense primitive. Or, more accurately, the paintstreaks are not part of the real object—the bed—which happens to be part of the artwork, but are *like* the bed, part of the artwork as such. And this might be generalized into a rough characterization of artworks that happen to contain real objects as parts of themselves: not every part of an artwork A is part of a real object R when R is part of A and can, moreover, be detached from A and seen *merely* as R. The mistake thus far will have been to mistake A for *part* of itself, namely R, even though it would not be incorrect to say that A is R, that the artwork is a bed. It is the 'is' which requires clarification here.

There is an *is* that figures prominently in statements concerning artworks which is not the *is* of either identity or predication; nor is it the *is* of existence, of identification, or some

special *is* made up to serve a philosophic end. Nevertheless, it is in common usage, and is readily mastered by children. It is the sense of *is* in accordance with which a child, shown a circle and a triangle and asked which is him and which his sister, will point to the triangle saying »That is me«; or, in response to my question, the person next to me points to the man in purple and says »That one is Lear«; or in the gallery I point, for my companion's benefit, to a spot in the painting before us and say »That white dab is Icarus.« We do not mean, in these instances, that whatever is pointed to stands for, or represents, what it is said to be, for the *word* 'Icarus' stands for or represents Icarus: yet I would not in the same sense of *is* point to the word and say »That is Icarus.« The sentence »That *a* is *b*« is perfectly compatible with »That *a* is not *b*« when the first employs this sense of *is* and the second employs some other, though *a* and *b* are used nonambiguously throughout. Often, indeed, the truth of the first *requires* the truth of the second. The first, in fact, is incompatible with »That *a* is not *b*« only when the *is* is used nonambiguously throughout. For want of a word I shall designate this the *is of artistic identification;* in each case in which it is used, the *a* stands for some specific physical property of, or physical part of, an object; and, finally, it is a necessary condition for something to be an artwork that some part or property of it be designable by the subject of a sentence that employs this special *is*. It is an *is*, incidentally, which has near-relatives in marginal and mythical pronouncements. (Thus, one *is* Quetzalcoatl; those *are* the Pillars of Hercules.)

Let me illustrate. Two painters are asked to decorate the east and west walls of a science library with frescoes to be respectively called *Newton's First Law* and *Newton's Third Law*. These paintings, when finally unveiled, look, scale apart, as follows:

As objects I shall suppose the works to be indiscernible: a black horizontal line on a white ground, equally large in each dimension and element. *B* explains his work as follows: a mass, pressing downward, is met by a mass pressing upward: the lower mass reacts equally and oppositely to the upper one. *A* explains his work as follows: the line through the space is the path of an isolated particle. The path goes from edge to edge, to give the sense of its *going beyond*. If it ended or began within the space, the line would be curved: and it is parallel to the top and bottom edges, for if it were closer to one than to another, there would have to be a force accounting for it, and this is inconsistent with its being the path of an *isolated* particle.

Much follows from these artistic identifications. To regard

the middle line as an edge (mass meeting mass) imposes the need to identify the top and bottom half of the picture as rectangles, and as two distinct parts (not necessarily as two masses, for the line could be the edge of *one* mass jutting up - or down - into empty space). If it is an edge, we cannot thus take the entire area of the painting as a single space: it is rather composed of two forms, or one form and a non-form. We could take the entire area as a single space only by taking the middle horizontal as a *line* which is not an edge. But this almost requires a three-dimensional identification of the whole picture: the area can be a flat surface which the line is *above (Jet-flight),* or *below (Submarine-path),* or *on (Line),* or *in (Fissure),* or *through (Newton's First Law)* — though in this last case the area is not a flat surface but a transparent cross section of absolute space. We could make all these prepositional qualifications clear by imagining perpendicular cross sections to the picture plane. Then, depending upon the applicable prepositional clause, the area is (artistically) interrupted or not by the horizontal element. If we take the line as *through* space, the edges of the picture are not really the edges of the space: the space goes beyond the picture if the line itself does; and we are in the same space as the line is. As *B,* the edges of the picture can be *part* of the picture in case the masses go right to the edges, so that the edges of the picture are *their* edges. In that case, the vertices of the picture would be the vertices of the masses, except that the masses have four vertices more than the picture itself does: here four vertices would be part of the art work which were not part of the real object. Again, the faces of the masses could be the face of the picture, and in looking at the picture, we are looking at these faces: but *space* has no face, and on the reading of *A* the work has to be read as faceless, and the face of the physical object would not be part of the artwork. Notice here how one artistic identification engenders another artistic identification. and how, consistently with a given identification, we are *required* to give others and *precluded* from still others: indeed, a given identification determines how many elements the work is to contain. These different identifications are incompatible with one another, or generally so, and each might be said to make a different artwork, even though each artwork contains the identical real object as part of itself — or at least parts of the identical real object as parts of itself. There are, of course, senseless identifications: no one could, I think, sensibly read the middle horizontal as *Love's Labour's Lost* or *The Ascendency of St. Erasmus.* Finally, notice how acceptance of one identification rather than another is in effect to exchange one *world* for another. We could, indeed, enter a quiet poetic world by identifying the upper area with a clear and cloudless sky, reflected in the still surface of the water below, whiteness kept from whiteness only by the unreal boundary of the horizon.

And now Testadura, having hovered in the wings through-

out this discussion, protests that *all he sees is paint:* a white painted oblong with a black line painted across it. And how right he really is: that is all he sees or that anybody can, we aesthetes included. So, if he asks us to show him what there is further to see, to demonstrate through pointing that this is an artwork *(Sea and Sky),* we cannot comply, for he has overlooked nothing (and it would be absurd to suppose he had, that there was something tiny we could point to and he, peering closely, say »So it is! A work of art after all!«). We cannot help him until he has mastered the *is of artistic identification* and so *constitutes* it a work of art. If he cannot achieve this, he will never look upon artworks: he will be like a child who sees sticks as sticks.

But what about pure abstractions, say something that looks just like *A* but is entitled No. 7? The 10th Street abstractionist blankly insists that there is nothing here but white paint and black, and none of our literary identifications need apply. What then distinguishes him from Testadura, whose philistine utterances are indiscernible from his? And how can it be an artwork for him and not for Testadura, when they agree that there is nothing that does not meet the eye? The answer, unpopular as it is likely to be to purists of every variety, lies in the fact that this artist has returned to the physicality of paint through an atmosphere compounded of artistic theories and the history of recent and remote painting, elements of which he is trying to refine out of his own work; and as a consequence of this his work belongs in this atmosphere and is part of this history. He has achieved abstraction through rejection of artistic identifications, returning to the real world from which such identifications remove us (he thinks), somewhat in the mode of Ch'ing Yuan, who wrote:

Before I had studied Zen for thirty years, I saw mountains as mountains and waters as waters. When I arrived at a more intimate knowledge, I came to the point where I saw that mountains are not mountains, and waters are not waters. But now that I have got the very substance I am at rest. For it is just that I see mountains once again as mountains, and waters once again as waters.

His identification of what he has made is logically dependent upon the theories and history he rejects. The difference between his utterance and Testadura's »This is black paint and white paint and nothing more« lies in the fact that he is still using the *is* of artistic identification, so that his use of »That black paint is black paint« is not a tautology. Testadura is not at that stage. To see something as art requires something the eye cannot decry - an atmosphere of artistic theory, a knowledge of the history of art: an artworld.

III. Mr. Andy Warhol, the Pop artist, displays facsimiles of Brillo cartons, piled high, in neat stacks, as in the stockroom of the supermarket. They happen to be of wood, painted to look like cardboard, and why not? To paraphrase the critic of the

Times, if one may make the facsimile of a human being out of bronze, why not the facsimile of a Brillo carton out of plywood? The cost of these boxes happens to be 2×10^3 that of their homely counterparts in real life — a differential hardly ascribable to their advantage in durability. In fact the Brillo people might, at some slight increase in cost, make their boxes out of plywood without these becoming artworks, and Warhol might make *his* out of cardboard without their ceasing to be art. So we may forget questions of intrinsic value, and ask why the Brillo people cannot manufacture art and why Warhol cannot *but* make artworks. Well, his are made by hand, to be sure. Which is like an insane reversal of Picasso's strategy in pasting the label from a bottle of Suze onto a drawing, saying as it were that the academic artist, concerned with exact imitation, must always fall short of the real thing: so why not just *use* the real thing? The Pop artist laboriously reproduces machine-made objects by hand, e.g., painting the labels on coffee cans (one can hear the familiar commendation »Entirely made by hand« falling painfully out of the guide's vocabulary when confronted by these objects). But the difference cannot consist in craft: a man who carved pebbles out of stones and carefully constructed a work called *Gravel Pile* might invoke the labor theory of value to account for the price he demands; but the question is, What makes it art? And why need Warhol *make* these things anyway? Why not just scrawl his signature across one? Or crush one up and display it as *Crushed Brillo Box* (»A protest against mechanization . . .«) or simply display a Brillo carton as *Uncrushed Brillo Box* (»A bold affirmation of the plastic authenticity of industrial . . .«)? Is this man a kind of Midas, turning whatever he touches into the gold of pure art? And the whole world consisting of latent artworks waiting, like the bread and wine of reality, to be transfigured, through some dark mystery, into the indiscernible flesh and blood of the sacrament? Never mind that the Brillo box may not be good, much less great art. The impressive thing is that it is art at all. But if it is, why are not the indiscernible Brillo boxes that are in the stockroom? Or *has* the whole distinction between art and reality broken down.

Suppose a man collects objects (ready-mades), including a Brillo carton; we praise the exhibit for variety, ingenuity, what you will. Next he exhibits nothing but Brillo cartons, and we criticize it as dull, repetitive, self-plagiarizing — or (more profoundly) claim that he is obsessed by regularity and repetition, as in *Marienbad*. Or he piles them high, leaving a narrow path; we tread our way through the smooth opaque stacks and find it an unsettling experience, and write it up as the closing in of consumer products, confining us as prisoners: or we say he is a modern pyramid builder. True, we don't say these things about the stockboy. But then a stockroom is not an art gallery, and we cannot readily separate the Brillo cartons from the gallery they are in, any more than we can separate the Rauschenberg

bed from the paint upon it. Outside the gallery, they are paste-board cartons. But then, scoured clean of paint, Rauschen-berg's bed is a bed, just what it was before it was transformed into art. But then if we think this matter through, we discover that the artist has failed, really and of necessity, to produce a mere real object. He has produced an artwork, his use of real Brillo cartons being but an expansion of the resources available to artists, a contribution to *artists' materials,* as oil paint was, or *tuche.*

What in the end makes the difference between a Brillo box and a work of art consisting of a Brillo Box is a certain theory of art. It is the theory that takes it up into the world of art, and keeps it from collapsing into the real object which it is (in a sense of *is* other than that of artistic identification). Of course, without the theory, one is unlikely to see it as art, and in order to see it as part of the artworld, one must have mastered a good deal of artistic theory as well as a considerable amount of the history of recent New York painting. It could not have been art fifty years ago. But then there could not have been, every-thing being equal, flight insurance in the Middle Ages, or Etrus-can typewriter erasers. The world has to be ready for certain things, the artworld no less than the real one. It is the role of artistic theories, these days as always, to make the artworld, and art, possible. It would, I should think, never have occurred to the painters of Lascaux that they were producing *art* on those walls. Not unless there were neolithic aestheticians.

IV. The artworld stands to the real world in something like the relationship in which the City of God stands to the Earthly City. Certain objects, like certain individuals, enjoy a double citizenship, but there remains, the RT notwithstanding, a funda-mental contrast between artworks and real objects. Perhaps this was already dimly sensed by the early framers of the IT who, inchoately realizing the nonreality of art, were perhaps limited only in supposing that the sole way objects had of being other than real is to be sham, so that artworks necessarily had to be imitations of real objects. This was too narrow. So Yeats saw in writing »Once out of nature I shall never take/My bodily form from any natural thing.« It is but a matter of choice: and the Brillo box of the artworld may be just the Brillo box of the real one, separated and united by the *is* of artistic identification. But I should like to say some final words about the theories that make artworks possible, and their relationship to one an-other. In so doing, I shall beg some of the hardest philosophical questions I know.

I shall now think of pairs of predicates related to each other as »opposites,« conceding straight off the vagueness of this *de-modé* term. Contradictory predicates are not opposites, since one of each of them must apply to every object in the universe, and neither of a pair of opposites need apply to some objects in the universe. An object must first be of a certain kind before

either of a pair of opposites applies to it, and then at most and at least one of the opposites must apply to it. So opposites are not contraries, for contraries may both be false of some objects in the universe, but opposites cannot both be false; for of some objects, neither of a pair of opposites *sensibly* applies, unless the object is of the right sort. Then, if the object is of the required kind, the opposites behave as contradictories. If F and non-F are opposites, an object o must be of a certain kind K before either of these sensibly applies; but if o is a member of K, then o either is F or non-F, to the exclusion of the other. The class of pairs of opposites that sensibly apply to the $(ô)Ko$ I shall designate as the class of *K-relevant predicates.* And a necessary condition for an object to be of a kind K is that at least one pair of K-relevant opposites be sensibly applicable to it. But, in fact, if an object is of kind K, at least and at most one of each K-relevant pair of opposites applies to it.

I am now interested in the K-relevant predicates for the class K of artworks. And let F and non-F be an opposite pair of such predicates. Now it might happen that, throughout an entire period of time, every artwork is non-F. But since nothing thus far is both an artwork and F, it might never occur to anyone that non-F is an artistically relevant predicate. The non-F-ness of artworks goes unmarked. By contrast, all works up to a given time might be G, it never occuring to anyone until that time that something might both be an artwork and non-G; indeed, it might have been thought that G was a *defining trait* of artworks when in fact something might first have to be an artwork before G is sensibly predicable of it — in which case non-G might also be predicable of artworks, and G itself then could not have been defining trait of this class.

Let G be 'is representational' and let F be 'is expressionist'. At a given time, these and their opposites are perhaps the only artrelevant predicates in critical use. Now letting '+' stand for a given predicate P and '—' for its opposite non-P, we may construct a style matrix more or less as follows:

F	G
+	+
+	—
—	+
—	—

The rows detemine available styles, given the active critical vocabulary: representational expressionistic (e.g., Fauvism); representational nonexpressionistic (Ingres); nonrepresentational expressionistic (Abstract Expressionism); nonrepresentational nonexpressionist (hard-edge abstraction). Plainly, as we add artrelevant predicates, we increase the number of available styles at the rate of 2^n. It is, of course, not easy to see in advance which predicates are going to be added or replaced by their opposites,

but suppose an artist determines that H shall henceforth be artistically relevant for his paintings. Then, in fact, both H and non-H become artistically relevant for *all* painting, and if his is the first and only painting that is H, every other painting in existence becomes non-H, and the entire community of paintings is enriched, together with a doubling of the available style opportunities. It is this retroactive enrichment of the entities in the artworld that makes it possible to discuss Raphael and De Kooning together, or Lichtenstein and Michelangelo. The greater the variety of artistically relevant predicates, the more complex the individual members of the artworld become; and the more one knows of the entire population of the artworld, the richer one's experience with any of its members.

In this regard, notice that, if there are m artistically relevant predicates, there is always a bottom row with m minuses. This row is apt to be occupied by purists. Having scoured their canvasses clear of what they regard as inessential, they credit themselves with having distilled out the essence of art. But this is just their fallacy: exactly as many artistically relevant predicates stand true of their square monochromes as stand true of any member of the Artworld, and they can *exist* as artworks only insofar as »impure« paintings exist. Strictly speaking, a black square by Reinhardt is artistically as rich as Titian's *Sacred and Profane Love*. This explains how less is more.

Fashion, as it happens, favors certain rows of the style matrix: museums, connoisseurs, and others are makeweights in the Artworld. To insist, or seek to, that all artists become representational, perhaps to gain entry into a specially prestigious exhibition, cuts the available style matrix in half: there are then $2^n/2$ ways of satisfying the requirement, and museums then can exhibit all these »approaches« to the topic they have set. But this is a matter of almost purely sociological interest: one row in the matrix is as legitimate as another. An artistic breakthrough consists, I suppose, in adding the possibility of a column to the matrix. Artists then, with greater or less alacrity, occupy the positions thus opened up: this is a remarkable feature of contemporary art, and for those unfamiliar with the matrix, it is hard, and perhaps impossible, to recognize certain positions as occupied by artworks. Nor would these things be artworks without the theories and the histories of the Artworld.

Brillo boxes enter the artworld with that same tonic incongruity the *commedia dell'arte* characters bring into *Ariadne auf Naxos*. Whatever is the artistically relevant predicate in virtue of which they gain their entry, the rest of the Artworld becomes that much the richer in having the opposite predicate available and applicable to its members. And, to return to the views of Hamlet with which we began this discussion, Brillo boxes may reveal us to ourselves as well as anything might: as a mirror held up to nature, they might serve to catch the conscience of our kings.

George Dickie

What is Art?

Although he does not attempt to formulate a definition, Arthur Danto in his provocative article, »The Artworld,« has suggested the direction that must be taken by an attempt to define »art.«[1] In reflecting on art and its history together with such present-day developments as Warhol's *Brillo Carton* and Rauschenberg's *Bed*, Danto writes, »To see something as art requires something the eye cannot decry — an atmosphere of artistic theory, a knowledge of history of art: an artworld.«[2] Admittedly, this stimulating comment is in need of elucidation, but Danto points to the rich structure in which particular works of art are embedded: he indicates *the institutional nature of art.*[3]

I shall use Danto's term »artworld« to refer to the broad social institution in which works of art have their place.[4] But is there such an institution? George Bernard Shaw speaks somewhere of the apostolic line of succession stretching from Aeschylus to himself. Shaw was no doubt speaking for effect and to draw attention to himself, as he often did, but there is an important truth implied by his remark. There is a long tradition or continuing institution of the theater having its origins in ancient Greek religion and other Greek institutions. That tradition has run very thin at times and perhaps even ceased to exist altogether during some periods, only to be reborn out of its memory and the need for art. The institutions associated with the theater have varied from time to time: in the beginning it was Greek religion and the Greek state; in medieval times, the church; more recently, private business and the state (national theater). What has remained constant with its own identity throughout its history is the theater itself as an established way of doing and behaving. This institutionalized behavior occurs on both sides of the »footlights«: both the players and the audience are involved and go to make up the institu-

[1] Above: 9-20. [2] Ibid: 16.

[3] Danto does not develop an institutional account of art in his article nor in a subsequent related article entitled »Art Works and Real Things,« THEORIA, 39 (1973): 1-17. In both articles Danto's primary concern is to discuss what he calls the Imitation Theory and the Real Theory of Art. Many of the things he says in these two articles are consistent with and can be incorporated into an institutional account, and his brief remarks in the later article about the ascriptivity of art are similar to the institutional theory. The institutional theory is one possible version of the ascriptivity theory.

[4] This remark is not intended as a definition of the term »artworld,« I am merely indicating what the expression is used to refer to. »Artworld« is not defined, although the referent of the expression is described in some detail.

tion of the theater. The roles of the actors and the audience are defined by the traditions of the theater. What the author, management, and players present is art, and it is art because it is presented within the theaterworld framework. Plays are written to have a place in the theater system and they exist as plays, that is, as art, within that system. Of course, I do not wish to deny that plays also exist as literary works, that is, as art within the literary system: the theater system and the literary system overlap. Let me make clear what I mean by speaking of the artworld as an institution. Among the meanings of »institution« in *Webster's New Collegiate Dictionary* are the following: »3. That which is instituted as: a. An established practice, law, custom, etc. b. An established society or corporation.« When I call the artworld an institution I am saying that it is an established practice, not that it is an established society or corporation.

Theater is only one of the systems within the artworld. Each of the systems has had its own origins and historical development. We have some information about the later stages of these developments, but we have to guess about the origins of the basic art systems. I suppose that we have complete knowledge of certain recently developed subsystems or genres such as Dada and happenings. Even if our knowledge is not as complete as we wish it were, however, we do have substantial information about the systems of the artworld as they currently exist and as they have existed for some time. One central feature all of the systems have in common is that each is a framework for the *presenting* of particular works of art. If we step back and view the works in their institutional setting, we will be able to see the essential properties they share.

Theater is a rich and instructive illustration of the institutional nature of art. But it is a development within the domain of painting and sculpture — Dadaism — that most easily reveals the institutional essence of art. Duchamp and friends conferred the status of art on »ready-mades« (urinals, hattrack, snow shovels, and the like), and when we reflect on their deeds we can take note of a kind of human action which has until now gone unnoticed and unappreciated — the action of conferring the status of art. Painters and sculptors, of course, have been engaging all along in the action of conferring this status on the objects they create. As long, however, as the created objects were conventional, given the paradigms of the times, the objects themselves and their fascinating exhibited properties were the focus of the attention of not only spectators and critics but of philosophers of art as well. When an artist of an earlier era painted a picture, he did some or all of a number of things: depicted a human being, portrayed a certain man, fulfilled a commision, worked at his livelihood, and so on. In addition he also acted as an agent of the artworld and conferred the status of art on his creation. Philosophers of art attended to only some

of the properties the created object acquired from these various actions, for example, to the representational or to the expressive features of the objects. They entirely ignored the non-exhibited property of status. When, however, the objects are bizarre, as those of the Dadaists are, our attention is forced away from the objects' obvious properties to a consideration of the objects in their social context. As works of art Duchamp's »ready-mades« may not be worth much, but as examples of art they are very valuable for art theory. I am not claiming that Duchamp and friends invented the conferring of the status of art; they simply used an existing institutional device in an unusual way. Duchamp did not invent the artworld, because it was there all along.

The artworld consists of a bundle of systems: theater, painting, sculpture, literature, music, and so on, each of which furnishes an institutional background for the conferring of the status on objects within its domain. No limit can be placed on the number of systems that can be brought under the generic conception of art, and each of the major systems contains further subsystems. These features of the artworld provide the elasticity whereby creativity of even the most radical sort can be accommodated. A whole new system comparable to the theater, for example, could be added in one fell swoop. What is more likely is that a new subsystem would be added within a system. For example, junk sculpture added within sculpture, happenings added within theater. Such additions might in time develop into full-blown systems.

Having now briefly described the artworld, I am in a position to specify a definition of »work of art.« The definition will be given in terms of artifactuality and the conferred status of art or, more strictly speaking, the conferred status of candidate for appreciation. Once the definition has been stated, a great deal will remain to be said by way of clarification: A work of art in the classificatory sense is (1) an artifact (2) a set of the aspects of which has had conferred upon it the status of candidate for appreciation by some person or persons acting on behalf of a certain social institution (the artworld).

The second condition of the definition makes use of four variously interconnected notions: (1) acting on behalf of an institution, (2) conferring of status, (3) being a candidate, and (4) appreciation. The first two of these are so closely related that they must be discussed together. I shall first describe paradigm cases of conferring status outside the artworld and then show how similar actions take place within the artworld. The most clear-cut examples of the conferring of status are certain legal actions of the state. A king's conferring of knighthood, a grand jury's indicting someone, the chairman of the election board certifying that someone is qualified to run for office, or a minister's pronouncing a couple man and wife are examples in which a person or persons acting on behalf of a social institu-

tion (the state) confer(s) *legal* status on persons. The congress or a legally constituted commission may confer the status of national park or monument on an area or thing. The examples given suggest that pomp and ceremony are required to establish legal status, but this is not so, although of course a legal system is presupposed. For example, in some jurisdictions common-law marriage is possible — a legal status acquired without ceremony. The conferring of a Ph.D. degree on someone by a university, the election of someone as president of the Rotary, and the declaring of an object as a relic of the church are examples in which a person or persons confer(s) nonlegal status on persons or things. In such cases some social system or other must exist as the framework within which the conferring takes place, but, as before, ceremony is not required to establish status: for example, a person can acquire the status of wise man or village idiot within a community without ceremony.

Some may feel that the notion of conferring status within the artworld is excessively vague. Certainly this notion is not as clear-cut as the conferring of status within the legal system, where procedures and lines of authority are explicitly defined and incorporated into law. The counterparts in the artworld to specified procedures and lines of authority are nowhere codified, and the artworld carries on its business at the level of customary practice. Still there *is* a practice and this defines a social institution. A social institution need not have a formally established constitution, officers, and bylaws in order to exist and have the capacity to confer status — some social institutions are formal and some are informal. The artworld could become formalized, and perhaps has been to some extent in certain political contexts, but most people who are interested in art would probably consider this a bad thing. Such formality would threaten the freshness and exuberance of art. The core personnel of the artworld is a loosely organized, but nevertheless related, set of persons including artists (understood to refer to painters, writers, composers), producers, museum directors, museum-goers, theater-goers, reporters for newspapers, critics for publications of all sorts, art historians, art theorists, philosophers of art, and others. These are the people who keep the machinery of the artworld working and thereby provide for its continuing existence. In addition, every person who sees himself as a member of the artworld is thereby a member. Although I have called the persons just listed the core personnel of the artworld, there is a minimum core within that core without which the artworld would not exist. This essential core consists of artists who create the works, »presenters« to present the works, and »goers« who appreciate the works. This minimum core might be called »the presentation group,« for it consists of artists whose activity is necessary if anything is to be presented, the presenters (actors,

24

stage managers, and so on), and the goers whose presence and cooperation is necessary in order for anything to be presented. A given person might play more than one of these essential roles in the case of the presentation of a particular work. Critics, historians, and philosophers of art become members of the artworld at some time after the minimum core personnel of a particular art system get that system into operation. All of these roles are institutionalized and must be learned in one way or another by the participants. For example, a theater-goer is not just someone who happens to enter a theater; he is a person who enters with certain expectations and knowledge about what he will experience and an understanding of how he should behave in the face of what he will experience.

Assuming that the existence of the artworld has been established or at least made plausible, the problem is now to see how status is conferred by this institution. My thesis is that, in a way analogous to the way in which a person is certified as qualified for office, or two persons acquire the status of common-law marriage within a legal system, or a person is elected president of the Rotary, or a person acquires the status of a wise man within a community, so an artifact can acquire the status of candidate for appreciation within the social system called »the artworld.« How can one tell when the status has been conferred? An artifact's hanging in an art museum as part of a show and a performance at a theater are sure signs. There is, of course, no guarantee that one can always know whether something is a candidate for appreciation, just as one cannot always tell whether a given person is a knight or is married. When an object's status depends upon nonexhibited characteristics, a simple look at the object will not necessarily reveal that status. The nonexhibited relation *may* be symbolized by some badge, for example, by a wedding ring, in which case a simple look will reveal the status.

The more important question is that of how the status of candidate for appreciation is conferred. The examples just mentioned, display in a museum and a performance in a theater, seem to suggest that a number of persons are required for the actual conferring of the status. In one sense a number of persons are required, but in another sense only one person is required: a number of persons are required to make up the social institution of the artworld, but only one person is required to act on behalf of the artworld and to confer the status of candidate for appreciation. In fact, many works of art are seen only by one person — the one who creates them — but they are still art. The status in question may be acquired by a single person's acting on behalf of the artworld and *treating an artifact as a candidate for appreciation.* Of course, nothing prevents a group of persons from conferring the status, but it is usually conferred by a single person, the artist who creates the artifact. It may be helpful to compare and contrast the notion of confer-

ring the status of candidate for appreciation with a case in which something is simply presented for appreciation: hopefully this will throw light on the notion of status of candidate. Consider the case of a salesman of plumbing supplies who spreads his wares before us. »Placing before« and »conferring the status of candidate for appreciation« are very different notions, and this difference can be brought out by comparing the salesman's action with the superficially similar act of Duchamp in entering a urinal which he christened *Fountain* in that now-famous art show. The difference is that Duchamp's action took place within the institutional setting of the artworld and the plumbing salesman's action took place outside of it. The salesman could do what Duchamp did, that is, convert a urinal into a work of art, but such a thing probably would not occur to him. Please remember that *Fountain*'s being a work of art does not mean that it is a good one, nor does this qualification insinuate that it is a bad one either. The antics of a particular present-day artist serve to reinforce the point of the Duchamp case and also to emphasize a significance of the practice of naming works of art. Walter de Maria has in the case of one of his works even gone through the motions, no doubt as a burlesque, of using a procedure used by many legal and some non-legal institutions — the procedure of licensing. His *High Energy Bar* (a stainless-steel bar) is accompanied by a certificate bearing the name of the work and stating that the bar is a work of art only when the certificate is present. In addition to highlighting the status of art by »certifying« it on a document, this example serves to suggest a significance of the act of naming works of art. An object may acquire the status of art without ever being named but giving it a title makes clear to whomever is interested that an object is a work of art. Specific titles function in a variety of ways - as aids to understanding a work or as a convenient way of identifying it, for example — but any title at all (even *Untitled*) is a badge of status.[5]

The third notion involved in the second condition of the definition is candidacy: a member of the artworld confers the status of candidate for appreciation. The definition does not require that a work of art actually be appreciated, even by one person. The fact is that many, perhaps most, works of art go unappreciated. It is important not to build into the definition of the classificatory sense of »work of art« value properties such as actual appreciation: to do so would make it impossible to speak of unappreciated works of art. Building in value properties might even make it awkward to speak of bad works of art. A theory of art must preserve certain central features of

[5] Recently in an article entitled »The Republic of Art« in BRIT J AES (1969): 145-56, T. J. Diffey has talked about the status of art being conferred. He, however, is attempting to give an account of something like an evaluative sense of »work of art« rather than the classificatory sense, and consequently the scope of his theory is much narrower than mine.

the way in which we talk about art, and we do find it necessary sometimes to speak of unappreciated art and of bad art. Also, not every aspect of a work is included in the candidacy for appreciation; for example, the color of the back of a painting is not ordinarily considered to be something which someone might think it appropriate to appreciate.

The fourth notion involved in the second condition of the definition is appreciation itself. Some may assume that the definition is referring to a special kind of *aesthetic* appreciation. There is no reason to think that there is a special kind of aesthetic consciousness, attention, or perception. Similarly, I do not think there is any reason to think that there is a special kind of aesthetic appreciation. All that is meant by »appreciation« in the definition is something like »in experiencing the qualities of a thing one finds them worthy or valuable,« and this meaning applies quite generally both inside and outside the domain of art. The only sense in which there is a difference between the appreciation of art and the appreciation of nonart is that the appreciations have different *objects*. The institutional structure in which the art object is embedded, not different kinds of appreciation, makes the difference between the appreciation of art and the appreciation of nonart.

In a recent article[6] Ted Cohen has raised a question concerning (1) candidacy for appreciation and (2) appreciation as these two were treated in my original attempt to define »art.«[7] He claims that in order for it to be possible for candidacy for appreciation to be conferred on something that it must be possible for that thing to be appreciated. Perhaps he is right about this; in any event, I cannot think of any reason to disagree with him on this point. The possibility of appreciation is one constraint on the definition: if something cannot be appreciated, it cannot become art. The question that now arises is: is there anything which it is impossible to appreciate? Cohen claims many things cannot be appreciated; for example, »ordinary thumbtacks, cheap white envelopes, the plastic forks given at some drive-in restaurants.«[8] But more importantly, he claims that *Fountain* cannot be appreciated. He says that *Fountain* has a point which can be appreciated, but that it is Duchamp's gesture that has significance (can be appreciated) and not *Fountain* itself. I agree that *Fountain* has the significance Cohen attributes to it, namely, that it was a protest against the art of its day. But why cannot the ordinary qualities of *Fountain* — its gleaming white surface, the depth revealed when it reflects images of surrounding objects, its pleasing oval shape — be appreciated. It has qualities similar to those of works by Brancusi and Moore

6 »The Possibility of Art: Remarks on a Proposal by Dickie,« PHIL REV, LXXXII, (1973): 69-82.

7 »Defining Art,« AMER PHIL QUART, VI, (1969): 253-256.

8 »The Possibility of Art«: 78.

which many do not balk at saying they appreciate. Similarly, thumbtacks, envelopes, and plastic forks have qualities that can be appreciated if one makes the effort to focus attention on them. One of the values of photography is its ability to focus on and bring out the qualities of quite ordinary objects. And the same sort of thing can be done without the benefit of photography by just looking. In short, it seems unlikely to me that any object would not have some quality which is appreciatable and thus likely that the constraint Cohen suggests may well be vacuous. But even if there are some objects that cannot be appreciated, *Fountain* and the other Dadaist creations are not among them.

I should note that in accepting Cohen's claim I am saying that every work of art must have some minimal *potential* value or worthiness. This fact, however, does not collapse the distinction between the evaluative sense and the classificatory sense of »work of art.« The evaluative sense is used when the object it is predicated of is deemed *to be* of substantial, actual value, and that object may be a natural object. I will further note that the appreciatability of a work of art in the classificatory sense is *potential* value which in a given case may never be realized.[9]

The definition I have given contains a reference to the artworld. Consequently, some may have the uncomfortable feeling that my definition is viciously circular. Admittedly, in a sense the definition is circular, but it is not viciously so. If I had said something like »A work of art is an artifact on which a status has been conferred by the artworld« and then said of the artworld only it confers the status of candidacy for appreciation, then the definition would be viciously circular because the circle would be so small and *uninformative*. I have, however, devoted a considerable amount of space to describing and analyzing the historical, organizational, and functional intricacies of the artworld, and if this account is accurate the reader has received a considerable amount of *information* about the artworld. The circle I have run is not small and it is not uninformative. If, in the end, the artworld cannot be described independently of art, that is, if the description contains references to art historians, art reporters, plays, theaters, and so on, then the definition strictly speaking is circular. It is not, however, viciously so, because the whole account in which the definition is embedded contains a great deal of information about the artworld. One must not focus narrowly on the definition alone: for what is important to see is that art is an institutional concept and this requires seeing the definition in the context of the whole account. I suspect that the »problem« of circularity will arise fre-

[9] I realized that I must make the two points noted in this paragraph as the result of a conversation with Mark Venezia. I wish to thank him for the stimulation of his remarks.

quently, perhaps always, when institutional concepts are dealt with.

The instances of Dadaist art and similar present-day developments which have served to bring the institutional nature of art to our attention suggest several questions. First, if Duchamp can convert such artifacts as a urinal, a snow shovel, and a hatrack into works of art, why can't natural objects such as driftwood also become works of art in the classificatory sense? Perhaps they can if any one of a number of things is done to them. One way in which this might happen would be for someone to pick up a natural object, take it home, and hang it on the wall. Another way would be to pick up a natural object and enter it in an exhibition. Natural objects which become works of art in the classificatory sense are artifactualized without the use of tools — artifactuality is conferred on the object rather than worked on it. This means that natural objects which become works of art acquire their artifactuality at the same time that the status of candidate for appreciation is conferred on them, although the act that confers artifactuality is not the same act that confers the status of candidate for appreciation. But perhaps a similar thing ordinarily happens with paintings and poems; they come to exist as artifacts at the same time that they have the status of candidate for appreciation conferred on them. Of course, being an artifact and being a candidate for appreciation are not the same thing — they are two properties which may be acquired at the same time. Many may find the notion of artifactuality being conferred rather than »worked« on an object too strange to accept and admittedly it is an unusual conception. It may be that a special account will have to be worked out for exhibited driftwood and similar cases.

Another question arising with some frequency in connection with discussions of the concept of art and seeming especially relevant in the context of the institutional theory is »How are we to conceive of paintings done by individuals such as Betsy the chimpanzee from the Baltimore Zoo?« Calling Betsy's products paintings is not meant to prejudge that they are works of art, it is just that some word is needed to refer to them. The question of whether Betsy's paintings are art depends upon what is done with them. For example, a year or two ago the Field Museum of Natural History in Chicago exhibited some chimpanzee and gorilla paintings. We must say that these paintings are not works of art. If, however, they had been exhibited a few miles away at the Chicago Art Institute they would have been works of art — the paintings would have been art if the director of the Art Institute had been willing to go out on a limb for his fellow primates. A great deal depends upon the institutional setting: one institutional setting is congenial to conferring the status of art and the other is not. Please note that although paintings such as Betsy's would

remain her paintings even if exhibited at an art museum, they would be the *art* of the person responsible for their being exhibited. Betsy would not (I assume) be able to conceive of herself in such a way as to be a member of the artworld and, hence, would not be able to confer the relevant status. Art is a concept which necessarily involves human intentionality. These last remarks are not intended to denigrate the value (including beauty) of the paintings of chimpanzees shown at natural history museums or the creations of bower birds, but as remarks about what falls under a particular concept.

Danto in »Art Works and Real Things« discusses defeating conditions of the ascriptivity of art.[10] He considers fake paintings, that is, copies of original paintings which are attributed to the creators of the original paintings. He argues that a painting's being a fake prevents it from being a work of art, maintaining that originality is an analytical requirement of being a work of art. That a work is derivative or imitative does not, however, he thinks, prevent it from being a work of art. I think Danto is right about fake paintings, and I can express this in terms of my own account by saying that originality in paintings is an antecedent requirement for the conferring of the candidacy for appreciation. Similar sorts of things would have to be said for similar cases in the arts other than painting. One consequence of this requirement is that there are many works of nonart which people take to be works of art, namely, fake paintings which are not known to be fakes. When fakes are discovered to be fakes, they do not lose that status of art because they never had the status in he first place, despite what almost everyone had thought. There is some analogy here with patent law. Once an invention has been patented, one exactly like it cannot be patented — the patent for just that invention has been »used up.« In the case of patenting, of course, whether the second device is a copy or independently derived is unimportant, but the copying aspect is crucial in the artistic case. The Van Meegeren painting that was not a copy of an actual Vermeer but a painting done in the manner of Vermeer with a forged signature is a somewhat more complicated case. The painting with the forged signature is not a work of art, but if Van Meergeren had signed his own name the painting would have been.

Strictly speaking, since originality is an analytic requirement for a painting to be a work of art, an originality clause should be incorporated into my definition of »work of art.« But since I have not given any analysis of the originality requirement with respect to works other than paintings, I am not in a position to supplement the definition in this way. All I can say at this time is what I said just above, namely, that originality in paintings is an antecedent requirement for the conferring of

[10] Pages 12-14.

the candidacy for appreciation and that considerations of a similar sort probably apply in the other arts.

Weitz charges that the defining of »art« or its subconcepts forecloses on creativity.[11] Some of the traditional definitions of »art« *may* have and some of the traditional definitions of its subconcepts probably *did* foreclose on creativity, but this danger is now past. At one time a playwright, for example, may have conceived of and wished to write a play with tragic features but lacking a defining characteristic as specified by, say, Aristotle's definition of »tragedy.« Faced with this dilemma the playwright might have been intimidated into abandoning his project. With the present-day disregard for established genres, however, and the clamor for novelty in art, this obstacle to creativity no longer exists. Today, if a new and unusual work is created and it is similar to some members of an established type of art, it will usually be accommodated within that type, or if the new work is very unlike any existing works then a new subconcept will probably be created. Artists today are not easily intimidated, and they regard art genres as loose guidelines rather than rigid specifications. Even if a philosopher's remarks were to have an effect on what artists do today, the institutional conception of art would certainly not foreclose on creativity. The requirement of artifactuality cannot prevent creativity, since artifactuality is a necessary condition of creativity. There cannot be an instance of creativity without an artifact of some kind being produced. The second requirement involving the conferring of status could not inhibit creativity; in fact, it encourages it. Since under the definition anything whatever may become art, the definition imposes no restraints on creativity.

The institutional theory of art may sound like saying, »A work of art is an object of which someone has said, 'I christen this object a work of art.'« And it is rather like that, although this does not mean that the conferring of the status of art is a simple matter. Just as the christening of a child has as its background the history and structure of the church, conferring the status af art has as its background the Byzantine complexity of the artworld. Some may find it strange that in the nonart cases discussed, there are ways in which the conferring can go wrong, while that does not appear to be true in art. For example, an indictment might be improperly drawn up and the person charged would not actually be indicted, but nothing parallel seems possible in the case of art. This fact just reflects the differences between the artworld and legal institutions: the legal system deals with matters of grave personal consequences and its procedures must reflect this; the artworld deals with important matters also but they are of a different sort entirely.

[11] Morris Weitz »The Role of Theory in Aesthetics«, J AES ART CRIT (1956): 27—35.

The artworld does not require rigid procedures; it admits and even encourages frivolity and caprice without losing its serious purpose. Please note that not all legal procedures are as rigid as court procedures and that mistakes made in conferring certain kinds of legal status are not fatal to that status. A minister may make mistakes in reading the marriage ceremony, but the couple that stands before him will still acquire the status of being married. If, however, a mistake cannot be made *in* conferring the status of art, a mistake can be made *by* conferring it. In conferring the status of art on an object one assumes a certain kind of responsibility for the object in its new status — presenting a candidate for appreciation always allows the possibility that no one will appreciate it and that the person who did the conferring will thereby lose face. One *can* make a work of art out of a sow's ear, but that does not necessarily make it a silk purse.

Joseph Margolis

Works of Art Are Physically Embodied and Culturally Emergent Entities

It's clear that one's account of the nature of criticism and of the nature of a work of art are conceptually linked in the most intimate way. What we indicate we are talking about and what we may justifiably say of it depend on what it is; and what it is will be conceded by considering how it may be fixed and identified and what may be said of it. I have elsewhere tried to show that the problem of identifying and fixing the reference of a work of art and the concession of characteristically admissible critical remarks can be managed without deciding the precise ontological nature of a work of art;[1] that, on the contrary, a premature solution of that problem is bound to do violence to the concessions that must be made. I had put my point in terms of the avoidance of an excessive idealism that finds nothing in the public world that would count as a work of art and an excessive (or reductive) materialism that denies that anything exists that is not merely and entirely physical. I

[1] Cf. my »On Disputes about the Ontological Status of a Work of Art«, BRIT J AES 8 (1968): 147-54; and THE LANGUAGE OF ART AND ART CRITICISM, Detroit 1965, Ch. IV.

had attempted to show, also, how readily critics and historians of the arts confuse the logical status of their own comments because of their confusion about the nature of what they are commenting about.[2] But I was not able to formulate with any precision a theory of the actual ontological standing of a work of art fully congruent and sympathetic with the special problems of reference and characterization (particularly, interpretation) in the arts and responsive, at the same time, to the requirements of an informed account of the ontology of other kinds of entities. I hope here to redeem that limitation. Also, though I had not managed to provide a detailed account of the ontology of art, the arguments that had gone before definitely favor and disfavor particular theories.

The clue I now see is, I think, an intriguing one: admitting that they are enormously different, I believe that we treat *works of art* and *persons* as entities of a similar sort and speak about them in somewhat similar ways. Works of art, of course, characteristically lack minds; although when we think (however metaphorically) of man made in the image of God, of Pygmalion's art, and of the possibility of intelligent robots, even this contrast begins to fade. But both works of art and persons (not, by the way, merely human persons if it turns out that there are persons in interstellar space or that dolphins should prove to be persons) are *culturally emergent entities*. Both are accorded a measure of rationality below which they cannot fall, on pain of failing to be a work of art or a person. The schemata employed in our discourse in order to make this clear about works of art are decidedly variable. But we may take it, as a rough approximation, that Kantian 'purposiveness without purpose' (generously construed, for instance as allowing works of art to be directed to an external purpose and as allowing 'found art' to be imputed purposiveness in terms of an appreciative tradition) fixes the form of rationality that may be minimally assigned to anything construed as a work of art; correspondingly, for persons, rationality or coherence, for instance among intention, belief, desire and action, cannot be absent in any creature thought to function as a person (one cannot for instance be said to intend to do what one is said to believe oneself incapable of doing, and one cannot be said to perform actions that are utterly incongruent with what one is said to want and desire and believe). The elaboration of the respective schemata is, somewhat narrowly, the concern of the philosophy of criticism and the philosophy of mind.[3]

[2] Cf. my »Critics and Literature«, BRIT J AES 11 (1971): 369-84; and THE LANGUAGE OF ART AND ART CRITICISM, Chs. V-VI.

[3] I have sketched the need for these very briefly, both with regard to persons and with regard to works of art, in »The Perils of Physicalism«, MIND 82 (1973): 566-78; and »Reductionism and Ontological Aspects of Consciousness«, J THEORY SOC BEHAVIOUR 4 (1974): 3-16.

Works of art and persons, I should say, are embodied in physical bodies (or marks or movements in the case of some works of art) and as emergent entities exhibit emergent properties. These two considerations serve as the foci of any relevant ontological proposal. Embodiment and emergence must be properly understood. But embodiment — however appropriately construed — enables us to answer questions about how we refer to and identify works of art and persons, as well as questions about the prospects of such a programme as that of a consistent materialism; and emergence — however appropriately construed — enables us to answer questions about the propriety of ascribing attributes of given sorts to entities of given sorts, as well as questions about the prospects of such a programme as that of resisting reductionism. What is interesting, then, is that precisely the same puzzles and the same manoeuvres obtain whether we speak of works of art or of persons and that these are just the classical puzzles and manoeuvres available elsewhere in the metaphysical enterprise.[4] I shall here stress the properties and nature of a work of art, with only the most economical suggestions about the corresponding mode of discourse regarding persons.

If a work of art is 'embodied' in a physical object, then whatever convenience of reference and identity may be claimed for a physical object may be claimed for the work of art embodied in it in spite of the fact that to be embodied in an object is not to be identical with it. So embodiment can be readily seen to provide a possible basis for speaking of emergence without losing the advantages of reference and identity — the difficulty, precisely, of certain extreme forms of idealist views of works of art that locate them somehow in plural minds or in some vaguely specified 'space' of intersubjective ideology. Thus Michelangelo's *David* may be identified and referred to as a sculpture embodied in a particular block of marble; and thus identified, assuming that we understand how it is different from the marble and yet embodied in it, we may refer to it and attribute to it whatever properties it has. Physical objects have the advantage of being identifiable in exclusively extensional terms: the block of marble in which the *David* is embodied may validly be ascribed properties regardless of the description under which it is identified; its putative properties are in no way affected by the characterization under which it is identified as the thing it is. Alternatively put, physical objects have whatever properties they have, *qua* physical objects, independently of any cultural consideration and even independently of the existence of any culture; their properties do not depend on our coming to believe or know whatever we take them to be. What is true of purely physical objects, *qua* physical objects, is true of them however we may replace, in sentential

[4] Cf. my KNOWLEDGE AND EXISTENCE, N.Y. 1973, Chs. V, VIII.

contexts, the identifying expressions by which they are denoted or referred to; codesignative descriptions may be substituted in otherwise extensional contexts, *salva veritate*. But this is not true of *culturally* emergent entities (though it may be true of simple emergent entities, for instance of plants with respect to an inanimate world); hence it is not true of works of art (or of persons or even of actions ascribed to persons). Also, no special problems arise regarding musical scores and the like, simply because musical scores are notations by means of which to identify actual music, particular performances of given compositions, rather than as actual music themselves. Here, our usual idiom is elliptical.[5]

To say that a work of art is *embodied* in a physical object is to say that its identity is necessarily linked to the identity of the physical object in which it is embodied, though to identify the one is not to identify the other; it is also to say that, *qua* embodied, a work of art must possess properties other than those ascribed to the physical object in which it is embodied, though it may be said to possess (where relevant) the properties of that physical object as well. Also *if* in being embodied works of art are, specifically, emergent entities, then the properties that a work of art possesses will include properties *of a kind* that cannot appropriately be ascribed to the object in which it is embodied: there is a measure of adequation that needs to be acknowledged between entities *of* a certain kind and the *kind* of attributes ascribable to them as being of that kind. Finally if works of art, as emergent, are *culturally* emergent entities, then they will exhibit culturally significant properties that cannot be ascribed to the merely physical objects in which they are embodied and, as such, identifying references to them will exhibit whatever limitations obtain on the ascription of such properties. These rather abstract theorems may be animated by considering the homeliest cases. Stones cannot properly be said to feel anger: it's not just that it is always false that stones feel angry; it's inappropriate to say that they do or don't. Human beings dream: it could not be said that the bodies in which they are embodied dream, *unless,* by some ontological ingenuity, persons could be said to be identical with their bodies.[6] And paintings may have expressive qualities, but not the mere physical pigments in which they are embodied.

[5] Cf. THE LANGUAGE OF ART AND ART CRITICISM, Ch IV; and my »Nummerical Identity and Reference«, BRIT J AES 10 (1970): 138-46.

[6] In effect, this points to the essential weakness of P. F. Strawson's INDIVIDUALS, London 1959, for he distinguishes material bodies and persons as basic particulars — equally so — but he never explains the relationship between bodies and persons. In the context of the philosophy of art an analogous problem concerns the relationship between, say, sculptures and blocks of marble, the relationship here characterized as embodiment.

Now to say that works of art (and persons) are culturally emergent entities is to say that though they are physically embodied and identifiable in so far as they are embodied, *they* can be identified only because they are embodied as they are and because they are culturally emergent entities that are embodied. And *that* means that there is nothing *to be* identified as embodied in suitable physical objects apart from what, in certain cultural contexts, would rightly be said to be thus embodied. The point of this consideration is simply that works of art cannot be indentified as such except in a cultural context: only if we understand how, say, words can be culturally construed as embodied in sounds or marks or, say, José Limon's *Moor's Pavanne* in physical movements, can we even admit that there is anything to be identified, by some suitable conceptual linkage, with physical objects.

Works of art are identified extensionally only because, once we are clear about the kind of thing they are, we know that their identity can be straightforwardly linked with the identity of the physical objects in which they are embodied (but with which they are not identical). However they may be specified as the particular painting, dance, sonata, novel that they are, their identity will be linked with the identity of the physical marks and objects in which they are embodied. But to locate or specify something *as* a work of art thus embodied requires as well reference to the artistic and appreciative traditions of a given culture. Nowhere is this more strikingly clear than when we speak of 'found art'; for in speaking of found art, unless a person is suitably sensitized, he will not even see that there is a work of art *to be* identified by virtue of the identity of some physical object in which it is embodied. In this sense all art is found art — whether driftwood and smooth stones, or Duchamp's assemblages or constructions or readymades, or Michelangelo's *David*. To be aware of the presence of a work of art is, I am suggesting, to be aware of an object that (roughly speaking) exhibits purposiveness without purpose; and that to be aware of such an objects is to construe some physical objects or marks as supporting (by way of embodiment) a certain culturally emergent object. Only relative to some cultural tradition — normally continuous and congruent from society to society, but not always — can anything be identified as a work of art. Once identified, however, it always turns out that its identity depends on the identity of some physical object in which it is embodied. So works of art are said to be the particular objects they are, *in intensional contexts*, although they may be identified, by the linkage of embodiment, through the identity of what may be identified *in extensional contexts*. That is, works of art are identified extensionally in the sense that their identity (whatever they are) is controlled by the identity of what they are embodied in; but to identify them as what they are (thus embodied) can be accomplished only intensionally

(by reference to the very cultural tradition in which they may actually be discriminated).

If I hold an appropriate theory of the work of creative artists (for instance, that they make sculptures out of marble, objects exhibiting at least a certain minimal purposiveness in terms of which ascriptions of representation, symbolic import, expressiveness and the like may be supportably made of particular sculptures) or of the appreciation of found art (for instance that we may under favorable conditions impute a corresponding purposiveness to objects without antecedent evidence of the work of a particular artist or without there having been an independent artist who actually made the object or without a particular artist's having 'made' the object in the full sense in which, traditionally, that was thought to be required), then, confronted with a physical object of a suitable sort, I will identify and make reference to a work of art that I take to be embodied in it. The reference I have made presupposes my grasp of a cultural tradition in which such reference is intelligible; and in fact the recognition that a given work of art actually exists and has the properties it has depends on the cultural tradition in terms of which a particular physical object may justifiably be said to embody a particular work of art and in terms of which critical practice will support particular attributions to particular works identified. Looking at an array of great stones I can speak of and attribute properties to the Japanese stone garden embodied in it only by reference to a suitable cultural tradition; but *the garden* will be identified by identifying the set of stones in which it is embodied. The reason, once again, we do not confuse the two is because (since they are different) not all the properties attributed to the one can be truly attributed to the other and because (since art is culturally emergent) not all the kinds of properties attributed to the one can be coherently attributed to the other. So reference to physical objects is extensional, in being context-free; and reference to works of art is intensional, in depending on the contextual assumptions of particular cultures. Our theories about physical objects and works of art commit us to identifying the one extensionally and the other intensionally. There is nothing to be identified *as* a work of art except relative to a cultural concern with certain patterns of purposiveness that may be said to be embodied in a physical system that itself necessarily lacks all such properties. That is, it is *essential*, in speaking of works of art, to attribute to them certain patterns of purposiveness and it is essential to materialism to hold »that physical phenomena have none but purely physical explanations«.[7] On a materialist view, then, either the relationship be-

[7] Cf. D. K. Lewis »An Argument for the Identity Theory«, J PHIL 63 (1966): 17-25.

tween physical phenomena and the phenomena regarding the purposiveness of art is one of identity (which is problematic, given the intensional constraints on identifying works of art) or else it is of another sort, like embodiment, that is both compatible with materialism and that may accommodate the peculiarly emergent nature of art itself.

Phenomenologically, we listen to music, gaze at a painting, read a poem: we ourselves are culturally habituated to notice works of art directly and to attend spontaneously to their distinctive powers and attributes. Even in language, however, where the physical constraints on meaningful discourse are minimal, we attend to cadence, to the properties of the speaking voice, to breathing, rhyme, alliteration and the like. In the literary arts a fully embodied medium (language) is antecedently prepared. In the other arts the medium is somewhat less completely prepared, in the sense that musical forms, dance movements and the like are not regularly used to facilitate independent and relatively self-sufficient modes of communication. Still the artistic and appreciative traditions of a culture prepare both would-be artists and would-be audiences to construe ordered physical materials as artistic *media*. Here a useful equivocation arises. For in mentioning media we mean to speak at one and the same time of the physical medium in which the work of art is embodied and of the artistic medium in which the (embodied) emergent work is actually formed. Thus a painting is embodied in the medium of colored pigments applied to canvas; but, also, a painting emerges from the pigment as a purposive system of brush-strokes — that is, placed colors and forms. Similarly a dance is embodied in physical movements but it is itself a system of articulated dance steps. Alternatively put, artistic media may themselves be construed as embodied (by way of particular brush-strokes, dance steps, words and phrases, and the like) in physical media. The crucial point to consider here is that, in so speaking, we make an automatic ontological adjustment: we shift from reference to a purely physical medium whose properties yield, in the relevant sense, to »purely physical explanations« to reference to the art object essentially composed of *dance steps, brush-strokes* or the like, compositional ingredients that are themselves informed by the purposiveness of the entire work.

These simple observations support certain extremely large distinctions. Works of art are Intentional objects of a culturally emergent sort and, because they are culturally emergent, they can only be identified, as such, intensionally. To say that they are Intentional is merely to say, in the Kantian manner, that they exhibit an interior purposiveness; they are composed of strokes, or steps, or phrases, or the like. It is not to say that works of art are *about* anything at all, although novels and poems are, characteristically, Intentional in this sense as well. But architecture and music and landscape gardening and car-

pets are normally not 'about' anything, normally do not refer to or denote anything at all.[8]

Human actions provide an instructive analogue. A man raises his arm to signal; the action has that Intentional property. Apart from human society there is no such action, no more than a movement of the arm; within the conventions of a culture the action may be seen as such, embodied in the arm's movement, endowed with the Intentional property it is seen to have. The point is this: works of art and other culturally emergent entities are distinguished by their Intentional attributes (different attributes and different kinds of attributes for different kinds of entities); but neither they nor their attributes can be discriminated as embodied in physical objects (objects totally lacking Intentional properties) without reference, intensionally, to some culture — in accord with the traditions of which only, provision is made for the admission of such objects and such attributes.

To pursue the analogy, signaling occurs only in a cultural context (like works of art and persons). To identify an act of signaling one must identify a suitable physical movement that by reference to an appropriate tradition or rule or custom or the like may fairly be taken as embodying the act. So the very existence of the action depends on a cultural context, and its identification depends intensionally on reference to the appropriate features of the context in which it may be marked out; physical movements (and, correspondingly, physical bodies) never exhibit this trait. Moreover actions are characteristically thought to be performed for reasons; and yet the reasons that may be assigned to an action can only be assigned to the action under a certain description. Discourse about reasons, therefore, is thoroughly intensional, in the sense that they cannot, *salva veritate*, be assigned to actions, in sentential contexts, indifferently to whatever co-designative terms may be used.[9]

Similarly a work of art can be indentified as such only relative to a favorable culture with respect to the traditions of which it actually exists. But works of art exhibit a further ontological complication. They often cannot themselves be ascribed a coherent design, an internal purposiveness, without imputing by interpretation properties that yield a plausible and suitably complete purposiveness. Think, for instance, of interpreting a puzzling story like Kafka's *Penal Colony* or a painting like Leonardo's *Last Supper*. Is the representation of

[8] This points to a central weakness in A. Danto's theory of works of art. Cf. »The Artworld«, above: 9-20, to which Danto has quite recently added this essential ingredient of 'aboutness' (e. g., at the State University of New York Conference on Philosophy and the Arts, Nov 2-4, 1973).

[9] Cf. my Puzzles about Explanation by Reasons and Explanations by Causes«, J PHIL 67 (1970): 187-95; also D. Davidson »Actions, Reasons, and Causes«, J PHIL 60 (1963): 685-700.

Leonardo's fresco to be construed in terms of Judas's betrayal or in terms of the institution of the Eucharist? And is the scene to be construed in terms of a pregnant moment of natural time or in terms of the timeless import of all relevant moments of the story? It's not simply that the ascription of certain properties to an object logically depends on the ascription of other properties — for instance, that being a square entails being a rectangle — but rather that the ascription of properties of certain sorts and the appraisals of works of art themselves depend on the identification of the work *under a certain description* (or interpretation), that is, they are intensionally qualified. For it is logically possible to identify one and the same work under alternative and incompatible interpretations (each interpretation compatible with the minimally describable features of the work in question), where the truth value of further characterizations and appraisals of given works will be affected by such intensional identification.[10] Isabel Hungerland, it may be remarked, once advocated that we accept 'that interpretation which does the best for the work, i.e., which results in the highest rating in the order of worth'.[11] But she did not consider that the nature of the work is not first fixed and then interpreted; she did not consider that the work is itself identified *for* relevant description and appraisal *when* 'it' is interpreted (that is, when the embodying medium may be plausibly construed, by way of interpretation, to embody a work of a given design). This is the reason, also, that Checkov objected to Stanislavsky's portrayal of his plays as tragedies: the intensional characterization under which the plays are identified precludes certain further characterizations and appraisals of *the plays*.

What we see, then, is that discourse about works of art behaves intensionally in at least two distinct ways: first, in that works of art are identified intensionally relative to cultural contexts in which they may be said to be embodied in a physical medium; second, in that characterizations and appraisals of the work are relativized to plausible interpretations of the work (where relevant). It is, precisely, the physical embodiment of a work of art that minimizes the threat of common reference and common grounds for interpretative and appraisive dispute; for by linking the work of art to its embodying medium we minimize intensional considerations.

What shall we understand, then, by physical embodiment and cultural emergence? First of all we must admit a logically

[10] On the theory of interpretation cf. THE LANGUAGE OF ART AND ART CRITICISM, Pt III; also »Three Problems in Aesthetics«, ART AND PHILOSOPHY, (ed) S. Hook, N.Y. 1966. The complications regarding the interpretation of Leonardo's fresco are discussed in a forthcoming book by Leo Steinberg.

[11] »The Concept of Intention in Art Criticism«, J PHIL 52 (1955): 740.

distinctive use of 'is', the 'is' of embodiment, not to be collapsed into the 'is' of identity, different in somewhat the same sense in which the 'is' of composition is different from that of identity.[12] Michelangelo's *David is* that block of marble (or, that block of marble *is* the *David*) in the sense only that the *David* is embodied in it. And second, to hold that one *entity* is embodied in another is simply to subscribe to a theory regarding different kinds of entities and the attributes properly ascribable to them such that reference can be made jointly to embodying and embodied entities. Embodied entities need not, of course, be emergent entities — though, characteristically, they will be; the issue concerns only the matter of the (ontological) adequation between entities and their attributes. Since everything there is is of one kind or another, being of a kind sets constraints on what may properly be ascribed (whether truly or falsely) to any putative entity. In admitting entities of different kinds we implicitly admit the possibility of entities of one kind being embodied in entities of another — persons in sentient bodies; works of art in physical objects and movements. So embodiment is essentially a question of reference and attribution, ontologically construed. Consequently it raises no questions whatsoever of dualism or the like — no more than the question of composition does. Emergence, on the other hand, with regard to entities is concerned with the question of the enabling circumstances under which entities of given kinds first exist relative to a backdrop of entities of other sorts. Emergent entities need not, of course, be embodied entities — though, prominently, they include such. Perhaps plants may be construed as emergent entities not in any clear sense *embodied* in any other entity, even if *composed* of other entities (substances, for instance, or congeries of micro-theoretical entities). But culturally emergent entities — notably, persons and works of art — cannot but be embodied entities; for in speaking of such entities we mean to say, precisely, that within and only within the context of a cultural tradition we can identify certain entities (persons and works of art) that possess both certain distinctive Intentional attributes (not attributable to purely physical objects) and certain physical attributes (that may also be attributed to purely physical objects). Only if we admit the existence of embodied entities will this way of speaking be possible. Also the admission of emergent entities, accounted for either in terms of an artist's craft or in terms of an audience's tradition of appreciation, counts against reductionism, simply because of the intensional constraints on reference and attribution that must be admitted to obtain.

The upshot, then, is that to speak of works of art as physically embodied and culturally emergent is remarkably econo-

[12] Cf. D. Wiggins IDENTITY AND SPATIO-TEMPORAL CONTINUITY (1967); also my KNOWLEDGE AND EXISTENCE, Chs V, VIII.

mical at the same time that it is hospitable to certain particularly puzzling features of the world of art. Provisionally some form of none-reductive materialism may be taken to be entirely compatible with the admission of the Intentionality of works of art and the intensionality of reference to them and of appraisals based on the interpretation of works of art — always the most troublesome problems confronting ontological speculations about art.

Having said this much, we need to refine our theory. First of all, we must clarify the concept of a culture or a cultural context. By 'cultural', is meant the property of any system in virtue of which *certain* entities emerge and exist, a system in which *both* persons *and* what they may produce — *a fortiori,* works of art — exist or once existed. Such a system is at once rule-governed, in that what is typically produced is intelligible only in terms of rulelike regularities (traditions, customs, practices, institutions), and rule-following, in that persons (as distinct from Homo sapiens) are essentially capable of using language, of intentionally acting in accord with rules which they understand and are able to violate. These considerations straightforwardly point to the conceptual dependence of a theory of art on a theory of persons: the rulelike properties of art are ascribable only in a context in which creatures capable of acting in accord with rules, and therefore of informing things with rulelike properties, are already admitted to exist. Also, clearly, the anomalies of found art, driftwood, the dabbling of chimpanzees, and the like are all resolvable in terms of the dependence of the corresponding appreciative tradition on some active tradition of actual craft work: to construe a sunset as a painting, for instance, is to presuppose painting; there can be no extension of the range of what may pass as art without reference to the distinctions of an institutionalized craft, of how to work in an artistic medium.

But all discourse about rule-governed and rule-following phenomena and, in a fair sense, the phenomena themselves are intensional. Consider only that rulelike regularities provide for the distinction between such paired categories (ranging, inevitably, far beyond the purview of aesthetics) as 'appropriate'/'inappropriate', 'legitimate'/'illegitimate', 'right'/'wrong', 'beautiful'/'ugly', and a host of others including, prominently, distinctions of period styles and of kinds of artistic excellence. Now, nothing can be ascribed such attributes, except under a relevant description, a description in accord with the postulated criteria by which, precisely, such attributes are rightly ascribed. The intensional, therefore, is at once essentially linguistic (or dependent on language) and cultural: only a creature capable of construing something *under one description rather than another* could possibly be said to understand the nature of a rule and to follow it intentionally. It is in this sense that the cultural is sometimes said to concern the 'signi-

ficant' and it is in this sense that rule-following behavior is either incipiently linguistic or presupposes linguistic ability.[13] Hence, too, cultural entities may be said to exist only Intentionally (using that term as a term of art), in the sense that rule-following capacities (of persons) or rule-governed attributes (of machines, artifacts, words and sentences, works of art) are properly ascribable. Since the intensional is a distinctly linguistic — *a fortiori*, a cultural — phenomenon, there is no way to reduce the cultural to the physical, or cultural entities to physical entities. In that sense, the thesis that cultural entities are embodied in, and not identical with, physical bodies (or physical marks or movements — distinguishing, say, sculpture, poetry, and dance) must appear as a promising thesis.

Regarding embodiment, we may say the following: it is sufficient for embodiment to obtain if, for some set of physical objects, 1) we postulate entities having certain essential rule-governed or rule-following attributes; 2) we ascribe to such entities, individually, some of the properties of the individual physical objects admitted; and 3) we hold the identity of individual entities having rulelike properties to be necessarily dependent upon the identity of those individual physical objects whose very properties they may possess. These conditions are sufficiently general to permit an interesting variety of puzzles to be explored, about the numerical identity of works of art (and of persons) — for instance, involving type/token distinctions — but we need not pursue these here.[14] The 'is' of embodiment clearly differs from that of identity, since, given the intensionality of the concept, the first but not the second is asymmetrical, non-reflexive, and intransitive. The conditions stipulated may be taken as both necessary and sufficient for cultural entities, but whether there is a useful sense in which we may speak further of embodied entities that are not of a cultural kind, for instance, bee swarms or sponges, is an arguable matter; in any case, that question has been left open. The principal if not the exclusive use of the concept obtains in cultural contexts; and there, it permits us to locate persons and other cultural entities extensionally, in some spatio-temporal field, at the same time we acknowledge that such entities possess traits essentially different from those of physical objects, which are paradigmatically so located.[15]

Cultural entities, then, are emergent, not in the sense that a novel substance mysteriously evolves out of a physical substratum, but in the sense that, in familar contexts of discourse,

[13] Cf. my »Mastering a Natural Language: Rationalists vs Empiricists«, DIOGENES 84 (1973): 41-57.

[14] See THE LANGUAGE OF ART AND ART CRITICISM, Ch IV.

[15] A full-scale account of persons and other cultural entities in terms of the embodiment-relation (consistent with materialism) is attempted in an as yet unpublished book, PERSONS AND MINDS.

we admit novel particulars that essentially possess properties essentially lacking in purely physical objects. Since those properties are merely Intentional, rulelike, functional, it's particularly appropriate to specify a relationship between such entities and physical bodies that precludes identity, permits the ascription of both cultural and physical properties to selected entities, and obviates dualism. On the face of it, only the concept of embodiment can accommodate these objectives. We may, then, account for the emergence of persons, works of art, and other cultural entities by tracing the causal influences on physical objects and merely sentient creatures that produce the various sorts of cultural entities we acknowledge; but such causes *cannot* be restricted to those supplied in purely physical explanations, they must be Intentionally qualified as well. What, otherwise, are the causal forces acting on a sound or acting on the physical processes that produce a sound, that produce a word? And what were the causes acting on a certain block of marble that once produced the *David*?

Finally, rules and rulelike phenomena are themselves essentially cultural. Rules must be instituted or at least develop in some recognizably social way; must be capable of being viably replaced by alternative systems of rules; must be capable of being followed and violated by beings themselves capable of recognizing that rules obtain and that rules are followed or violated; and must be capable of being conformed to and reformed or revised for reasons to which the beings affected subscribe.[16] Conceivably, some relatively weak qualification under these conditions would count as rule-following behavior or rulelike phenomena. But a theory of rules is inseparable from a theory of societal life in which common norms and purposes, criteria for discriminating conforming and nonconforming behavior and what may be produced thereby, may be specified. The very idea of rules, of grounds for distinguishing between legitimate and illegitimate, correct and incorrect, and the like implies that the work of artists and the significance of what they produce obtain only *in intensional contexts*. But this is to say, precisely, that they obtain in a context in which to admit the existence of such entities as works of art entails the admission of culturally emergent entities that cannot be taken as identical with whatever physical objects they are normally »associated« with. The most economical ontological relationship that may be conceded, hospitable at the same time to materialism, to the ascription of physical properties to works of art, to the puzzles of reference and reidentification, to the similarity with which persons and works of art are characterized, and to the essential rulelike properties of art itself is just the relationship of embodiment here advanced. Works of art

[16] Cf. D. Schwayder THE STRATIFICATION OF BEHAVIOR. N.Y. Humanities Press 1965; and D. K. Lewis CONVENTION, Cambridge 1969.

may be said to exist only relative to a tradition, that is, relative to a system of rulelike regularities and their extension and alteration, in which the craft endeavors of suitably informed persons produce objects that, in their turn, essentially possess congruent rulelike properties. That context is the intensional context of culture, within which works of art exist as Intentionally emergent entities.

Søren Kjørup

Art Broadly and Wholly Conceived

About ten years ago, a Danish sculptor (according to what he would call himself in the phone book) had a horse slaughtered in a field in North Zealand. The horse was then chopped up, and various scraps of it were put on show, preserved in marmelade jars, as part of an exhibition of Danish modern art at the Louisiana museum of modern art. It almost goes without saying, this caused some protest and discussion. Some of the visitors at the show, but mostly people who only read about the slaughtering and the show in the papers, were enraged. Scraps of a dead horse in marmelade jars is certainly not art! Yet the sculptor, that unworthy scoundrel who only wants to make fools of us all, had lately been given a three years fellowship by the Foundation of Art under the Danish Secretary of Cultural Affairs. At least the trustees of the Foundation of Art must have considered him a worthy artist before. And very soon fellow artists and some younger critics tried to argue that not only the stuff put on show, but the whole procedure had to be considered a genuine work of art, a work, obviously, in the venerable tradition from Goya's paintings of fleeced heads of oxen and Soutine's paintings of butchers' displays. And by now, I guess, nearly ten years after the event, the sculptor's act has become an accepted part of the national Danish history of art.

This is an example of the Institution of Art in action. Yes, *Institution* of Art, for by an »institution« I understand a social structure of certain persons or groups of persons acting according to certain rules in connection with one another and maybe with certain objects and often within certain sub-institutions. And within the Institution of Art we see people like artists, critics, foundation trustees, museum people, and an »audience« performing roles like those of creating, putting on show, experiencing, analyzing, and evaluating certain objects, the works

of art, and some of this takes place within certain sub-institutions like museums and foundations.

You won't be able to understand what art is unless you consider this social structure as a whole, unless you know the different parts of the Institution, their relations, and the constitutive and regulative rules that can be regarded as the base of it all. You cannot achieve an understanding of art through some more or less complete definition of the works of art, for nothing sets works of art apart from everything else in the world except their position as what we might call the focal point and the very *raison d'être* (at least from the traditional point of view) of the Institution as a whole. As many aestheticians have pointed out, it is at least impossible to give a satisfactory traditional definition of »work of art« that mentions only more or less »directly exhibited« properties, formal features or the like. And though definitions that mention the relationship of the work of art to its creator or to the audience may seem to be a little more to the point, even these are not only too narrow, but fundamentally mistaken.

Let me give an example to substantiate this latter claim. Imagine a definition that may even be of an institutional kind, a definition in the form of a constitutional rule stating that »whatever someone — implicitly or explicitly — has proclaimed a work of art, counts as a work of art.« A definition like that obviously does have a certain plausibility. In a period where urinals (Marcel Duchamp), Brillo boxes (Andy Warhol), or scraps of a dead horse (our Danish sculptor) can be accepted as works of art, anything goes. You must have to »proclaim« whatever you want a work of art to have it accepted as such. And, obviously, you do not have to make a formal proclamation; taking your urinal, Brillo box, or horse to a show will do.

Yet a moment's consideration will reveal that something more than this is wanted. Not any person who takes himself to a show, counts as a work of art. Neither do the chairs in the show rooms. At least, it seems, you have to have the intention of having your whatever accepted as a work of art. Imagine that Duchamp brought his urinal and his umbrella; evidently only the urinal would count as a work of art, for only the urinal was intended to count as one. And then again: Imagine that not Duchamp but some unknown somebody (not to say »nobody«) brought a urinal (or an umbrella) and wanted it to count as a work of art. I am sure that he would not have the intended work of art accepted as one.

So not only may you have to talk about intentions, you also have to make a distinction between the »officers« (in this case artists, but in other cases maybe critics, trustees, museum people and the like) of the Institution of Art and the »privates,« the audience in a broad sense. And you have to reformulate the definition to something like »whatever some artist has proclaimed a work of art — explicitly or implicitly, but at least

intentionally — counts as a work of art.« And since »being a work of art« or »having the status of a work of art« has something to do with being accepted as such or as having a status as such by the Institution as a whole (and by the officers of the Institution in the first place), you might prefer to add something like »proclaimed in behalf of the Institution of Art.« And since »being an artist« or »having the status of an artist« in certain respects has the same institutional character as »being a work of art,« you might even prefer to say that our original definition is really a short version of the more complete and satisfactory one to the effect that »whatever somebody who has been accepted as an artist by the Institution of Art proclaims — explicitly or implicitly, but always intentionally — on behalf of the Institution to be a work of art, counts as a work of art.«

This proposed definition cannot really be criticized as being too narrow, as the original one might be said to be. It does mention the whole Institution of Art, it does talk about the »acceptance« of the Institution, and of the »proclamation on behalf of« the Institution as a whole. However it does distort the facts as I see them, namely by focusing at a wrong point (or by focusing at all, one might say). Although the proposed definition acknowledges the necessity of the Institution as a whole, it still is an attempt in the traditional way of procuring an understanding of what art is by focusing on the relationship between an artist and his work. And this is a distortion. You won't understand what art is if you focus on this relationship, even if you pay lip service to the fact that obviously this relationship has a place within a social structure of a more elaborate kind — just as you won't achieve an understanding of what law is by being told that a crime is an act that you are arrested for by a policeman, even though lip service may be paid to the obvious fact that this takes place within a more elaborate social structure. You have to go the other way around, you have to achieve an understanding of the elaborate social structure as a whole, to be able to grasp any of the specific relationships within it. You have to understand the Institution of Art as a whole before you can grasp what creating or proclaiming something a work of art is, let alone what a work of art is as such. One might even say that you have to become a member of the Institution of Art to grasp these things, and no formal definition of »work of art« will make you a member.

Being a member of the Institution of Art, grasping its internal relationships and its whole way of working (being able to see, for instance, that references to Goya are relevant in the discussion about the alleged equine work of art of our sculptor in a way that references to the bylaws of horse racing would not be) does not presuppose any explicit knowledge of the constitutional and regulative rules of the Institution. To find and formulate these is the job of a special kind of officers

of the Institution, the aestheticians or philosophers of art, at least if aesthetics is conceived in the modern analytical way as the philosophical discipline that deals with the concepts we use when we talk about, think about, or in other ways »handle« works of art. On the basis of their own understanding of the Institution of Art as a whole, it is the task of aestheticians to analyze the ways all the different persons and groups of persons talk and act as members of the Institution, and through this to see which are the actual rules that make up the logical framework of the Institution and according to which the procedures within the Institution take place.

Some of the more perplexed questions of aesthetics seem to derive their perplexity from the fact that they are not conceived and treated in this way within the more elaborate setting of the Institution as a whole. One might here mention the problem of aesthetic value and the related problem of whether »work of art« is a (positive) normative or evaluative term, a purely descriptive or classificatory term, or now this, now that, depending on the way one wants to use it. In what follows I try to show how a broad conception of the Institution of Art as the basis for aesthetics can throw new light on these »eternal« questions.

Especially the discussion of the question of evaluation in aesthetics gets a whole new foundation within the institutional theory of art, for one characteristic of an institution is that it may act as a kind of logical background that permits inference from what we call »statements of fact« to what we call »statements of value.« If you do not consider yourself a member of a certain institution, you are of course not logically committed to any inference about value that might be drawn from statements of fact that even you would be willing to acknowledge. But if you do consider yourself a member of, say, the institution of promising, you cannot logically — without contradicting yourself, that is — seriously say that you promise to do a certain thing and yet maintain that you are not obliged to do this thing.

What is true for the institution of promising is true for the Institution of Art, (though I readily admit that the two are extremely different in many other respects): Within the Institution of Art specific statements of fact — results of a correctly performed elucidation and interpretation of a work of art, say — entail specific evaluations. Constitutive rules lay down specific criteria for evaluation that are binding for members of the Institution.

I do not want in this connection to commit myself to any specific set of evaluational rules or criteria, but I take it that traditional criteria like the ones of unity, diversity, and emotional intensity can be reasonably used as an example. I shall say, then, that even though to state that a work of art has a high degree of unity, diversity, and emotional intensity is to

state a result of a more or less conscientious analysis of the work and therefore in a way to state a fact, for the Institution of Art this statement entails a certain evaluation, namely that the work in question is a *good* work of art. As a member of the Institution of Art you cannot logically maintain both that the work has a high degree of unity, diversity, and intensity, and that it is a bad work of art (presupposing that these are the actual criteria of the Institution). An open question does not exist; the question »this work of art has a high degree of unity, diversity, and emotional intensity, but is it good?« takes only one true answer, namely a positive one. The institutional framework provides the ticket of inference.

Does this mean, then, that what we take to be evaluations of works of art (statements like »This painting is magnificent,« which is »extremely good in a special way«) are not really evaluations at all, since they are entailed by purely empirical statements? I do not think so, partly because I do not think that statements like »This novel has a very unified structure« is a »purely empirical statement.« For as I suggested with my quotes already, it is my opinion that talking about statements of fact entailing statements of value is already distorting the real point about institutions by using the vocabulary of a presumed opponent.

For I take it to be a characteristic of at least very complex institutions like the Institution of Art that there is only a difference of degree between what we use to call »statements of fact« and »statements of value,« respectively. In a way, I do not mean to say that an evaluation is directly entailed by a statement of fact, but rather that the procedures of analysis and evaluation within the Institution of Art are so that at each level of analysis, from the simple pointing to an element in a work to the final general statement of its aesthetic value, relatively »empirical« findings at one level are always summed up at a higher level in a relatively »evaluative« formulation.

At one level we still find, for instance, a person in a novel reacting in different ways to a lot of different situations, which is a pretty empirical thing to notice and express. At a higher level we will, however, sum this up in the remark that the novel gives a deep and clear picture of this person, which is already a positive remark about the book. At a yet higher level this may again be summed up together with other results of the analysis with the remark that the novel has a high degree of both unity, diversity, and intensity. And then we hardly need sum up again and say that it is a magnificent work, to express our positive evaluation.

Of course all this only counts for people that consider themselves members of the Artinstitution. For someone who does not consider himself a member of the Institution of Art (at least on this one specific occasion), it is not logically impossible, even, to go through the analysis of a work of art in the way

the Institution demands or expects it, and yet turn up with the conclusion that since this work has a high degree of unity, diversity, and intensity it is bad; but this would certainly be odd. More often than not, an attack on the way the Institution expects the evalution to be performed will also be an attack on the way it expects the analysis to be performed. If you are at all concerned with works of art, and yet do not want to consider yourself a member of the Institution, it is probably because you want to find other things in the works than critics and scholars would normally look for, and because you want to apply other criteria to the things you find (and not only the criteria of the Institution turned upside down). Typically you will then be looking in the works for features that may live up to different instrumental criteria, and you will evaluate the works positively for having a presumed political impact of sorts, for its entertaining qualities, for its monetary worth, for the things it tells you about its author or about man or society or history, or the like.

Of course there is nothing internally wrong with any of these criteria or with the evalutions they may lead to. Only they are not the criteria of the Institution of Art (as you remember: supposedly). If you do not consider yourself an evaluator on behalf of the Artinstitution, nothing prevents you (logically) from using these or any other criteria that you may choose. But if you do consider yourself a member of the Institution, you do not have any choice about which criteria to use: you are logically committed to the criteria and the evaluating procedure of the Institution of Art, and you are logically committed to the results of these procedures.

Another »eternal« question of aesthetics on which the institutional point of view may throw some new light is the question whether »art« or »work of art« is a normative or a descriptive term. Does saying that something is a work of art contain an element of praise for the work, or is it just a purely classificatory statement?

That the classificatory point of view may come closest to the truth is, I think, pretty easily brought home by the simple fact that we do not consider the expression »a bad work of art« as a contradictory one. Yet we do often use the expression »a work of art« in an emphatic sense, for instance when we say »This is what I understand by a real work of art,« and thereby imply that a »real« work of art is a good one. So there is at least these two ways of using the expression »a work of art.«

But this does not take care of the whole problem, since it does not explain why many people would be very reluctant to call many modern works of art »art,« even though it might be pointed out to them that they might perhaps better express their despect for these works and for their creators by saying something like »These are extremely bad works of art.«

The institutional theory of art may, however, give a hint a-

bout the reason for this reluctance. For if it is true that the concept of »a work of art« must be explained through the concept of the Institution of Art, then to say that something is a work of art even with a mere classificatory intention is not only also to make an implicit normative statement (since every classificatory statement contains an implicit normative statement because classifying consists in giving a rule for the way in which the classified thing should be treated, namely as the other things of the same category; »normativeness« and »descriptiveness« cannot be held completely apart); at the same time it is to commit the object to a very specific sort of treatment to which a lot of value is attached, partly because it is the treatment characteristically given to very valuable objects.

To say that something is a work of art even in a classificatory way is to say that the object, although it may be a *bad* work of art, is still one of the things that should normally be analyzed in a certain way; it is one of the things that should normally be evaluated in a certain way; it is one of the things that may be imported free of customs to the United States (and probably several other countries) and that may be exempted from the income tax return if it is given to a museum or foundation, etc. To say that something is a work of art in the classificatory sense is to say that the object should at least be taken seriously as art by the audience, critics, scholars, foundation trustees, etc., even if for only so long as it takes to see how bad it is; it is to say that its creator may call himself »an artist« even though a poor one; that he may at least demand to be taken seriously as an applicant for a fellowship for artists; that he should be allowed a certain freedom (for instance to produce works with a sexual theme and make them public) that may not be allowed to others (who would be sheer pornographers and might be punished as such in certain countries if they did the same), etc.

To say that something is not a work of art is to relegate it from serious consideration within a highly complex institution that for many people has a certain aura, for reasons that may be better or worse, but are probably not only bad and superficial. To say that something is an incredibly bad work of art is not simply to derive it of any value whatsoever. No wonder that some people may want to say of some objects proposed as works of art that they are not works of art at all.

In a way, then, the question whether »art« or »work of art« is a normative or a descriptive term goes right to the kernel of the institutional view. It is a question that cannot be answered directly, but an insight into the Institution of Art as a whole and to its place within society as a whole gives an understanding of why the question is regarded as a question at all.

To me, however, the most important and valuable aspect of the institutional theory of art is not that it may solve certain traditional problems of aesthetics. The most important and val-

uable aspect is that it may pose some new problems, function as a background on which new sets of questions may be put (and maybe answered).

I am here thinking of problems about the relationship between art and society and the relationship between art and history. It is, of course, an accepted fact within traditional aesthetics and traditional history of aesthetics that the concept of art has undergone great changes between Antiquity and now. Few historians of aesthetics would now seriously argue, I take it, that Plato, say, tried to elucidate *our* concept of art but failed, and fewer that he simply told the eternal truth about the eternal concept of art. Most historians of aesthetics would now agree, I presume, that our concept of art — our Institution, I should prefer to say — did not evolve before, roughly, the 18th Century.

But traditional (history of) aesthetics cannot explain why the modern concept of art did not evolve before, nay, it cannot even raise this question consistently. Traditional aesthetics may note that nobody seems to have thought about art the way we do before the 18th Century, but the question »why?« only seems to make sense if you are willing to find an explanation outside the specific aesthetic conceptual framework — and this is already to leave traditional aesthetics behind.

From the institutional point of view, however, the question becomes a natural one. All social institutions undergo changes, so why shouldn't the Artinstitution? And the emergence and development of all social institutions must, obviously, be explained through a consideration of the whole social structure. So we may put the question quite naturally by asking which were the general changes of the social structures that caused the modern Institution of Art to develop? And we will pretty easily see, I presume, that the modern Insitution of Art not only *did* not, but also *could* not evolve before the 18th Century, for the various other social institutions on which the Institution of Art most conspicuously depends did not evolve before between, say, 1500 and 1750: the »liberal« division of labor (as opposed to the guild system), the »liberal« money economy, the institution of »the public«, and of »public opinion« (»die Öffentlichkeit«), etc., not to mention the whole ideological change interrelated with these basic changes and with the Institution of Art.

The institutional theory of art must have a historical branch that treats the problem of how and why the modern Institution of Art emerges and develops along with the emergence and development of Capitalist society; and it must have a theoretical branch that treats the problem of how the Institution of Art now functions within Capitalist society. And just as the historical branch might show, for instance, how the modern Capitalist distinction between labor and leisure creates a demand for some sort of secular and individual art, while the modern division of labor and the modern market structure cre-

ates the specific institutional setting for the creation and distribution of works of art in our sense, so the theoretical branch might show, for instance, how the specific structure of the Institution of Art as we know it with its officers and privates mirrors and in a way contributes to the »naturalization« of the structure of our society as a whole.

As a matter of fact, the institutional theory of art must see the modern Institution of Art as a bourgeois institution, as an element in the ideological superstructure of bourgeois society that is just as much a product of (the material basis of) bourgeois society as it is a factor in its self-preservation. The institutional theory of art points to the relationship between works of art and the people that are concerned with the works in different ways, it points further to the relationship between these people and society as a whole, and, first of all, it de-mystifies the whole concept of »a work of art« and shows its origin in specific social relations. Better than any theory of »social criticism in art,« »social realism,« or »art as a defying factor in bourgeois society« (all of them, really, only products of traditional bourgeois thinking about art), the institutional theory of art could in this way be a point of departure for a real marxist theory of art.

But of course to say this is not in itself to create this marxist theory of art. It is only to indicate what might be done within the framework of a broad institutional theory.

Leonard B. Meyer

Forgery and the Anthropology of Art

In primitive cultures as a rule no special realm of experience is separated out as the aesthetic. Music, poetry, and the plastic arts are related — often through religion and ritual — to all other activities of the culture. And this was probably the situation in our own prehistory. Early in the course of Western civilization, however, Greek thought distinguished, though it did not radically separate, aesthetic experience from other fields of philosophical inquiry — from religion, politics, science, and so on. Indeed, Plato's insistence on the relevance of art for ethics and politics is an indication that the distinction was already generally recognized.

The distinction was necessary and justified. For, as philosophers and critics have pointed out, aesthetic behavior is different from ordinary behavior. We have certain distinctively

aesthetic beliefs and attitudes which lead us to act in a special way in relation to works of art. This can be most clearly illustrated in the drama. We believe in the reality of dramatic action, emphathizing with the characters and understanding their behavior; but at the same time we are aware that what is taking place is make-believe. The yokel who supposedly rushed up on stage during a melodrama and shot the villain made his mistake precisely because he had not learned that in our culture aesthetic experience calls for inward action rather than overt behavior.

Yet the differentiation between aesthetic experience and other forms of experience can be carried too far. It began as a legitimate distinction, but over the years it had tended to become formalized as a categorical separation. One of the consequences of this separation is the view, explicitly asserted or implicitly held, that aesthetic criteria are a special kind of criteria unrelated to our other cultural beliefs and attitudes. The most obvious instance of this is the common contention that we judge — or should judge — works of art on the basis of their intrinsic qualities alone, though what these qualities are is by no means always clear. The work of art, accordingly, is said to have its complete meaning within itself. Cultural history, style history, and the genesis of the art work itself do not enhance *true* understanding. According to Clive Bell, one of the most eloquent spokesmen for this view

> Great art remains stable and unobscure because the feelings that it awakens are independent of time and place, because its kingdom is not of this world. To those who have and hold a sense of the significance of form what does it matter whether the forms that move them were created in Paris the day before yesterday or in Babylon fifty centuries ago?[1]

It is clear, however, that in actual practice we do not judge works of art in terms of their intrinsic qualities alone. Recently this fact was brought home forcefully once again when the prized Etruscan sculptures at the Metropolitan Museum of Art were discovered to be forgeries. As physical objects the statues were unaltered, but something had changed, and it is safe to predict that soon the works will be quietly consigned to the basement.

If the criteria of judgment are purely aesthetic, why should a work of art once found moving and valuable become a worthless curiosity when it is discovered to be a forgery? The purist is in a difficult position. He may argue that the original judgment was mistaken: that judged by its intrinsic qualities the work is in fact a poor one. But the coincidence between the discovery of forgery and the revision of judgment makes the objectivity of the criteria employed seem more than a little

[1] ART, London 1949: 37.

suspect. The courageous and consistent purist, however, will stick to his guns and contend that the work, though a forgery, is still beautiful and should be kept on exhibit. Thus Bell asserts that if a work »were an absolutely exact copy, clearly it would be as moving as the original.«[2] This also seems to be the position taken by Emily Genauer in an article on the Etruscan forgeries. She wistfully hoped that »perhaps we are almost at the point of sophistication where we are able to enjoy a work of art for what it is.«[3] In Genauer's opinion, the trouble seems to be simply that museum directors and the general public are naive.

Others would say that putting forgeries in the basement is nothing but a form of snobbism. This too is doubtful, but a consideration of what snobbism is may bring us closer to the issue involved. In a fascinating essay, »The Anatomy of Snobbery«, Arthur Koestler defines snobbery as »the result of the psychological fusion of two independent value systems which are separate by origin and nature, but are inextricably mixed up in the subject's mind«.[4] This focusses attention on the crucial point. If the value systems of aesthetics are independent of our cultural beliefs, as the purists like Bell argue, then it *is* snobbish to banish forgeries. But in fact we are neither naive nor childish when we banish them, because the effort to make a watertight separation between aesthetic criteria and cultural beliefs is mistaken and misguided.

Though the almost atomic differentiation of the surface of our culture tends to obscure them, a set of basic, encompassing beliefs and attitudes nevertheless underlies and conditions all our thinking and behavior. These beliefs, which are as a rule implicit and unconscious, have to do with our most fundamental assumptions about the nature of the universe and man's place and function in it, including the works of art that man creates.

Two interdependent aspects of belief may be distinguished. On the one hand, the term »belief« refers to convictions, consciously held or unconsciously accepted, that something is the case — an existing, enduring fact or principle. Belief in the existence of causation is an example of such a conviction. On the other hand, the term designates those modes of organization — e. g., language or mathematics — within which our convictions are embodied. As Michael Polanyi has put it:

Our most deeply ingrained convictions are determined by the idiom in which we interpret our experience and in terms of which we erect our articulate systems. Our formally declared beliefs can be held to be true in the last resort only because of our logically anterior acceptance of a

[2] Ibid: 59f.

[3] »Some Forgeries We Have Loved« HERALD TRIBUNE (»The Lively Arts«), February 19, 1961: 19.

[4] THE ANCHOR REVIEW 1 (N.Y. 1955): 19.

particular set of terms, from which all our references to reality are constructed.[5]

Beliefs are, then, deep-seated dispositional habits of mind and body and they constitute the fundamental framework within which we apprehend, interpret, and respond to the world.

It should be emphasized that the validity of the beliefs to be discussed is not at issue. I am not contending that causation, freedom, time, and so forth exist, but only that our culture believes that they exist and that its behavior, judgment, and understanding are subject to such beliefs. My role is that of the anthropologist studying the concepts and behavior of our culture rather than that of a philosopher examining the nature and truth of its concepts.

Cultural beliefs not only influence the way in which we perceive, think, and act, but they also condition and modify our emotional and physiological responses. It has become increasingly clear in recent years that mental attitudes, including cultural beliefs, have a direct and vital effect upon human physiology and human feeling. For instance, Ronald Melzack points out that »the significance which pain has in the culture in which we have been brought up plays an essential role in how we feel and respond to it.«[6]

Because our fundamental beliefs influence our sensations, feelings and perceptions, *what* we know literally changes our responses to a work of art. Thus once we *know* that a work is a forgery our whole set of attitudes and resulting responses are profoundly and necessarily altered. It is pointless to say that it is all in the mind. Our beliefs are our beliefs and we can no more escape them once they have become part of our ingrained modes of thought and behavior than we can breathe in a vacuum.[7] Once we have them, such beliefs condition and qualify

[5] PERSONAL KNOWLEDGE, Chicago 1958: 287. In a similar vein E. Sapir writes that language is heuristic in the sense »that its forms determine for us certain modes of observation and interpretation«. »Language« ENCYCLOPEDIA OF THE SOCIAL SCIENCES 9, N.Y. 1934: 157.

[6] »The Perception of Plain« SCIENTIFIC AMERICAN 204 (1961): 41; see also J. V. Brady »Ulcers in 'Executive' Monkeys«, ibid. 199 (1958): 95-100; E. Hess »Attitude and Pupil Size«, ibid. 212 (1965): 52-6; and P. G. Zimbardo et al »Control of Pain Motivation by Cognitive Dissonance«, SCIENCE 151 (1966): 217-19.

[7] The analogy is more apt than I realized when this was written. For it is not a matter of having a particular set of beliefs versus HAVING NONE AT ALL. It is a matter of having these beliefs rather than some other ones. Once the existence of any attribute, process, or relationship is recognized by a culture or an idividual as being distinguished as a characteristic of the world, then it is an inescapable conceptual category. Particularly when it is given verbal recognition and sanction, the culture is obliged to adopt some attitude toward it. After that, beliefs about it may change, but they seldom disappear. Not all cultures, e. g., have distinguished between aesthetic objects and other kinds of

our responses just as surely as do physical forces or physiological processes. To pretend that this is not so — to continue to admire a proved forgery — is a pretentious form of inverted snobbery.

It may at this point be asked whether these observations do not lead to a completely subjective position vis-à-vis aesthetic criteria. Is not a work of art, then, great simply because we believe it to be so? This does not follow. For cultural beliefs are necessary causes for aesthetic apprehension and response; but they are not sufficient causes. All our cultural beliefs might be relevant to and involved in the apprehension of a particular work of art and we might still judge the work to be poor. But were they not pertinent, the work could not be seriously judged at all.

What are the cultural beliefs that underlie our aesthetic criteria? Probably one of the most important — one from which many of the others are directly or indirectly derived — is the belief in causation. This belief, which is evidently shared by most major cultures, is manifest in our language (the thesaurus, for instance, devotes a whole section to causation), our myths, our science, and our daily behavior.

Causation not only changes the quality, quantity, and relationships of things already in the world, but, from time to time, these are reordered in such a way that new entities and patterns come into existence. There is creation. And, for us, human creation is not just another ordered occurrence. It is a purposeful act of the individual human will.[8]

To create is to discover something new — to reveal in a timely and timeless *aperçu* some aspect of the world or some relationship of which we were previously unaware and, by so doing, to change forever our experience of the world and of ourselves. »When a great poet has lived,« writes T. S. Eliot, »certain things have been done once and for all and cannot be achieved again.«[9] The crucial word here is »achieved«. They

objects, e. g., religious, useful ones. But once the distinction has been made, it changes culture's way of conceiving AND perceiving. There can be no ideological vacuum.

[8] This point is forcefully stated by John Dewey: »Suppose . . . that a finely wrought object, one whose texture and proportions are highly pleasing in perception, has been believed to be the product of some primitive people. Then there is discovered evidence that proves it to be an accidental natural product. As an external thing, it is now precisely what it was before. Yet at once it ceases to be a work of art and becomes a natural 'curiosity'. It now belongs in a museum of natural history, not in a museum of art. And the extraordinary thing is that the difference that is thus made is not one of just intellectual classification. A difference is made in appreciative perception and in a direct way. The aesthetic experience — in its limited sense — is thus seen to be inherently connected with the experience of making.« ART AS EXPERIENCE, N.Y. 1934:48f.

[9] NOTES TOWARD THE DEFINITION OF CULTURE, N.Y. 1949:118.

can perhaps be done again, but they cannot be achieved again. Beethoven's late style is a discovery and an achievement. Someone coming later can only imitate it. And it is for this reason that forgers and copyists are considered to be artisans, not artists.

Creation is possible only if there is choice. And choice is possible only if there is freedom. Thus complementing our belief in causation is an equally basic belief in human freedom. An antecedent event is a necessary condition for the consequent event which follows, but it does not as a rule fully determine that consequent event. Consequent events are only probable, not inevitable.

In human affairs an event has more than a single implication. It generally has a host of implications, some of which may even be contradictory. Without the paintings of Cézanne the *Three Musicians* by Picasso might not even have been possible. Certainly it would have been different. But it might have been different anyhow. For the implications of the past are so abundant and so various that only a very few can be realized in any one work or discovered by any one artist. Creation is possible because within the limits of his artistic inheritance — his tradition — the artist is free to choose among the implications he can discover.

The central importance of this belief in freedom of choice is illustrated in our myths — from the story of Adam's fall on — in the disquisitions of philosophers, and in our everyday behavior. We act, and interpret the acts of others, on the assumption that there is personal freedom; and all our moral judgments depend upon our conviction that free choice is possible. (But it should at the same time be noted that we are able to choose effectively only because, like the artist, we act within a tradition which limits the range and probability of the choices available to us in a particular situation. Were all modes of behavior equally possible and probable we should be paralyzed in trembling indecision.)

Every achievement, every true discovery risked failure.[10] For a great work of art or a great scientific discovery is great precisely because the creator dared to choose beyond the limits and bounds of the normal, the accepted, and the obvious. In

[10] Risk-taking may be a special case of a general psychological need for patterned novelty: see e. g., F. Barron »The Psychology of Imagination« SCIENTIFIC AMERICAN 199 (1958): 151-66; D. E. Berlyne »Curiosity and Exploration« SCIENCE 153 (1966): 25-33; D. W. Fiske & S. R. Maddi FUNCTIONS OF VARIED EXPERIENCE, Homewood, Ill. 1961; W. Heron »The Pathology of Boredom« SCIENTIFIC AMERICAN 196 (1959): 52-6; and J. R. Platt »The Fifth Need of Man« HORIZON 1 (1959): 106-11. It is important to recognize, of course, that the ways in which the need for stimulation is satisfied will vary from one culture to another and even between different subcultures. Its realization as risk-taking behavior has evidently been especially important in Western culture, and particularly since the Renaissance.

so doing the creator — artist, scientist, scholar, or man of affairs — frees us from the determinism of the probable and the routine and makes significant changes in culture possible.[11] Of course, changes in our most basic beliefs — perhaps modifications would be a more accurate word — are very gradual indeed. But the accretion of minute changes does modify the character of such beliefs. Our conception of the universe is different, though not *very* different, from that of classical Greece.

We value — even revere — originality in art because the great artist, challenged by the unknown or the partially understood (by the ambiguities in and incompleteness of our vision of the world), has dared to risk failure in order to reveal a new aspect of the universe to us.[12] That such originality has been prized since earliest times is shown by the fact that poets were thought to be divinely inspired and by the more mundane fact that even in ancient Egypt, as well as later Rome, forgeries of works of the masters were not uncommon. If in the Middle Ages (and in some primitive societies) the individuality and originality of the artist were not considered very important, perhaps it was because his work was seen primarily as a religious symbol rather than as a work of art. Its revelation was generic rather than personal and individual.

The importance our culture attaches to originality is a corollary of our attitude toward repetition. In our culture — particularly since the Renaissance — repetition has been consid-

[11] The forger, however, takes no AESTHETIC risk — only the risk of being discovered — nor does the artist who employs chance in a systematic way. Not only because he is not really responsible for the particular results produced, but because there is no way of judging whether the results are »successful« or not. As John Cage has put it »a 'mistake' is beside the point, for once anything happens it authentically is.« SILENCE, Middletown 1961: 59.

[12] Ordinary experience indicates that aesthetic activity and risk-taking are related. Consider the difference between art-behavior and game-behavior. When attention is directed primarily to achieving a particular result — winning a game, e. g. — risk is usually minimized, and the activity is not thought of as having an aesthetic component. However, when attention is directed primarily to means — to the pattern itself, rather than to the goal — risk-taking become probable, and the activity is felt to be in some sense aesthetic. Thus we speak of a high-wire »artist« and consider bullfighting to be an »art« rather than a game or a sport. In similar fashion, we speak of »playing« the stockmarket (and the relation of art to play is well-known) when gambling is involved, but refer to »investing« when prudence minimizes risk.

It follows from this that artistic creation is generally an individual, not a group, activity. Except when it is controlled by a single leader, e. g., the conductor of an orchestra, a theater director, or the choreographer of a ballet, for whom risk-taking may be a positive value, group behavior, acting through consensus and compromise, tends to be directed to specific goals. Consequently risk is minimized. Individuals, on the other hand, not only can take risks, but frequently find positive value in doing so. And the tendency toward hazard will be especially strong in a culture such as ours which has, at least until recently, placed a premium upon individualism and originality.

ered wasteful and unproductive. But this may not be the view of other cultures. According to Benjamin Lee Whorf, the hopi, for instance, have a very different attitude toward repetition

> To us, for whom time is a motion on a space, unvarying repetition seems to scatter its force along a row of units of that space, and to be wasted. To the Hopi, for whom time is not a motion but a 'getting later' of everything that has ever been done, unvarying repetition is not wasted but accumulated. It is storing up an invisible change that holds over into later events.[13]

Though originality has probably always been considered an important attribute of art, the cult of the new, arising out of nineteenth-century notions of personal expression, has come to dominate our thinking about art to such an extent that it is well to remember that not all novelty is originality. Novelty, as Stravinsky has pointed out, is not difficult to come by — it is everywhere about us.[14] But true originality is rare indeed. As Max Friedländer, the arthistorian, has said

> Something original is strange when first seen, shocking and unpleasant; something bizarre is striking and entertaining. The former is something enduring and permanent and only gains in impressiveness; the latter is a thing of fashion, is ephemeral, causes satiety and vanishes before long ... Whoever is creative in a truly original sense — especially if he be a man of genius — aims at being self-sufficient; whoever indulges in the bizarre, endeavours to impress his contemporaries or to amaze them.[15]

Here lies perhaps the most difficult problem of contemporary criticism: to distinguish the truly original from the bizarre.

From earliest childhood, we are taught by precept and example to believe in the cardinal importance of the creative act. Following the biblical account of creation come stories of Orpheus, Pygmalion, and David and Saul. Later we learn about the lives of the great artists of historical times. In hushed, reverent wispers our parents guide us through museums and point out masterpieces. In the concert hall and theater behavior is even more patently ritualized — as though it were a holdover from distant past when art was handmaiden of magic and religion. As adults we read biography and criticism and are today, perhaps more than ever before, concerned with the mysteries of the creative mind. Psychologists study creativity in scientists, artists, and children. Musicologists and art historians study sketches for large works and discuss problems of influence in an attempt to understand the creative process.

Our belief in the creative power of the great artist has about

[13] COLLECTED PAPERS ON METALINGUSTICS, Washington D. C. 1952: 39.

[14] I. Stravinsky POETICS OF MUSIC, trans. A. Knodel & I. Dahl, Cambridge, Mass 1947: 32.

[15] ON ART AND CONNOISSEURSHIP, Boston 1960: 242f.

it an aura of primitive magic. His work of art is a kind of talisman, a fetish, through which we become identified with and participate in his magic power. Our willingness to become involved in aesthetic experience is partly a function of the relationship we feel with the artist's creative force. An original drawing, e. g., is more valuable than the finest reproduction, even one all but distinguishable from it. This is true not merely in the economic sense that the original is scarce and hence costly. The original is also more valuable and more exciting aesthetically because our feeling of intimate contact with the magic power of the creative artist heightens awareness, sensitivity, and the disposition to respond. Once a work is known to be a forgery that magic is gone. All that remains is a cultural aberration, less valuable than a reproduction.

Belief in the importance of the individual creator is also indicated by the desire to know the name of the artist, composer, or writer who created the particular work we are enjoying. Some, of course, may want to know because they are afraid of appearing ignorant. But it must be emphasized that the desire to know who created a work is not necessarily a sign of snobbism. The pseudo-sophisticate who declares that he does not care who painted a picture or composed a quartet is just as mistaken as the snob who will venture no judgment until he is sure that the creator of the work is socially acceptable.

Our need to know the names of artists stems in part from an almost primordial dependence upon words. Without their magic we feel lost. We look at the stars at night and ask their names. Why? If the night enchants, what difference do names make? And yet we tend to ask. The reason is, I think, that from earliest childhood we learn to understand and manipulate the world with words. To know the name is to exercise some control, however small — to be a bit less insecure.

But there is another, more important reason why we want to know who created a particular work of art — and when it was made. It is this. A work of art does not exist in isolated splendor. It is a part of history — the history of culture, the history of the art, and the history of the artist.[16] We invariably understand an event or an object, partly at least, by understanding how it came to be what it is and, if it is an event in the present, by imagining its implications for the future or, if it is an event in the past, by being aware of its implications as realized in history.

Here, in fact, we arrive at the core of the problem. The great

[16] Writing of the artist rather than the work of art, T. S. Eliot contends: »No poet, no artist of any art, has his complete meaning alone. His significance, his appreciation is the appreciation of his relation to the dead poets and artists. You cannot value him alone ... I mean this as a principle of aesthetic, not merely historical, criticism.« SELECTED ESSAYS, London 1941: 15.

forgers have not been mere copyists. They have tried — and some have probably succeeded, for we know only their failures — to become so familiar with the style of the master, his way of thinking, that they can actually paint or compose as he did. Thus thought their vision is not original, their works are, in a sense, creations. To state the case even more forcefully: suppose that, without any attempt to decieve and using his own name, a contemporary composer were to write a first-rate string quartet in, say, the style of Mozart. Would that work be judged to be as good as a work of comparable excellence by Mozart himself? To answer this question, let us return to the notion of causation.

In everyday affairs we tend to think of causation as involving two more or less independent and separable aspects of experience — a cause and an effect, a means and an end. And where the issues are unimportant this is probably an acceptable and practical way of looking at the matter. It does not as a general rule make much difference which of two routes we take to get to the supermarket. But in matters of moment, this is not the case. What a thing *is* — its significance — includes our knowledge and belief, whether these are correct or not, of how it came into being.

Music furnishes as clear an example of this point as one can find. In simple folk tunes as well as great symphonies a sequence of tones stated early in the piece sometimes returns toward the end. Yet when they recur, their significance is fundamentally changed. Think, e. g., of a simple folk tune such as »Au clair de la lune«. The last four measures are exactly the same as the first four. But because their recurrence is the result (the effect) of what has gone before, they are truly different. This difference is easily tested. No matter how many times the first four measures are repeated, they will not end the piece satisfactorily. In order for this sequence of tones to end the tune, they must be the result of the means-end relationship which brings about their repetition.

The significance and value of an idea, a human being, or a work of art do not exist in pristine isolation. Just as we judge an individual in the light of his past behavior and upon our expectation as to what he will do in the future, so we understand and evaluate works of art, artists, and artistic developments in terms of their genesis and their implications for the future. And just as we revise our opinion of the value of individuals depending upon what they become — noting that this one succeeded beyond our expectation or that one failed to fulfill his promise — so too it is with works of art and artists.

It is because we understand the early works of a master in terms of their implications (later works) and late works in terms of their genesis (the earlier works which led to them) that we emphasize the whole oeuvre of an artist with retrospective exhibits, concerts of one composer's music, and col-

lected editions of a writer. And as Genauer points out — rightly this time — one of the reasons why it is important to get rid of forgeries is that, by corrupting our vision of the artist's work as a whole, they lead to misunderstanding of his genuine works.[17] The Etruscan forgeries are a particularly clear illustration of this danger. It is for this reason, too, that historians of art, music, and literature are so intent upon ferreting out false attributions.

Another indication that in actual practice we evaluate particular works of an artist in terms of other works he has created is this: even the masters — a Mozart or a Shakespeare — have created works that fall short of greatness. And though these works are generally performed less often than their greatest works they are more often performed than equally good or even better works of lesser artists. Partly, no doubt, this is because they will from time to time contain those brilliant insights, that sensitivity of phrase or line, which are the mark of the master. But partly they are performed more often because these lesser works are connected with and have implications for the greater ones. Each reveals and hence enhances the significance and value of the other.

Suppose, however, that our neo-Mozartian quartet, at first rejected as merely imitative of a past style, subsequently gave rise to new stylistic developments. Then, seen in retrospect as having been the beginning of a new movement, its implications would be different and, consequently, our understanding of its significance and value would be changed. It would no longer seem a bizarre anomaly. For it would now be judged not only in terms of its relationship to eighteenth-century music, but also in terms of its implications for twentieth-century music.[18]

Implicit in our belief in causation is a belief in time as a sequentially ordered series, articulated and made manifest by the chain of causally related events. For us time is not reversible. It seems to move in one direction only — toward the future.[19] We cannot, e. g., imagine that evolution or history will

[17] Op.cit. Also see R. Harris »The Forgery of Arts«, in which S. Keck is quoted to the same effect: »When a person who lives in the twentieth century tries to fling himself back hundreds of years...he can't help injecting into that attempt part of his own times, his own style, his own personality, his own attitudes. And once a work of art of this sort finds its way into a museum, it wrenches the chronological and aesthetic framework out of joint. It falsifies history, and makes it much harder for us to go back to our roots.« THE NEW YORKER 37 (1961): 142f.

[18] The illustration is more than hypothetical. In recent years many artists have tended to turn to the past for syntax, subject and form. I have discussed this tendency, suggesting it is a symptom of a significant change in contemporary cultural beliefs and attitudes, in MUSIC, THE ARTS AND IDEAS, Chicago 1967, Ch 9.

[19] W. Walter Grey argues that »the obvious radical difference between space-patterns and time-patterns is that the latter are projected upon a uni-directional parameter; time, for us, has an arrow that points

ever go backwards, that life could gradually return through the various stages of history and evolution to primordial protoplasm. Even if some catastrophic debacle were to return us, say, to the state of cavemen, we would not assert that time had reversed itself, but rather that the present resembled the past. This is also true of our interpretation of the history of the arts. The flat, two-dimensional representation preferred by many painters today is not that of ancient Egypt, though it resembles it. For today's emphasis upon the picture plane comes after, and is a deviation from, the three-dimensional perspective which dominated art from the Renaissance onward.

Because we experience the world in terms of past, present, and future, there is history. Our awareness of time — the causal chain of history — provides the framework within which we interpret and understand works of art. Without such a framework all works of art would coexist in a never-ending present and we would be unable to select and bring into play the attitudes, dispositions, and habit responses appropriate to a particular style, whether present or past.

It is because we believe in time and history that when we encounter a work written in the past — even if the past is only yesterday — we adjust to its pastness, bringing into play modes of discrimination and patterns of expectation which are relevant to the style of the work. That is, we attune our minds to the viewpoints, conventions, and normative procedures which the artist had and which he presumed his audience to have. In so doing we exclude, as irrelevant, habits developed in connection with and appropriate to other styles — particularly later styles. Thus if we are to understand the significance of and experience the tensions created by the opening Adagio of Mozart's String Quartet in C Major, K. 465, we must attune our minds to, must be able to believe in, the reality and vitality of the harmonic norms of Mozart's style, even though we have experienced later music — say, that of Wagner or Bartók — in which these same harmonies might well represent repose. We are willing to believe in — to take seriously — the norms of a style only because of the prior belief that when the work

to the grave.« »Activity Patterns in the Human Brain« ASPECTS OF FORM, ed. L. L. Whyte, London 1951: 181. I believe that there is another reason why time is uni-directional for us. Because human behavior is not for the most part genetically determined, human beings must choose if they are to survive. To choose successfully, they must not only consider alternative courses of action, but must envisage the consequences of the imagined alternatives. It is for this reason that our understanding of the present always involves some sense of its implications for the future. And such envisaging fixes the direction of time for us. It is also worth noting that because the outcome of a specific choice depends upon the idiosyncratic relationship among a number of variables, whose precise weighting and interaction is usually only partially understood, human existence is characterized (save in the most routine matters) by the ambiguities and the uncertainties mentioned earlier.

was created its style was a vital, living universe of discourse with unexplored potentialities and undiscovered implications.

But if the work is discovered not to have been written in the past, such adjustments become irrelevant. Indeed, they become impossible. For we have no reason to believe in the norms of an eighteenth-century style if we know that a work was written last week. To say »it is all in the mind« is still no solution. The fact of the matter is that the mind cannot ignore what it knows and the body's physiological responses are not separable from the mind's cognition.

Though we relegate forgeries to the basement and will probably continue to do so,[20] we feel somehow uneasy, almost dishonest, about it. Partly this is because in a world full of uncertainty, we would like to think that our judgments are wholly rational, objective, and absolute. Partly our uneasiness stems from the way in which we ordinarily verbalize and rationalize experience. We say »the painting is beautiful« and tend to think of beauty as an objective attribute of the work — an attribute independent of our act of perception. And if beauty in an objective attribute of a work of art, why should the discovery that the work is a forgery make any difference? It should still be beautiful. A tendency toward Platonic idealism is, so to speak, embedded in the way in which we ordinarily talk about and conceive of the world. This implicit Platonism, together with whatever we may have absorbed of the philosophic tradition itself, makes us uneasy.

But deep down we seem to be Aristotelians. For our behavior indicates that beauty is a quality of experience and that such experience is the result of an interaction which takes place within a cultural context, between an individual and a work of art. Our Platonic misgivings do not in the last analysis really disturb our behavior, but only our understanding of that behavior.

Whatever conflicts may arise on the level of philosophical ratiocination, it would seem that even a culture as differentiated and apparently fragmented as ours is really one. Our perception, apprehension, and understanding of the world arise within and are limited by an interrelated set of beliefs and attitudes. They are the most fundamental attributes of the style of our culture as a whole. They control, though they do not determine, the questions we ask of the world and the answers we discover in it. They provide the continuum of Western

[20] Aagaard-Mogensen has called my attention to the possibility that the Etruscan sculptures might have been exhibited for arthistorical, rather than aesthetic, reasons, and that they were relegated to the basement because, once they were shown to be forgeries, their historical significance was destroyed. The point is well taken and pertinent. Nevertheless, as Genauer's statement shows, they were also admired for their »beauty«. Nor does this point affect the more general problem — for instance, the case of the Vermeer forgeries.

culture, which links Democritus to Einstein, Plato to Whitehead, and Praxiteles to Picasso. And because they establish a finite framework within which particular styles of art arise, develop, and change, it is these beliefs and attitudes which in the final analysis, make creation and communication possible.

Our cultural beliefs condition and qualify our experience of the world. And art is just as much part of that world as philosophy, ping-pong, or pandering. But this does not mean that aesthetic criteria are subjective — only that cultural beliefs are prior to them. Given genuine works of art within a vital stylistic tradition, objective understanding and evaluation are possible. Forgeries are banished to the basement because they are in conflict with our most fundamental beliefs about the nature of human existence: beliefs about causation and time, creation and freedom.[21]

Teddy Brunius

Theory and Ideologies in Aesthetics

1. The idea of *theory* has deep roots in Western thought. In the beginning there was the Pythagorean insight or staring (the Greek word *theorein* means »to stare«) into the harmonious order of the universe. This mathematical view was taken over by Plato, in his *Timaeus*. He stressed the importance of mathematics in education in his *Republic*. In fact, mathematics is not distorted in a world of two-dimensional shadows on the wall of the cave. Exercise in mathematics can bring us away from the distorted world into a richer world of pure learning.

Aristotle presented the readers, or rather the listeners of his lectures, later on entitled the *Nicomachean Ethics* (in fact, »ethics« is a Stoic concept) with a choice of different ways of life: the way of action, or the way of pure learning — *theory*. There are different sources of pleasure for man. In the fourth chapter of his *Poetics*, Aristotle pointed out that knowledge will always give pleasure, an apodictic statement that can be doubted. However, Euclid and Archimedes gave paradigms of research in mathematics and geometry, and that study was

[21] I have argued elsewhere (op. cit. Chs. 8 & 9) that our cultural ideology is changing in such a way that, were it not for the importance of scarcity, the aesthetic appreciation of forgeries might become a real possibility.

continued into what we would call pure theory, foundational research. In the world of theory there should not be a conflict or contradiction, and statements should cohere into an architectural structure with economic simplicity.

Kepler and Galileo, Newton and Gauss offered paradigms of foundational research. The intellectual beauty of such achievements was combined with a social implication. The great innovators in this field were working away from secluded arcanism into a community of ideas and competetive research inside the institutional frames of academies and universities. They contributed with thoughts of social importance since theory of this kind improved the technology and engineering with the effect of increasing man's living standards.

A test of such research was that it should be formalizable. According to a dominating learned opinion what mattered was measures and quanta. This hard-data approach has meant very much to the social sciences and the humanities in our century, although there seems to be a Hamlet-doubt in modern physics with alternative theories for the same facts, and in modern mathematics due to Goedel's theorem. The fortress of mathematics seemed to be withering from within, as Nelson Goodman has pointed out.[1]

Contemporary debate in the social sciences has introduced a conflict between hard-data and soft-data research, between methods of statistics and methods of understanding. Should research be a search for general laws and applying them from above to individual cases, or should it start from the bottom with the understanding of individual cases and carefully move upwards to more general conclusions? In contemporary research humanists try to find company with hard-data scholars or they fight for survival at the universities as phenomenologists or existentialists. Taking aesthetics as an example, it is evident that there are difficulties in finding paradigms for research and theory.

2. The first consistent theory of aesthetics, presented as a general theory of art, beauty, and the sublime was written by Kant in the first half of his *Critique of Judgment*, 1790. Afterwards, numerous alternatives appeared; following Hegel and Marx, or Darwin and Spencer there was a quest for a general history of taste. The Kantian art for art's sake was challenged by sociologism and naturalism. This rich debate was centered round the dilemma of finding an acceptable theory. It has been my privilege to live in a time where it was found out that the idea of »theory« in this debate was based on illusion ideals of research.[2]

A traditional theory of aesthetics takes for granted a specific view of the arts, one that has considered a definite state

[1] N. Goodman FACT, FICTION, AND FORECAST, N.Y. 1965.

[2] T. Brunius THEORY AND TASTE, Uppsala 1969.

of artistic affairs after a fairly long progress from primitive efforts to produce art. The so-called primitive societies started making art for art's sake, art was emerging from utilitarian purposes in order to achieve a formal refinement. What matters in aesthetics, then, is pure non-utility in purpose and a refined contemplation in enjoyment.

There were, of course, rich variations and alternatives, but aesthetic theory of a traditional kind was built on assumptions of this kind: art is created with a specific purpose (the aesthetic intention); art itself is permeated with this expression of the creator (the aesthetic property or form); this art-making property, or set of properties, is contemplated with a calm pleasure (the aesthetic enjoyment); the critic evaluates the work of art taking into account the existence or non-existence of art-making properties and the aesthetic enjoyment.

This was, on the whole, the theory that philosophically trained professors, professors of philosophy, of comparative literature, of history of art, and of musicology refined to fit the world of art, past and present.

But such a theory, as theory goes, was as bad as the display to sell a slightly damaged parachute. The idea of a theory is that it is complete, there should be no holes. Aesthetic theory was never complete and in its essence it was more than slightly damaged. It never did fit the world of creative art.

This is difficult to prove. My intention is to give reasons for such an assumption and to line out what we need in research instead of theory.

3. What was wrong with the traditional theory of aesthetics?

First of all its basic social and historical assumptions were completely wrong. There was no birth of art among primates, or cave men, or primitive tribes. There always existed a kind of art, more or less organized, simple or complicated in the human crowd, just as there always existed linguistic communication. Just as animals have communication and sometimes tools capable of changing the environment, so men had through history instruments of communication, tools, change of environment, and play. Different technologies made such objects and activities different. Anthroplogical research has shown how tools for getting food, housing, defense, division of labor, education, play, technology, competition and status activities in connection with the social hierarchy are existing in different social systems.

Obviously there existed proto-arts such as singing songs, telling stories, dancing, producing ritual drama, ornamenting the human bodies, the utensils, and the environment. Technology improved and diversified these products. Wood, stone, clay, leaves, and fur were turned into utensils and housing. Ceramics, porcelain, enamel, glass, metals, leather, textiles, colors, written language, musical instruments, printing gave richer varia-

tions. There is no simple evolutionary trend of art. Different cultures refine different artistic expressions, and sometimes innovations are delayed by the inertia of cultural and educational institutions.

So the family of art has specific roots to proto-artistic activities. Technology gives new possibilities. Written language makes performances such as song, drama, and stories into new genres. You have arts for the literate élite and other arts for the illiterate crowd. Musical instruments of different kinds change music. Pictorial, sculptural, and architectural arts evolve as well. Mosaic, enamel, stained glass windows, illuminated manuscripts, graphic art, illustration, and typography are diversified in response to technology. In our days electronic equipment gives music another sound, and musical performances can be kept not only by means of score but also on records and tapes. The art of welding and reinforcing change sculpture and architecture. Silent movies, talkies, color movies, panavision, radio and television are new lively arts. So there are arrivists breaking into the old traditional family of art.

Therefore we cannot look at the arts as members of a definite system. Paul Oskar Kristeller showed in an excellent study how the modern system of the arts occurred fairly late, in the eighteenth century.[3] It could not exist in the cultures of antiquity in the same way because the qualified arts were activities of the social élite. The arts of the Muses were poetry, or rather song, dance, drama, and learning; all of them activities. The production of objects such as pictures, sculptures, and buildings was manual labor and not a job for gentlemen. This is the reason why there is no sense of fine arts or a general theory of art in antiquity. In the Middle Ages the arts of the universities (logic, grammar, rhetoric, arithmetic, geometry, astronomy, and music) were accordingly liberal, neither organized in guilds nor subject to taxation.

The change into a broader concept of art came with the Renaissance. Leonardo da Vinci discussed the different arts as competitive forces, and, according to him, painting was most important. His *Paragone* pioneered the idea of a new system of the arts, and this system was brought into final shape by means of academies of art. The academy of art gave a person the education that changed him from artisan into artist.

When the modern system of the arts was defined, a corresponding philosophical territory was introduced to research. With no sense of history, the new idea of a general concept of art was taken for granted and expanded over past history. A distorted history of aesthetic ideas was introduced and read by students generation after generation.

Plato was thought of as an aesthetican although he disliked

[3] P. O. Kristeller »The Modern System of the Arts«, J HIST IDEAS 12 & 13 (1951 & 52).

the arts and argued against them. He had no theory of art but a basic cultural policy and from this negative evaluation he gave reasons for the idea that the arts did not communicate knowledge and truth and therefore were inadequate means for the education of a gentleman. Aristotle contradicted his teacher and said that art was quite useful because it could communicate knowledge. A picture of something disgusting was, according to him, pleasant because such an imitation communicated knowledge. Poetry was, furthermore, a general knowledge and more important than history. These Aristotelian arguments are based on a cultural and educational standpoint, or better yet — an ideology, systems of evaluations, reasons, descriptions, explanations, and recommendations.

The historical study of aesthetics through theory has accounted for much learned and inadequate writing. The teaching of aesthetics should be redirected: instead of concentrating on the contraptions and contrivances of aesthetic theory we should study the ideologies of art in different cultures. There are important ideologies in Homer's and Hesiod's poetry, in the comedies of Aristophanes, in the book on architecture of Vitruvius, in the history of painting and sculpture of Pliny the Elder, and in the rhetoric of Quintilian. We should not be in search for theory in these writers but for ideologies of taste.

Our revaluation of theory in aesthetics will change our way of studying and teaching the classics. Such revaluation can in fact be a diversion of emphasis in discussion and research from ambitious but illusory theory to the study of working ideologies of taste. The aim is to stress the fact that most theories in aesthetics are hidden ideologies of taste.

Now we reach the second argument against traditional theory in aesthetics. The construction of a theory took for granted the contemporary state of affairs in the artworld as paradigmatic' and useful, but other activities of utmost importance were overlooked. The weakness of the systems of aesthetics was exposed by Charles Baudelaire, saying that they were static and not taking into account novelty. Walter Pater, Rupert Brooks, and I. A. Richards have given more arguments in favor of such a view. Every moment new art and new types of art are produced. A closed system based on just one type of art-making properties will be completely useless and inadequate for explaining the arts and organizing them by means of resemblances and differences but with one aesthetic common denominator.[4]

Inspired by Wittgenstein, Morris Weitz and William Kennick have shown that the role of theory in aesthetics has been played in an inadequate way and is based on mistakes.[5] The

[4] Empirical studies in this field are T. Munro THE ARTS AND THEIR INTERRELATIONS, rev. ed. Cleveland 1969.

[5] M. Weitz »The Role of Theory in Aesthetics«, J AES ART CRIT 15 (1956); W. E. Kennick »Does Traditional Aesthetics Rest on a Mistake?«,

arts can be organized in an open system according to family resemblances and not according to a common aesthetic denominator. Independently of this debate, Thomas Munro and George Boas argued a similar view based, however, on empirical research.[6]

Instead of trying to find the necessary and sufficient conditions for something being art we have to find out what kind of resemblances in different respects are considered important to art. Such likeness change from age to age, from region to region. Mainly there is a tradition with a generosity pointing at quite different objects and activities and asking individuals to consider them art. However, it is up to the individual to challenge these recommendations and introduce other items to be considered art. This is what is going on in the art life, a debate with a competition between traditional inertia and individual innovations.

Research in aesthetics should be an exposure of these forces. The starting point of aesthetics is not at all a definition of art, of artistic purpose, of aesthetic experience, of criteria of aesthetic evaluation but a study of traditions and innovations of taste. What has been called theory in aesthetics has started from cultural evaluations and has been dogmatic sources for what is good and bad in art.

Such theory was based on a canon of taste accepted by a power élite in the Western world in a limited period of time. It overlooked art regions of other cultures, e. g. Islam, India, China, Japan, or Aztec Mexico. There was a written discussion of the arts partly resemblant to and partly different from the Western tradition of aesthetics in these distant realms. A general theory of aesthetics will never be complete without a basis on research in comparative aesthetics.[7]

It is, however, useless to debunk professors of aesthetics of the past. They were learned and it is possible to find in their basic definitions of art recommendations of what is, in their taste, important in art. Their descriptions of aesthetic experiences are, of course, recommendations of how we should experience works of art. Accordingly, there is a new manner of respecting their labors and of finding out how they introduced new ways of looking at art and new ways of experiencing the arts. In the chain of assumptions that they took for granted, there was a belief in a canon of taste as universal. It was, in

MIND 67 (1959). A precursor is P. Ziff »The Task of Defining a Work of Art«, PHIL REV 62 (1953).

[6] G. Boas »Historical Periods«, J AES ART CRIT 11 (1952-53), and WINGLESS PEGASUS, Baltimore 1950; see also E. Panofsky »Style and Medium in the Motion Picture«, CRITIQUE 1 (1947), rep. in M. Weitz (ed) PROBLEMS IN AESTHETICS, London 1970.

[7] T. Brunius »Aesthetics: The Wider Scope in Philosophy and Education«, PAIDEIA 1 (1972).

fact, a set of personal preferences taken over from tradition and partly reorganized by their own experiences. So theory was mantle for practical criticism.

From this point of view we should not take over the lip service for the necessity of harmony and unity in art, for enjoyment, harmony, and contemplation in aesthetic experiences. Such requisites are never universal. Perhaps they are regularly in existence but there are also important exceptional cases. In fact, the study of aesthetics should never try to make a theory out of preferences, should never try to institutionalize a personal or traditional liking. There should be no monopoly definitions, but a study of partial definitions in use in arguments concerning the arts, their coming into being, their properties, and their uses and evaluations.

A final point: Is there an aesthetic experience in the sense that a specific state of mind is always returning in front of the works of art? Psychologists seem to deny a specific type of experience, but there is a possibility of a typical organization, of our experiences in front of the work of art. All single experiences are in the stream of consciousness and they happen in front of bull fights, figure skating, football competitions, art exhibitions, concerts, cities, buildings, museums, and ice-hockey matches in about the same way: by expectation, obesrvation, association, memory, reasoning, exclusion and inclusion, in different mixtures with pleasure and pain. It just happens as a line of experiences, and this mental traffic can be described. It is not an experience of a specific kind — because then we can ask at exactly what time, when we read *War and Peace* or saw *Hamlet,* the aesthetic experience occurs. It cannot actually happen the whole time in the same way, nor can it be a single recollection in tranquility. In fact, so-called aesthetic experience is what we can get out of a confrontation with art. This is best tested in the descriptions of works of art made by experienced critics. Many good critics have experienced *Hamlet* in many different ways.[8] We cannot line out a monopoly experience and say that just this experience is the proper aesthetic experience.

Traditional asthetics has existed as a production of theories. These theories have been links of assumptions brought together into systems. A critical discussion of every link is a painful exposure of pseudo-theory. A new sense of theory should not be introduced. It is quite satisfactory if the aesthetician tries to keep to the different links with the ambition of research. He should see how it happens in the world of art, how the systems of thought permeated by preferences and recommendations are acting in the debates of arts. This type of renovation of aesthet-

[8] M. Weitz HAMLET AND THE PHILOSOPHY OF LITERARY CRITICISM, London 1964; see also my study on the unfinished works of Michelangelo »Michelangelo's Non Finito«, FIGURA, N. S. 6 (1969), and the works of G. Boas referred to in note 7 supra.

ics is a matter of empirical aesthetics and of the study of ideologies.

4. We can start empirical aesthetics by inspecting ourselves and ask how we learned to use the word »art«.

In my case it happened in this way. The maid said one day: »Don't play with marbles in the front room! There is the vase. It is a work of art.« Another day my mother told me: »Be careful with the ball. There is the Perugino-painting on the vall. It is a work of art.« So the maid and my mother told me that a crystal vase and a painting are both works of art. Coming to school my teacher said: »We will now sing a national anthem by Johan Ludvig Runeberg. It is a real work of art, a precious specimen of lyrics. Music by Pacius.« According to the teacher a song was a work of art. Teachers should be believed.

In my teens, a friend asked me to come along to the concert hall where we listened to Schubert's unfinished symphony. There a man gave an introductory speech and informed the audience that this was not an unfinished composition but it was really complete and a work of art. So this composition of music was a work of art.

Then later on I was confronted with other works of art, Tschaikovsky's ballet *Swan Lake,* Rodin's sculpture *The Thinker,* and *Hamlet.* All of them were called ART. Why? Because we were told so. And we could sit for hours discussing whether a photograph or movie were works of art. First I was a tastetaker following the recommendations of usage of my environment. Later on I tried to be taste-maker telling my environment that a photograph *is* a work of art, that a movie *is* a work of art.

So art life is made up of institutional preferences. We take over their evaluations and their way of looking at the arts, and we follow their recommendations to see what is good and bad, better and worse, and finally what is resemblant in them. After a while we start fighting this established taste. The richness of a culture is shown in the intensity and scope of such discussions.

Art happens to be a big cage in which different birds fly in and out. At any time items are selected, serving as paradigms. What resembles these paradigms is considered art. So »art« is not at all a class of items with a common property. It is a bundle of quite different items, activities as well as objects, and what makes them art is that persons are pointing at them saying that they are works of art.

The *façon de parler* is sometimes vague and without preciseness, sometimes sophisticated and distinct. Common language is in this manner working differently in different situations. An astronomer can write a poem on a beautiful sunset although he knows that the word is inadequate. The horizon rises, according to proper astronomy!

Our goal is to find out how our basic cultural ideology forces such items as works of art together. It is evident that we accept a *Pietà* by Michelangelo as art, but not a bull fight or a figure skating contest. Works of art are objects and activities pointed at by individuals and recommended and accepted as art because there is a more or less widespread ideology, a system of thought with descriptions, norms, reference to norms, personal expressions, and recommendations. To have such an ideology and to live under the influence of such ideologies in competition, supporting each other or in conflict with each other, is the way of life of an educated person. The sources of such ideologies are persons who represent institutions of different kinds but also written texts of different kinds.

5. Most of our discourse has an ideological character. When we discuss politics we start from accepted ideologies such as conservatism, liberalism, socialism. Wishful thinking is mixed with disillusioned observations. We leap from is-phrases to ought-phrases, we use analogies from our personal past or from historical past, trying to line out necessities.

We have also religious ideologies, expressing what is a decent human life, what is the good conduct, what are our station and duties, what are my relations to God and to my fellow countrymen and to the starving population of the Third World.

As an aesthetician I can be dedicated to a research ideology. I can accept and recommend logical analysis, linguistic analysis, phenomenological research, existentialism, or empirical aesthetics. When we choose a research ideology we try to persuade colleagues and students that this is the way research should be made.

I have chosen the word »ideology« because it is traditionally associated with evaluations and recommendations in philosophical thinking. Napoleon used the word to point at his philosophical opponents. Marx and Engels used the word to point at the German bourgeoisie-philosophy. However, to be dedicated to an ideology is not necessarily something wrong. As far as I can see an ideology, or rather a set of many ideologies, is part of our every day equipment.

I have said that theory in aesthetics is of an ideological character because it starts from a limited set of evaluations combined with observations. The definition »art is...« has the functions »art ought to be...«, »good art is...«, and »you should be in search for... in art«. So traditional aesthetics, based on definitions expresses a set of evaluations, a canon of taste, and reinforces it with a system of practical syllogisms.

So-called theories in aesthetics is part of the history of taste in the Western world. There is an interaction between theory and taste. Practical critics have been innovating in close touch with the artists making programs for art and for the experience of works of art. Slowly, the philosophers, lagging behind, try to institutionalize what is acceptable in a new art. So there

are close and refined relations between taste and theory, between critic and philosopher. The philosopher keeps to older art in his studies. Hegel, for instance, choose *Antigone* as a paradigm for tragedy, and he did not follow the traditional Aristotelian choice of *Oedipus Tyrannus*. This evaluation created a new type of tragedy, since Ibsen studied the Hegelian concept of tragedy.

So we can select fertile ideas changing taste and artistic production. On the other hand, new art changes so-called theory. This dynamic situation is best characterized with the word »ideology«. Classicism, a construction of an ideology on classical sources such as Aristotle, Horace, Vitruvius, Cicero, and Pliny the Elder, dominated the artistic situation during two or three centuries. Writers such as Sidney and Dryden, Bellori, Boileau, and Pope made ideologies far different from classical paradigms.

A new ideology was elaborated in works by Lessing and Kant giving birth to purism and *l'art pour l'art*. Writers such as Hanslick and Fry were creating a new look on the arts. Against this ideology romanticism and symbolism were growing. Men like E. T. A. Hoffmann, Edgar Allan Poe, Richard Wagner, and Charles Baudelaire were fighting the ideology of purism in favour of an art being a *Gesamtkunstwerk*, taking the resonance of different sensual territories. Against purism and symbolism was the ideology of realism, and later on emerged socialistic realism, giving the artist the responsibility to interpret and to change the social process and contribute to its correct direction to the benefit of the working people.

Evidently the ideologists consider themselves philosophers with strict theories. If I am right this is a creative illusion. Ideologies are in search for monopoly in aesthetics. But in my opinion aesthetics is just a study of how the ideologies act, and what kind of discourse they represent. Of great interest is also the study of the relations between ideologies and cultural and social institutions.

The study of ideologies of taste breaks down the arbitrary borderline between aesthetic theory and aesthetic criticism. The critic evaluates and interprets, he communicates observations and preferences. Behind his work is an organization of likings and dislikings established in reasons. The reasons should not be mistaken for criteria, since the critic's argument is no proof or syllogism but rather a manner of communicating likings and dislikings in the form of argument. By studying the critics' reasons we find personal ideologies of taste, a kind of fragmentary ideologies used in particular evaluative activities and situations.[9]

[9] In MUTUAL AID IN THE ARTS, Uppsala 1972, I have studied the ideologies of artists and critics during the second half of the nineteenth century in France.

6. Summing up the discussion on theory and ideology in aesthetics I wish to point out that what we call »theory« in aesthetics serves two different functions. Theory is permeated with evaluations and recommendations concerning what is good and bad in art. Theory is also a summary of the present research in aesthetics and a guide to what a scholar thinks is important in research.

The theories of aesthetics resemble a geological section of the earth with different levels corresponding to different historical and cultural situations of the arts. The arts and tastes change in different cultural environments, and ideas and thinking about the arts change accordingly. The artists satisfy different cultural demands in different cultures and the way of looking at their works changes accordingly. What is typical in one situation is obsolete in another. However, the tradition of the ideas is a retarding power that we find in aesthetic theories through the ages.

The factors that are constituting a typical traditional aesthetic theory are built on observations concerning (1) the artist, his milieu, and his artistic intention, (2) the work of art and its supposed artistic properties, (3) the observer of the work of art and his selection of the artistic properties of the work of art. There is a fourth bundle of problems in connection with the evaluation of the work of art.

In traditional aesthetics there is a search for a common denominator making a chain between the three or four different parts of the theory. There is supposedly *one* state of mind when artists create works of art, *one* typical property or set of properties in his work of art, and *one* typical experience returning when we are confronted with works of art. We give this unity the name of »aesthetic«, the monopoly label of a preferred property of and a state of mind in front of art. So there are aesthetic objects, aesthetic intentions, aesthetic qualities, aesthetic experiences, aesthetic emotions, aesthetic criteria, and aesthetic evaluations.

Let me sketch an analogy between aesthetic research and the practice of political science. There is a bundle of problems in political science connected with laws, constitutions, and political opinions and behavior of groups and individuals in different nations. Political theory is a summary of observations of such a political life in different nations and an outline of rules of research on this particular field of research.

Political ideologies show the interesting combination of observations and evaluations amalgamated into lines of argument and organized into a system in order to give a pseudo-theory on good society. It is not exceptional that a political scientist is a conservative, a liberal, or a socialist. It gives him important insights into reasons to political decisions and planning. As a professional political scientist he is not creating a conservative theory, a liberal theory, or a socialistic theory, but rather a

theoretical study in conservatism, liberalism, or socialism.

There are ideologies of taste as well. They communicate important observations and rules in connection with the arts, summaries of reasons behind evaluations, and recommendations of what is good in art. There has to be made a border between reasoning about art and recommendations of what is good in art.[4] In this way we can see how the same person has to play two different roles, just as we are inclined to say about the political scientist. As a scientist he is a kind of dr. Jekyll, but as a man creating opinions about art he is in practice like Mr. Hyde (using these names I don't want to say that dr. Jekyll is better than Mr. Hyde; their assignments are different although related to each other).

A theory of aesthetics has to avoid the cultural and personal bias of the scholar and to introduce summaries of comparative research from different cultures in order to avoid the exclusively ideological pattern. In fact, the pattern of traditional theory evaporates successively and instead there will be a research of the same kind as scholars of history and cultural anthropology are trying to do. The scholar being interested in problems of aesthetics will not find problems but more issues of research. He will avoid the pattern of ideology in his research but he will study ideologies.

A general theory of aesthetics will be possible only as a summary of research for the time being, a line up of a research strategy. »Theory« is useful as a headline for substantial research. It is good as a mirror of what the scholar thinks is important to study in his specific field. The study of aesthetics is partly a study in ideologies of taste and a summary for the time being of research concerning the different uses of the works of art recommended in ideologies of taste.

Artistic Puzzlement

1. A persistent feature of the last hundred or so years of art history has been seasonal recurrence of what Ian Dunlop has recently labeled *The Shock of the New*.[1] On a number of occasions during this period the art world has been shocked by the appearance of avant garde movements that have seemed to challenge artistic traditions and prevailing conceptions of art. One thinks immediately of the impact made by the first

[1] I. Dunlop THE SHOCK OF THE NEW, N.Y. 1972.

Impressionist showings, the Fauves, the Post-Impressionists, the Surrealists, and so on. Professional critics and casual gallerygoers alike have been disturbed and puzzled by new developments that they did not know what to make of. The new works did not seem to accommodate themselves to what art was thought to be like and frequently the motives of the artists were themselves impugned. This sort of thing is still very much with us. What are we to make of the artistic activities of the last very few years? I am thinking now of such things as some examples of Pop art, conceptual art, earth works, and my own favorite example of the suspicious, the grave that Claes Oldenburg had dug and then filled in again in Central Park behind the Metropolitan Museum.

To bring into focus the very real problem that this kind of thing poses for us I want to imagine someone who does not see the point of these recent goings-on and yet is sensitive to a great deal in art; he is very much at home, let us say, in the history of art in general and the twentieth century in particular and admires a wide range of periods and styles from cave paintings to Abstract Expressionism. He is puzzled by Oldenburg's grave. He is relctant to dismiss it out of hand — after all, a great many people do take it seriously — and his reluctance is all the more understandable when he reminds himself how wrong the critics were about those radical developments of the past that Dunlop describes for us.

His position here is rather like that of someone with a good sense of humor who does not see the point of a joke. He cannot say that it is a bad joke because that presupposes that he got the point of it and then found the point not worth the getting. It is rather that he doesn't even know what there is in the story that is supposed to be funny. The reader will perhaps recall the Peter Arno cartoon quite a few years ago in *The New Yorker* showing two well past middle age couples in dinner dress on the sidewalk outside a New York town house speaking through the window to a similar group inside. »Come along,« they say, »we're going to the Trans-Luxe to hiss Roosevelt.« A younger generation is quite unmoved by this. When one doesn't see the point one does not know where to look for the humor. Is it in the fact that the people are rather old (as if hissing was a young man's sport)? that they are in dinner dress (one hisses only in tweeds)? that they want to hiss at the Trans-Luxe (Loewe's is the place for that)? and so on. Explaining the joke to these people involves reconstructing a whole sociopolitical background now almost vanished. And even then there is the danger that the appreciation of the joke will be rather academic by way of the necessary explanatory footnotes; it cannot have the bite for them that it did — and still does — for those who lived through the period.

Another example should help bring the kind of problem I want to talk about into view. The joke in the Arno cartoon turns upon exposing a certain already familiar species of human foible. Explaining the joke involves making clear the situation in which those foibles are operating. Consider now the story of the man who rushes breathlessly into the doctor's office and exclaims »Doctor, I've got Bright's disease — and he's got mine!«[2] Here the humor depends upon a conceptual ploy rather than the exploitation of foibles. It involves what might be called a different principle of humor to which a foiblephile may be wholly immune. When the point of a joke passes us by we may not even know where to look for the clue that will make it all clear, whether it is a matter of some background that we need to have sketched in for us or perhaps of having our attention directed to the kind of joke it is, the principle of humor that is at work. And similarly, I would suggest, in the case of art. We have yet to learn how to understand Oldenburg.

If someone is baffled by Oldenburg's grave — does not see the point of it — he is in no position to say that it is bad, or, for that matter, that it is good since he does not know what there is about the thing that is supposed to be relevant to its description and evaluation as a work of art. What is he missing? How do we explain the point of a work of art?[3] How do we bring someone to understand and describe and assess correctly what he now neither understands nor understands how to describe and assess? In the case of the kinds of art I have been referring to this question is one with the question how such things are in fact to be understood, described and assessed.

This problem is not itself a philosophical problem although it is out of reflection upon such problems that philosophy gets started. I must confess to a certain lack of clarity about what relation there is between problems in art appreciation and criticism and the philosophical theorizing that is generated by them. Nevertheless, I would like to think that the right sort of philosophical investigation can shed light of some kind on these problems and have something to do with how we deal with them, if in no other way than by helping us understand what

[2] My apologies to J. Cook who was the first, I believe, to get philosophical milage out of this one. Cook attributes the joke to Perelman; »Wittgenstein on Privacy«, PHIL REV (1965): 302.

[3] It is perhaps misleading to speak of THE point of a work of art as we speak of THE point of a joke for there is not always some one thing that sums up a painting and when pointed out makes everything clear. Nevertheless, paintings are like jokes in that they can be understood and misunderstood. It seems quite natural to say of someone who demands to know what an abstract painting is supposed to be a picture of that he missed the point of that painting.

kinds of questions we have on our hands and the kinds of considerations that will be relevant to answering them.

Sometimes our puzzlement in the face of new and unfamiliar art forms is expressed in the form of the question, »Is this really art?« First of all, to clear the air, I want to insist that this is not to be answered by advancing a definition or theory of art, no more than is the question, »Is this supposed to be a joke?« to be met by a definition of the joke or a theory of the comic. In the latter case it is obvious that what is wanted is an explanation of the point of that particular joke and, similarly, what is behind the question about art is bewilderment about how the thing is to be understood and appreciated.[4] This is why the sometime response that it is art if the artist says it is is altogether wide of the mark; the real issue of understanding and appreciation is not touched.[5]

I believe that the questions about appreciation and criticism that I have raised can be profitably approached by examining another instance in which new works of art shocked the art world and produced something of a crisis in criticism and appreciation. The case I want to examine is that of those painters for whom Roger Fry coined the name »Post-Impressionist« in 1910. This case is instructive because we now have an advantageous historical perspective from which to view it and also because Fry's critical defense of those painters is an excellent example of how a new movement can be sympathetically understood and judged. But before going on to a discussion of the Post-Impressionist controversy and Fry's place in it, I want to lay a foundation for the discussion by calling attention to two important remarks by Wittgenstein.

2. In the *Lectures and Conversations* Wittgenstein says that »The words we call expressions of aesthetic judgments play a very complicated role, but a very definite role, in what we call the culture of a period. To describe their use or to describe what you mean by a cultured taste, you have to describe a culture.«[6] This is, of course, another instance of Wittgenstein's insistence that our words form a language, that we can say things, ask and answer questions, give instructions, and so on only in a context of human interests and activities. The remark also sug-

[4] I have argued this point in »Wittgenstein, Games, and Art«, J AES ART CRIT (1973).

[5] Thus, while it is a way of dealing with one kind of issue, Dickie's claim that a work of art is an object »upon which some person ... has conferred the status of candidate for appreciation« leaves so many of the important issues that have lurked behind the »what is art?« question still unsettled. »The Institutional Conception of Art«, LANGUAGE AND AESTHETICS, (ed) B. R. Tilghman, Lawrence 1973: 25.

[6] L. Wittgenstein LECTURES AND CONVERSATIONS ON AESTHETICS, PSYCHOLOGY AND RELIGIOUS BELIEF, (ed) C. Barrett, Berkeley 1966: 8.

gests the familiar, although rather obscure, theme that words are intelligible only within a language-game and that a language-game must itself be understood against the deeper background of a form of life. I don't think it is necessary here to make clear these notoriously difficult notions or to try to make a case for there being an artistic »form of life«; it will be enough to lay out the kinds of things that go into making up »the culture of a period« that gives sense to the things we say and the questions we ask about works of art. We needn't go any further into this background than is necessary to illuminate the particular issue we have at hand.

To describe this cultural context we would have to describe a great number of things such as the kind of training given to artists, traditions of artistic style, the social and economic status of artists, the state of art history, the system of exhibitions and galleries and how paintings get bought and sold, the kind of art education given to the general public and its attitude toward art, styles in decoration, and the like. And then we must keep in mind that it is only against such a background that descriptions of paintings, evaluations, and critical disputes are intelligible and any attempt to talk about art independently of such a context is only language gone on holiday.

The second remark that I want to call attention to comes from Part II, Section xi of the *Philosophical Investigations*. That section begins in this way.

Two uses of the word »see.«
The one: »What do you see there?« — »I see this« (and then a description, a drawing, a copy). The other: »I see a likeness between these two faces« — let the man I tell this to be seeing the faces as clearly as I do myself.
The importance of this is the categorical difference between the two 'objects' of sight.
The one man might make an accurate drawing of the two faces, and the other notice in the drawing the likeness which the former did not see.
I contemplate a face, and then suddenly notice its likeness to another. I SEE that it has not changed; and yet I see it differently.[7]

Most of the discussions of Wittgenstein's account of »seeing-as« have focused on the duck-rabbit and similar ambiguous figures. To the best of my knowledge no one has talked about the topic with which Section xi begins, seeing likenesses. I suggest that this is enormously important for understanding art appreciation and criticism and also for understanding the notion of style and the role it plays in art appreciation and art history.

That background against which aesthetic puzzlement and critical disputes must be understood, what Wittgenstein called the culture of a period, includes, of course, how people look at and appreciate paintings. This appreciation can involve sensitivity to such things as various principles of design and space

[7] PHILOSOPHICAL INVESTIGATIONS: 193e.

composition, color, dramatic significance, and the like. This sensitivity rests upon the ability to see the figures on the canvas as hanging together in a certain design and dramatic grouping, the colors as emotionally charged or, in the case of bad art, to see the canvas as failing to achieve the kind of thing demanded by style and tradition. This kind of »seeing-as«, which is the basis of so much aesthetic appreciation, is logically linked to the seeing of likenesses. This shows itself in the teaching of art and its appreciation when it proceeds, as it frequently does, by directing attention to some model or paradigm whose style and technique is to be emulated and against which other paintings are to be looked at and understood. Thus one way to explain why a painting like Guérin's *Phaedra and Hippolytus* is such a disaster is by comparing it with something of David's. We see Guérin as striving after the same kind of composition and dramatic effect as David, but managing to achieve only shabby melodrama played by bad actors.

An important corollary of the concept of seeing likenesses might be introduced under the heading of »seeing differences.« It was not always realized, for example, that the painting of the period we now call Mannerist is stylistically different from that of the High Renaissance on the one side or the Baroque on the other. These differences along with, of course, the important resemblances among the relevant sixteenth century paintings themselves, had to be seen before art historians could begin to look for the features responsible for the differences and thus begin to formulate »definitions« of Mannerism. The use of style concepts in art history and criticism would be quite unintelligible apart from considerations of seeing both likenesses and differences.

I have argued elsewhere[8] that the grammar of the word »art« and so many of its sub-concepts cannot be understood except in the context of an artistic life with its traditions and forms of appreciation. If appreciation is to a large extent a matter of seeing, of seeing likenesses and seeing-as, then the suggestion follows naturally that attempts to describe the grammar of »art«, whether in terms of »family resemblances«, »open concepts«, or more traditional notions is bound to lead us into one fly bottle or another if we don't keep in mind the centrality of seeing likenesses. It is not in order here to develop this line of argument nor is it in order to lay out the details of the grammar of »seeing a likeness« in particular or of »seeing-as« in general; what must be done is to show this kind of seeing at work in art appreciation and criticism.

3. In november of 1910 the first Post-Impressionist exhibition, organized by Roger Fry, opened at the Grafton Gallery in London. The exhibit included paintings by Manet, Cézanne, Gauguin, Van Gogh, Vlaminck, Derain, Seurat, Signac, Matisse,

[8] »Wittgenstein, Games, and Art«, op. cit.

Rouault, and Picasso, to name only some of the more important. The great majority of the work was new to British artists as well as to the British public. Critical and public reaction was generally one of outrage. When they were not simply laughed at the paintings were called indecent and pornographic. The tendency was for critics to regard it all as destructive of artistic tradition and of the artistic values so laboriously developed from the Renaissance on. Roger Fry was well known and highly respected both as a critic and art historian; and it was especially puzzling that a man who could lecture eloquently on Botticelli could at the same time perpetrate a thing like the Grafton exhibition.

The artistic taste of Great Britain at that time, the culture of that period, has been described for us in some detail.[9] The masters of the High Renaissance were much admired and the popular academic painters of the nineteenth century, Alma-Tadema, for example, were thought of as carrying on that tradition. Some artists and collectors were beginning to make their peace with Impressionism and if the Impressionists were not exactly in vogue, at least they were no longer despised. There was, however, no avant garde in Britain and nothing at all of a bohemia in which new artistic ideas could ferment. Although a number of British painters had studied in France, they had not, apparently, penetrated into *la vie bohème* and hence knew nothing of what was really going on in Paris.

Against this background the reaction to the Post-Impressionists is easily understood and we can see why they did not know what to make of them. There was no problem in describing and evaluating a new painting done in the familiar traditions. Here one knew what to look for, literary and historical content, drawing, space composition, perspective, color, atmospheric rendering, and so on and there was no great problem in telling a painter who had learned his lessons from the inept who couldn't make it all come off. But with the Post-Impressionists none of the familiar categories seemed to apply. No wonder they were seen as either hopelessly unskilled and doing very badly what the academic painters did very well or as deliberately and maliciously kicking over all that was of value.

In an article in *The Nation*[10] Fry defined the Post-Impressionists in the following way. He admitted that although »they are in revolt against the photographic vision of the nineteenth century, and even against the tempered realism of the last four hundred years,« nevertheless they are the most traditional

[9] See Dunlop's chapter on the Post-Impressionists and also V. Woolf's biography of Roger Fry, N.Y. 1940.

[10] »The Grafton Gallery. — I«, THE NATION (London, Nov. 19, 1910): 331f.

of recent artists. They represent a rather successful attempt to get behind »the too elaborate pictorial apparatus which the Renaissance established in painting. In short, they are the true Pre-Raphaelites.« He then went on to develop this point.

We think of Giotto as a preparation for a Titianesque climax, forgetting that with every piece of representational mechanism which the artist acquired, he both gained new possibilities of expression and lost other possibilities. When you can draw like Tintoretto, you can no longer draw like Giotto, or even Piero della Francesca. You have lost the power of expression which the bare recital of elementary facts of mass, gesture, and movement gave, and you have gained whatever a more intricate linear system and chiaroscuro may provide.

The essence of Fry's argument seems to be this. There is a view of art history at least as old as Vasari, who may have invented it, that sees Giotto as doing in a crude and clumsy beginner's way what the painters of the High Renaissance did superbly well. And it is also possible to see Cézanne and the others as doing very badly what the nineteenth century academics did very skillfully. There are, however, other ways to look at Giotto; he had his own values of form, design, and expression that tended to get submerged in the later development of Renaissance techniques of representation. Now, Fry tells us, don't look at Cézanne as you look at the nineteenth century academics; see him, rather, as doing the kind of thing that Giotto was doing. (Fry also compares Cézanne to Mategna and Piero.) To understand the Post-Impressionists the reference point must be Giotto rather than Raphael.

I have been speaking of Fry's argument, but it is surely not an argument in the logician's sense of that word. Fry's reasoning is not deductive; that Cézanne is good is not a conclusion entailed by previously accepted premises. And neither is it inductive; that the Post-Impressionists are worth looking at is not the result of the marshalling of evidence. What Fry is doing is asking us to look at Cézanne in a certain way so that we will see his value for ourselves. He helps us to see the value of Cézanne by pointing out likenesses between his work and aspects of the artistic tradition with which we are already familiar despite these aspects having been neglected in the then prevalent view of art history.

And this kind of pointing out is double edged. For if Fry can show us that Cézanne is like Giotto, then surely we can also see that Giotto is like Cézanne with the result that the kind of formal values common to the two are brought much more forcefully to our attention and this neglected aspect of the tradition can henceforth become another focus of appreciative and critical awareness. The artistic tradition has been to that extent modified and developed.

Very much the same kind of aesthetic commerce between the current and the past is instanced in an example drawn from literary criticism. Jorge Luis Borges, in a brief essay on Kafka,

calls attention to the existence of Kafkaesque themes in earlier writers. He then goes on to conclude that

Kafka's idiosyncrasy, in greater or less degree, is present in each of these writings, but if Kafka had not written we would not perceive it; that is so to say, it would not exist. The poem »Fears and Scruples« by Robert Browning is like a prophecy of Kafka's stories, but our reading of Kafka refines and changes our reading of the poem perceptibly... The fact is that each writer CREATES his precursors. His work modifies our conception of the past, as it will modify the future.[11]

Although it is certainly an exaggeration to say that Cézanne *created* Giotto, as if we had to have seen Cézanne before we could appreciate Giotto, nevertheless there is a point here well taken. The work of Cézanne and his contemporaries of the early twentieth century have indeed modified our conception of art history and artistic tradition. With the move toward abstractionism and expressionism Byzantine art and primitive art, for example, not to mention a unique figure like El Greco, cannot possibly look the same to us. The new developments are sometimes, to be sure, the result of the influence of a tradition, but they need not be linked to that tradition merely by historical ties; for sometimes it is the new works themselves that help mark out just what that tradition is.

It is in the light of all this that we can understand what is going on logically in the theory of art as »significant form« that Fry and his colleague, Clive Bell, worked out as a result of their thinking about Post-Impressionism. If the theory is taken as an attempt to explain the meaning of the word »art« or to provide the necessary and sufficient conditions for the word's application, the result is the sheerest nonsense. It should be understood, I believe, as an expression of how Fry looked at the Post-Impressionists and as an instrument in the critical and interpretive labor that he took up on their behalf in the context of Edwardian taste. This allows us to appreciate Morris Weitz's apt characterization of the theory.

What gives it its aesthetic importance is what lies behind the formula: In an age in which literary and representational elements have become paramount in painting, RETURN to the plastic ones since these are indigenous to painting. Thus, the role of the theory is not to define anything but to use the definitional form, almost epigrammatically, to pinpoint a crucial recommendation to turn our attention once again to the plastic elements in painting.[12]

There is a pattern in this history of Fry and the Post-Impressionists that now needs to be made explicit. This pattern is composed of essentially four elements. (1) There is the culture of the period, the background of artistic life, traditions, and

[11] J. L. Borges »Kafka and his Precursors«, OTHER INQUISITIONS: 1937-1952, trans. L. C. Sims, Austin 1964: 108.

[12] M. Weitz »The Role of Theory in Aesthetics«, J AES ART CRIT (1956): 35.

practices, against which works of art are understood, described, and evaluated. (2) Something is offered as a work of art that apparently cannot be accommodated by the tradition and that cannot be described and evaluated in terms of familiar categories and standards with the result that the critics as well as the general public are puzzled if not outraged as well. (3) The new work is defended by the demonstration of a connection, however unsuspected, with some aspect of the familiar tradition. The connection is established by showing the likeness that is to be seen between the new and the already familiar. The demonstration thus provides a way to understand and assess the new work. (4) The result of all this is that the relevant aspect of the tradition is given an importance it did not have previously and the tradition is thereby modfied and enlarged. It remains to be seen if this kind of conceptual pattern revealed in the criticism of Roger Fry has any application to the critical and appreciative concerns talked about in the first section of this paper.

4. There is one feature of our present day artistic life that is quite different from that of Britain in 1910. We are now habituated to artistic change and aesthetic experimentation and new movements are the order of the day. We are no longer disturbed simply because something is new and unlike what we are familiar with; in this respect we are undoubtly much more tolerant and open than the Edwardians. We are also much more sophisticated with respect to art history; we are aware of a vast historical and contemporary range of artistic styles and intentions and we know that these can make quite different kinds of demands on our appreciative faculties. Put in another way, this means that we have a wider and richer vocabulary for artistic description at our disposal than did that older generation that Fry had to contend with. Not only can we talk about the traditional values of representation and draftmanship, but about the formal values that Fry called our attention to and abstract values of color and texture as well, not to mention more recent styles and movements such as Cubism, Expressionism, and Surrealism that provide us with additional ways to categorize and describe both twentieth century art and that of the past. Needless to say, the ability to employ this vocabulary rests upon a basis of aesthetic perception, the ability to see appropriate features and likenesses.

Earlier I said that puzzlement in the face of a new kind of art is marked by not knowing how to describe the item in question. I want to bring out the importance of that now. We know how to describe a Raphael as, say, a madonna and as an exercise in Renaissance space composition. Fry's British public made the mistake of trying to describe a Cézanne or Matisse as an exercise in academic composition. That they also had to describe it as a singularly inept essay in that direction is therefore not at all surprising. How, then are we to characterize

Oldenburg's grave? A recent comment of Harold Rosenberg's helps to get at the nub of the problem and despite a certain lack of clarity makes an important point. I shall try to bring out both what is unclear and what is important.

> Since the eye and the analogies it discovers in common sense experience cannot be trusted, the first rule in discussing modern art is that a painting or sculpture must never be described as resembling (or being) an object that is not a work of art; a sculpture consisting of a red plank must under no circumstances be identified as a red plank, a set of Plexiglass cubes as a type of store fixture.[13]

What is it that the eye is supposed to discover in common sense experience? Whatever it is, it is presumably nothing artistic and therefore a »common sense« description will not employ the vocabulary of an aesthetic description. But this suggestion that there is something readily identifiable as a »common sense« description surely overlooks the many different uses of the question »What do you see?« and the corresponding variety of responses that can be appropriately given. Equally questionable is the suggestion that a nice distinction between aesthetic and non-aesthetic descriptions can always be drawn. What does the eye of common sense experience see in a painting? If Rosenberg suggests that in place of a sculpture it sees a red plank, are we to suppose that in place of a painting it sees a canvas covered with paint? Here we have to look at particular cases.

In the case of a Raphael or even a Cézanne the plain man ignorant of art would likely describe what he sees at least as a picture of something, a woman and child perhaps, even if he could not identify it as a madonna or »High Renaissance« and was unaware of its exquisite composition. Being able to describe it in these latter ways calls for some knowledge of both religious traditions and artistic styles and the appreciation of the composition presupposes some wider acquaintance with painting and the possibilities of pictorial organization. Paintings, of course, are made by putting paint on canvas, but the description »canvas covered with paint« is not always appropriate. That is the kind of description that might be insisted upon by a teacher who has in mind getting his students to confront certain technical problems of preparing canvases and manipulating pigment. It is by no means necessarily the description with which the plain man of common sense begins.

»Paint covered canvas« also seems the description appropriate for the scrap the artist wipes his brushes on. Prior to the twentieth century mistaking a painting for a paint covered canvas was a most unlikely event, but recent times have opened up a host of new opportunities for making mistakes. The plain man might well be pardoned for thinking a Jackson Pollock a nice piece of canvas unfortunately ruined by leaking paint.

[13] H. Rosenberg THE DE-DEFINITION OF ART, N.Y. 1972: 57.

Rosenberg is right to point out that not every true description of a work of art is appropriate in every discussion of it, e. g., »is a paint covered canvas« is not relevant to an account of Raphael's space composition (although a consideration of the physical nature of his pigments may at some point be important for understanding how he came to paint as he did). The plain man's descriptions, then, are inappropriate or, I would add, inadequate. But taking the plain man as we find him, we know how to go about educating him; we can show him that the Raphael is a great deal more than just a picture and the Pollock is not merely dribbles. We can do this because we belong to an artistic culture and others can be educated to share this with us.

Following Rosenberg's lead, if we are not to say that a red plank is a red plank, then we must suppose that Oldenburg's grave is not a grave either. But what is the Oldenburg in addition to a filled hole in the ground and what do we have to know in order to describe it as something besides just that? The artistic vocabulary that serves us for Raphael, Cézanne, and even Pollock doen't seem to apply. It can't be described as representational or symbolic, there are no elements of formal design, no colors or textures to add a sensual ingredient; in fact, now that the grass has grown over it, there isn't even anything to be seen. Small wonder our familiar — visual — descriptions have no place. And this seems to bring us right back to the situation of the man who does not understand the joke and who does not know where to look for the point.

It may be suspected by this time, and rightfully so, that I have no intention of answering the question about how Oldenburg's grave is to be understood. It was, after all, introduced only as an example of the kind of artistic puzzlement I have been talking about. There is, however, one way of responding to the thing that I wish to be adamant about rejecting. I spoke earlier about the much greater degree of artistic sophistication and historical awareness that we possess by contrast with older generations. There is a danger in this. We are perhaps too much aware of how wrong the traditional critics were about what we now acknowledge as so many of the masterpieces of modern art. Our fear of being scorned by the future as, we now scorn the academic critics, for failing to recognize the latest ditch in the desert or skyscraper wrapped in plastic as a masterpiece can produce a kind of paralysis of critical good sense. While our response to what puzzles us obviously should not be one of summary dismissal, it need not be one of critical paralysis either. We are puzzled because we do not know how to look at these things and accommodate them to the traditions of artistic practice with which we are familiar. Thus we have every right to our perplexity and there is no necessity for anyone to give way before either artist or critic for it is always in order to demand of them an explanation and a point of reference in terms of which the things are to be seen.

It may perhaps be objected that I assume uncritically that an explanation and defense of any new art movement must take the form of Fry's defense of Post-Impressionism. It would be unreasonable to claim that Fry's procedure is the only proper way to do criticism. In the particular instance of Oldenburg's grave the critic's procedure has to be in at least one important respect different from Fry's for, unlike Fry, he cannot ask us to *look*. Nevertheless, since the grave is offered as a work of art, some link with the familiar tradition will have to be established in order for that claim to be made good and for others to understand it as a work of art. What link is to be established and how that link is to be shown can for now be left open. The example of Fry was introduced to illustrate one way in which connections of this sort can be made, but was not meant to close out any possibilities.

I have pointed out that one way a new kind of art can be explained and defended is by demonstrating a link with an already familiar tradition. I want now to call attention to a way of making such a connection that has gained some currency and that I believe to be mistaken or, at the very least, to be in need of the most careful scrutiny. Conceptual art, for example, has been explained and defended by demonstrating links, not with other works of art, but with certain *theories* about art. Harold Rosenberg puts it in this way.

Art communicated through documents is a development to the extreme of the Action-painting idea that a painting ought to be considered as a record of the artist's creative processes rather than as a physical object. It is the event of the doing, not the thing done, that is the »work». Logically, the work may therefore be invisible — told about but not seen.[14]

This kind of theory is familiar enough to philosophers; it has its roots in romanticism and suggests the idealist thesis that the real work of art is in the mind of the artist. There are at least two things wrong here. As Magaret MacDonald once pointed out in criticism of this kind of theory, an artist who forever claimed only to have ideas for works of art, but never produced a work of art, is open to the charge of being a fraud.[15] Secondly, there are the objections that can be raised against the very idea of a theory of art as an attempt to say what art is, objections that are sufficiently familiar to need no rehearsing here. A philosopher acquainted with the intellectual pitfalls in this sort of thing must find the tendency to substitute theory for art distressing. Rosenberg quotes an unnamed artist as saying that »Art may exist in the future as a kind of philosophy by analogy«[16] and reports that the sculptor Robert Smithson

[14] Rosenberg: 59.

[15] M. Macdonald »Art and Imagination«, PROC ARIS SOC (1952).

[16] Rosenberg: 59.

believes that art today must become speculative philosophy.[17] One may be pardoned for his intuition that what is needed is not so much sympathetic understanding of the new movement, but showing the fly the way out of the fly bottle.

Let me conclude with this remark. I have tried to describe one kind of circumstance in which critical judgments must be made and defended and have tried to describe the logic of those judgments. It may be that the importance of this kind of philosophical, that is, conceptual, investigation is in its providing us with reminders of what the relevant factors are in those situations where it is vitally important that we keep our critical and appreciative wits about us.[*]

Timothy Binkley

Deciding about Art[**]

1. Is it art?
2. For example, Lucy Lippard recently put together a show of women conceptual artists. It was called »c. 7500« and I saw it at the Moore College of Art in Philadelphia. Photographs, statements, various documents decorated the walls of the gallery; a number of pieces in binders commanded two tables. Upon arriving at the first table I picked up the most eyecatching piece, bound in synthetic grass and filled with words in numbered squares. The other pieces were more modestly bound, though their contents were no less interesting. While going through the table pieces I came upon a small brown spiral notebook. Most of its pages were empty, though some here and there had statements or poems or fragments thereof written on them. Some loose sheets had been torn out, folded, and slipped back in between the pages. Eventually I turned to the front page which was filled with words in blue ink. In bold red letters at the top was the statement, »NOT PART OF THE EXHIBITION.«
3. My first reaction was to drop the notebook and look about sheepishly to see if anyone witnessed my blunder. But I began to wonder. I had reacted too quickly. The simple fact that someone wrote in the book a statement denying its membership in the show did not prove it was not part of the show. (Remember, this is conceptual art. Why not?) So I found my-

[17] Ibid.: 60.

[*] I am indepted to James R. Hamilton for several suggestions and much discussion.

[**] This piece was written with the support of a Post-Doctoral Fellowship from the National Endowment for the Humanities. I would like to express my gratitude to Lars Aagaard-Mogensen, Monroe Beardsley, Ann Clark, George Dickie, and Alan Tormey for reading the paper at various stages and offering valuable criticisms and suggestions.

self in a quandary: Is the notebook part of the show or isn't it? I scrutinized the table.

(a) All the other pieces lying there had substantial bindings and most of them had their pages protected against human fingers by sturdy plastic coverings. The spiral notebook looked naked and vulnerable by comparison. It was not decked out for travelling. (The show travelled.)

(b) Several tags, each bearing the name of an artist and a work, were mounted on the wall next to the table. There were more pieces than tags and no tag supported the brown spiral.

(c) An empty cigarette pack relaxed among the busy binders. Surely the notebook, like the cigarette pack, was a joke or perhaps an expression of contempt. I pictured three or four people in the gallery playing the game of who could make the best laugh or the worst insult.

(d) The other binders on the table had some organization to their contents. The spiral seemed unstructured and uninteresting. Too unsophisticated. A botched job. ... Yet why shouldn't this be the finishing touch on a piece intended to appear spurious?

4. At last I put my insecurity to a somewhat fitful rest. I didn't think the brown spiral was part of the show, and the evidence I had pointed in that direction. But there was still sufficient room between my inclination and certainty for the brown spiral to squeeze through and claim the status of *bona fide* member of the show. A change in perspective could reverse the weight of the evidence.

A few days later I returned to the gallery, hoping to find the object of my distress gone. It was still there.

By chance I later met the director of the gallery who assured me that the notebook was not part of the show. That clinched it. She should know. »Not part of the exhibition.«

5. Now the lurking ponderous question. Is the brown spiral notebook art?

Had the thing turned out to be part of the show, there would be no difficulty assigning it the status of art object (or at least artwork). But what now? Would something have to *make* it art? Would Lucy Lippard have to see it and like it enough to keep it in the show or at least write about it? Would someone have to grant the notebook its art credentials in an official forum in order to save it from being nothing but a little joke among a handful of people who saw the show in Philadelphia? Yet why couldn't the brown spiral be art just as it stands? Perhaps it is an artwork witnessed by only a few persons. Why can't a joke about art be art? Marcel Duchamp did it years ago; why shouldn't anonymous do it today? Duchamp's urinal called »Fountain« was submitted and suppressed; the brown spiral siezed its place without prior consent. Does forcible entry cancel art status?

These questions are not settled as easily and as tidily as the

first. There is no easy appeal to authority. Especially if the person who authored the book demurs in the absence of philosophical proclivities.

6. It did not occur to me to wonder whether the piece bound in synthetic grass is an artwork.

I. 1. The perplexed decider wants relief. Perhaps a dashing definition of art will come to the rescue. Scenario: The decider's distress is relieved in short order by seeing whether the resistant object meets the demands of the definition. If it fits, it's art; if not, no.

Even if a definition does not settle the issue, it could be helpful nonetheless. It would formulate a set of essential features of art by means of which questionable entities could be compared with unquestionable art and unquestionable non-art. The status of the problematic item would be elucidated if not decisively fixed.

Unfortunately, reliance upon definition does not appear to be a viable alternative. Consider the following argument.

2. Art cannot be defined. This proposition is demonstrated by explaining how to construct a counter-example to any particular definition of art. A formula will be given for producing artworks which stand as counter-examples to specific definitions of art claiming to distinguish art from what is not art. Any proposed definition is disproved by being subjected to the formula.

Before presenting the formula, it would be useful first to mention the Readymade tradition, which gives some rationale for the workings of the formula. Duchamp took several common objects (a shovel, a typewriter cover, a hatrack) and simply converted them unchanged into artworks. These pieces he called Readymades. One thing Duchamp demonstrated with these artworks is that in order to »create« a work of art it is necessary only to *specify* what the artwork is. An artist may specify as a piece an object he has designed, but that is not a *sine qua non* of arthood. In establishing this fact, Duchamp severed aesthetics from art. Aesthetics presupposes that to create an artwork is to bring into being aesthetic qualities, such as beauty and expressiveness, which are aspects of the appearance of an object or an event.[1] These qualities are found in the look of a painting, the sound of a sonata, etc., and they do secure one way of specifying an artwork. But it is not the only way. Anything can be art if it is indexed or catalogued as art. All one need do is make clear what he intends the piece to be. Artist since Duchamp have revelled in this realization.

The notions of specifying and indexing which have been introduced here need further discussion, and they will be examined later on. Let us return to the argument under way.

[1] For an insightful discussion of aesthetic qualities, see M. C. Beardsley »What Is An Aesthetic Quality?«, THEORIA 39 (1973): 50-70.

The formula. The formula gives instructions for making a piece, P_i, with reference to a definition of art, D_i. So let D_i be any definition of art. Appeal to a defender of D_i to exhibit an example of something which, according to the definition, is not art. If no defender can be found, a volunteer may select an example of non-art using the definition. If no volunteer can be found, you may do it yourself. The piece, P_i, will consist of this example of non-art.

The formula has roughly three steps for arriving at the artwork P_i: (1) Secure a definition of art, D_i; (2) Find an example, E_i, of non-art on the basis of criteria articulated by D_i; (3) The piece, P_i, is specified to be the example, E_i: $P_i = E_i$.

Although the »creative act« is signalized and accomplished by the declaration »$P_i = E_i$,« any »creativity« in the piece results from the groundwork for (3) constructed in (1) and (2). It is also worth noting for future reference that (3) does not involve taking something which is not art and christening it art. I am an artist. I want to make a piece. I avail myself of the formula. (3) says not »E_i is a work of art,« or »I hereby declare E_i a work of art.« (3) says the piece I am now making is E_i. Not *a* piece, *the* piece. The question of the art status of E_i need not explicitly arise. I am going to make a piece, P_i. The question »*Is* P_i a work of art?« does not arise in the course of applying the formula. The question is »*What* is the piece, the artwork?«, and the answer is supplied by (3), which finalizes the creation of the work of art P_i.

Consider a specific example of how the formula is used. I shall demonstrate that Susanne Langer's proposed definition of art does not define art. This I will do by making a piece (of art) which will be called »P-One,« and which will both (a) be an artwork and (b) not conform to Langer's definition. I begin with Langer's definition: art is significant form, by which she means form isomorphic to human feeling.[2] Now, according to this definition, the number one seems not to be artwork since it has no form isomorphic to human feeling. So I specify my piece, »P-One,« to be the number one. It is an artwork which is not judged to be an artwork by Langer's definition. Reservations about whether »P-One« is indeed a work of art will be addressed shortly.

As if to assure ourselves that the counter-example to the definition, D_i, is not just an anomaly, the formula may be used to construct a matrix of pieces, P_{ij}, where »i« indexes the definition and »j« the number of times the formula has been applied to the definition. Then we've got indefinitely many counter-examples to indefinitely many definitions of art. There could even be indefinitely many matrices, if one is so inclined. The matrix could be »performed,« each performance yielding a different array of artworks.

[2] See S. Langer FEELING AND FORM, N.Y. 1953.

The only circumstance under which this argument against definition fails is where no examples of non-art can be found, i. e. where D_i defines everything, including the null set, to be art.

3. Many questions arise. It might be useful to point out the relative unimportance of some misgivings. The fact that we have a formula and not actual pieces need create no special problems. The pieces could be executed (or whatever the word should be — created, specified, made, . . .) and stand witness against the definitions. I do not pretend to know in general what it would take for such pieces to be executed succesfully, but I suspect that if they were done by a recognized artist, for example, only those who balk at this kind of art in general would feel they were being served tripe for art. (The rest of us know that tripe can be art too.) One cannot describe generally what would have to happen before the items in the matrix became actual artworks, but I can suggest several specific methods of execution which have been used by artists and which would undoubtedly meet with success in creating artworks. One method would be to publish the pieces somewhere (in the classified section of a newspaper, in an art journal, in a book, . . .). One could explain the pieces, specify the definitions, and list the examples of non-art which constitute the P_{ij}, the elements of the matrix. Another method would be to convince the director of a gallery to allow space and time for the documentation of the pieces. Pictures or descriptions of each piece could be mounted on the gallery walls, along with an explanation of the project. The fact that the artworks would have to be supported by some linguistic act does not distinguish them from a great deal of recent art.[3] Either of these two methods, I claim, would be sufficient to establish the proposed pieces as actual works of art, because these methods have already been employed successfully by artists.[4] I could even go so far as to execute a matrix of pieces in this paper, but I won't go that far. What it would take to make such a matrix an artistic success, or even noticed, I will not attempt to say. Such things are difficult to explain even for traditional art.

4. Next a somewhat harder question whose answer has already been suggested. Are the pieces so proposed *really* art? The only response I can muster is that they certainly are, or could be when executed, if much of what currently passes as art is art indeed. I am thinking, for example, of a piece by Robert Barry: »All the things I know but of which I am not at the moment thinking — 1:36 P. M.; 15 June 1969, New York.«[5]

[3] Cf. H. Rosenberg »Art and Words«, THE DE-DEFINITION OF ART, N.Y. 1972.

[4] See, e. g., L. Lippard SIX YEARS: THE DEMATERIALIZATION OF THE ART OBJECT FROM 1966 TO 1972, N.Y. 1973.

[5] Ibid.: 112. Lippard's book contains numerous examples, similar to this one, where an artist »creates« a work simply by specifying some entity as his piece.

If this and similar »Conceptual« pieces are art, there is no reason why the proposed counter-definition pieces cannot be art. The only potential impediment is that they are created with an ulterior philosophical motive. But it would be simple enough to imagine them occurring in a more artistic context and serving a more artistic purpose, insofar as artistic and philosophical aims can be distinguished.

The only question left concerning the artistic status of the pieces in the matrix is whether Conceptual pieces such as Barry's are art. And I don't know what to say except that they are made (created, realized, or whatever) by people considered artists, they are treated by critics as art, they are talked about in books and journals having to do with art, they are exhibited in or otherwise connected with art galleries, and so on. Conceptual art, like all art, is situated within a cultural tradition out of which it has developed. Transitions from one kind of art to another are sometimes smooth and sometimes rough. But conceptual art, like any other radical development in art, has not simply appeared out of nowhere. It is within a long artistic tradition that this type of art has been accepted as art. The same critics who write about Picasso and Manet write about Duchamp and Barry. The same journals that publish articles about Abstract Expressionism publish articles about Conceptualism. The same people who made Pollock's drips and splashes objects of derision scoff at Barry's acts of specification.

It does not appear that one can deny the proposed pieces P_{ij} the status of art unless a convincing argument is offered discounting the *prima facie* evidence for accepting Conceptual art as art. No such argument has been forthcoming. When we philosophize about art we initially decide what to talk about by looking to artists, critics, and audiences, just as in the philosophy of science we initially decide what to study by looking to scientists, or in the philosophy of law we determine what to study by examining the actual practice of law. Needless to say, we can reserve the right to reject some purported art or science or law at a later time, but rarely find the need to exercise this right.

II. 1. So art cannot be defined. This conclusion is nothing new, I hear you cry. There is a familiar and much touted argument against the definability of art. Presuming to follow in the footsteps of Wittgenstein, Morris Weitz asserts that those things we call »art,« like those things we call »games,« do not exhibit some set of common properties by virtue of which they are called art (or games), but rather share a complicated network of »family resemblances« which ties them together under the single concept. 'Art' according to Weitz, is an »open concept«

A concept is open if its conditions of application are emendable and

corrigible; i. e., if a situation or case can be imagined or secured which would call for some sort of DECISION on our part to extend the use of the concept to cover this, or to close the concept and invent a new one to deal with the new case and its new property. If necessary and sufficient conditions for the application of a concept can be stated, the concept is a closed one.[6]

Weitz argues that 'art' does not fall into the latter category:

»Art,« ... is an open concept. New conditions (cases) have constantly arisen and will undoubtedly constantly arise; new art forms, new movements will emerge, which will demand decisions on the part of those interested, usually professional critics, as to whether the concept should be extended or not.[7]

In the first place, Weitz's claim turns out to say surprisingly little since he believes only the concepts of logic and mathematics are closed. The indefinability of art is the indefinability of almost every concept we use. By contrast, the indefinability argued above is unique to the concept 'art.' To appreciate this fact, it will be useful to explore several shortcomings in Weitz's account.

2. In the world of art, we are told, just as in the world of games, there are continually new items presented to us which are like old art or old games in some respects, but unlike them in others, so that we need decide whether to include them within the concept — whether to »extend« the concept.[8] I think this makes the situation with respect to art look far too tidy. It fails to capture the unique way in which art is indefinable. The concept 'art' is not just open, along with most other concepts; it is radically open, radically indefinable.

To see what I mean by calling art a »radically open« concept, consider what effect the anti-definition argument has on Weitz's portrayal of 'art' as a family resemblance concept. Alluding to Wittgenstein's development of the notion of family resemblances in discussing the concept 'game' Weitz says

The problem of the nature of art is like that of the nature of games, at least in these respects: If we actually look and see what it is that we call »art,« we will also find no common properties — only strands of similarities. Knowing what art is not apprehending some manifest or latent essence but being able to recognize, describe, and explain those things we call »art« in virtue of these similarities.[9]

[6] M. Weitz »The Role of Theory in Aethetics«, rep. in F. J. Coleman (ed) CONTEMPORARY STUDIES IN AESTHETICS, N.Y. 1968: 89. My reservations about Weitz's use of Wittgenstein are explained in WITTGENSTEIN'S LANGUAGE, The Hague 1973.

[7] Weitz, ibid.: 90.

[8] If the concept were genuinely »open«, why do we need to »extend« it? Also, is Weitz's description of the situation accurate? Do we hold a hearing? Do critics actually have to decide whether to extend the concept? Perhaps a concept without necessary and sufficient conditions could still fail to be »open« because we don't need to decide to extend the concept.

[9] Weitz, op. cit.: 89.

In other words, art is a family; no one property adheres to all art objects; they are related through a network of similarities or family resemblances.

The anti-definition argument defeats the family resemblance account of art as perfunctorily as it defeats a definition proposing necessary and sufficient conditions. Presumably the family resemblances structuring the concept of art act in some way to discriminate clear cases of non-art: some entities will conspicuously fail to be members of the art family. Suppose one of these entities is E_i. My piece will be E_i. Q.E.D. Family resemblances have no more power than necessary conditions to distinguish art from what is not. The artist in the house has license to lodge any vagabond or renegade he takes a liking to. This is because properties of objects are fundamentally irrelevant to art status, a point which might be made by saying that arthood is a relation, not a property. To be an artwork is not to share by identity or consanguinity properties which delineate 'art,' but to be catalogued as an artwork, a piece. The family resemblance approach to art falters at the same step which brings down definitions: both make the fundamental error of aesthetics, which is to suppose that arthood is a function of (aesthetic) properties of objects. Family resemblances are at best a heuristic for discerning arthood.

3. Compare art with games. Weitz would say that cases arise in which we find ourselves having to make a decision about whether the concept 'game' ought to cover new and different items. He says the same about art: »New conditions (cases) have constantly arisen and will undoubtly constantly arise.« This is probably an accurate description of the status of the concept 'game' but the function of Weitz's »undoubtedly« is far too weak for 'art.' What makes art different is that cases do not simply *arise* which force us to shuffle about trying to update our system of concepts. The artist is free consciously to create a work — an *artwork* — which calls into question or flagrantly violates some salient feature of the concept 'art' as it stood prior to the creation of the work. If art can be conceptual, the concept 'art' is grist for its mill. The history of recent art is the pyrotechnic pageant of one after another familiar feature of art being purposely called into question and deleted or exalted in the creation of works of art. The radical openess of the concept 'art' is the artist's freedom to discuss and challenge the concept itself in his artworks.

Whether a strange new activity should be included under the concept 'game' is probably decided, as Weitz says, by comparing it with what currently falls under the concept and searching for relevant similarities, or family resemblances. Not so with art. One reason for art's imperviousness has already been noted: similarities among objects are at best a tenuous guide to arthood. A reproduction of the *Mona Lisa* looks more like »art« than Duchamp's urinal, but the former is not an artwork, while

the latter is. Here is where any aesthetic approach to art founders. Aesthetics is a study of aesthetic qualities, and aesthetic qualities are neither a necessary nor a sufficient condition of arthood. Aesthetic qualities can be ascertained in things which are not works of art. They underlie the pursuit of Beauty in both art and nature, and hence establish no guarantee of the presence of arthood. They are not sufficient proof of art status. Neither are they necessary, as Duchamp has demonstrated with the Readymade. When he removed an ordinary snow shovel from the hardware store and titled it »In Advance of the Broken Arm,« no aesthetic qualities were changed. The work of art and the work of industry preceding it have identical aesthetic qualities which have nothing to do with the emergence of art. Furthermore, some works of art, such as the Barry piece mentioned above, lack aesthetic qualities altogether because they fall outside the category of things which *can* have aesthetic qualities.

Weitz's family resemblance account of art is also flawed by its emphasis upon decision. By the time an artist proffers something as an artwork, the decision about its art status has already been made. The artist says »Here is an artwork,« not »Here is something bizarre; tell me if it's art.« Sometimes a type of decision is called for; witness the brown spiral notebook. Yet the reason it is hard to say whether the notebook is a work of art is that it is unclear what the intentions of its author(s) were regarding art status, making it difficult for us to »read« the piece. Ultimately the power to decide about arthood rarely rests with the audience. The concept 'art' changes because it is changed by artists, and not by professional critics as Weitz would have it. Although not without power, critics are frequently just as overwhelmed by the onslaught of art as the rest of us. It is not as though we find the meticulous need to fit our concepts to intriguing and original data which keep surfacing.

It might now appear as though the responsibility for arthood has devolved upon the artist *qua* artist, but anyone can be an artist, even in his spare time. What is crucial is the act of specifying a piece, and the artist is simply the specifier. Success at specifying is not a question of whether you're an artist, but rather of whether you know and can use existing specifying conventions, or else can establish new ones.

4. The radical openness of the concept 'art' made possible the argument against definability presented in Part I. No similar argument could be constructed to prove the indefinability of 'game.' There is nothing about games, nothing about making up and playing games, which demands that the concept be open. The concept 'game' could be applied to a more restricted set of things and defined with necessary and sufficient conditions without thereby seriously affecting our ability to do what we now do with the concept. A slight change in bound-

aries and the invention of a few new terms would be necessary. The only reason the concept is open is that it takes in too wide a variety of things in order for there to be a single feature found in them all. This is undoubtedly true of art too, but it does not tell us anything about the unique indefinability of 'art.' What makes 'art' different is that it is centrally involved with the creation of new instances of the concept, while it is possible that no new games be invented in the future without seriously harming the concept 'game.' In other words, unlike 'game,' there is something about 'art' which makes it *really* an open concept. This is what I am calling radical openess. It is not a matter of the concept taking in too wide a range of things for necessary and sufficient conditions to be produced, but rather a matter of the concept including the feature that what falls under it has the freedom to question and expand it without prior permission from the prelate of concepts. Art determines what art is and we must see where it goes. Art, like philosophy, has the ability to be self-referential and self-critical, though the artist has an even freer hand than the philosopher in using his power.[10] If a DeKooning can be art, so can an erased DeKooning. And if an artist presented a De-Kooning painting as an »unerased DeKooning,« the piece would be different from the painting »unerased« to make the work. This underscores the elusiveness of 'art.' Artists are not bound by definitions of art. They have the license to violate them if only they have the ingenuity. Extending and changing the concept 'art' is the business of art today, and not merely the by-product of the creative genius of a few people.

5. Weitz worries that defining art (i. e. closing the concept) will stifle creativity. I think he has it reversed. Creativity stifles definition. And family resemblances as well.

III. 1. There is a purported definition of art which seems to escape the clutches of the anti-definition argument given above. I am thinking of George Dickie's »Institutional Definition,« which goes as follows:

A work of art ... is (1) an artifact (2) a set of aspects of which has had conferred upon it the status of candidate for appreciation by some persons acting on behalf of a certain social institution (the artworld).[11]

Donald Judd has said, »if someone calls it art, it's art,«[12] and

[10] C. Greenberg characterizes »Modernist« painting in terms of self-criticism«. See his »Modernist Painting«, rep. in G. Battcock THE NEW ART, N.Y. 1966: 100-110. Perhaps it is this self-scrutiny which makes 'art' an »essentially contested concept«. See W. B. Gallie »Essentially Contested Concepts«, PROC ARIS SOC 56 (1955-56).

[11] G. Dickie »What is Art?«, above: 23.

[12] See J. Kosuth »Art After Philosophy«, rep. in U. Meyer CONCEPTUAL ART, N.Y. 1972: 155-170.

with this idea Dickie circumvents the logic of the anti-definition argument by characterizing art in terms of what seems to be the act required to transform the examples of non-art into art. In producing the matrix of pieces, something without art status is granted that status, thereby awarding it the essential feature of art for the Institutional Definition. Any definition relevantly similar to Dickie's is not defeated by the matrix of counter-definition pieces. However, the most crucial part of the Institutional Definition, the notion of status-conferral, proves inadequate. But first let us see why status-conferral is the most crucial part of the Definition.

2. The artifactuality requirement is probably the most suspicious part of Dickie's definition. Consider the construction of the counter-definition matrix. Suppose a definer proposes as non-art the Black Forest and his grandmother's arthritis. Each of these things is transformed into art by the formula. According to Dickie, each becomes an artifact in the process. Henceforth we count the Black Forest and the definer's grandmother's arthritis as artifacts. Cristo could make an artifact by wrapping the Black Forest, but is christening enough? We could imagine the perplexed tourist standing before Yosemite Falls wondering whether he is feasting upon the wonders of nature or artifice — wondering not whether the Falls works by a hidden man-made mechanism, but simply whether some artist has made it into his piece yet. But then what happens to the concept of artifactuality? It becomes useless, and to no apparent purpose outside securing a place for an artifactuality requirement in a definition.

3. The next feature of the Institutional Definition which may give us cause to wonder is the concept of candidacy for appreciation. Dickie explains the meaning of the term »appreciation« as follows: »In experiencing the qualities of a thing one finds them worthy or valuable.«[13] Most art requests our »appreciation.« Yet must this »appreciation« be oriented toward the experience of valuable qualities? The experience of boredom while watching one of Andy Warhol's early films may be valuable in the absence of any experienced qualities which are found to be valuable. And then again, maybe the boredom lacks value altogether. There may be nothing of value in the *experience of qualities* of *Chelsea Girls* without the film thereby lacking both interest and importance as a work of art. In other words, an artist need not show his art with the implicit hope that someone will appreciate valuable qualities lodged in it. An artwork need not even be a *candidate* for appreciation, in Dickie's sense. If an artist has contempt for his audience and purposely tries to create art which frustrates attempts to ex-

[13] Dickie, above: 27. For some relevant criticism of Dickie's position on this and other points, see T. Cohen »The Possibility of Art«, PHIL REV 82 (1973): 69-82.

perience valuable qualities, he may be immoral, but his ability to create art is unaffected.

Because of its initial orientation toward perception, aesthetics assumes that a certain kind of experience is essential to art. But can we *experience* the knowledge making up Robert Barry's piece? — how could we experience what he knows but is not thinking about at a particular moment? Do we need to experience any of the counter-definition pieces in order for them to be approached properly as works of art? I think not. Some experience is required in order to find out what the pieces are; but for a great deal of contemporary art experience is but a mode of access to the art, much as the experience of reading a calculus book is a mode of access to the mathematics. This non-experiential facet of art has been especially prominent since Duchamp. Whether the experience of the art is discomforting or pleasurable matters only secondarily, as it does in mathematics. If we grant that thinking is a kind of experience, then perhaps experience is essential to all art, just as it is to all mathematics. This would be an admission of the failure of aesthetics to cope with art, however, since such experience is not an ingredient in the art, but merely a handle on it.

4. Having the status of candidate for appreciation does not appear to be a necessary condition for being a work of art. Neither is it sufficient, even if joined with the artifactuality stipulation. A brief biography of an artist mounted on the gallery wall beside his works is 1) an artifact 2) a set of aspects of which has had conferred upon it the status of candidate for appreciation by some person or persons acting on behalf of the artworld. The director of the gallery is acting in his or her official capacity as a member of the artworld in »exhibiting« the biographical sketch to be appreciated by visitors to the gallery. We appreciate knowing something about the person who made the art. But the biographical note is not a work of art. It is not indexed as a work of art, but rather as an item of interest.

Consider also the brown spiral notebook. There is a sense in which, here too, someone has acted on behalf of the artworld to confer the status of candidate for appreciation. But that doesn't settle the issue of arthood. We still have to ask, as we do of the biography, Is the thing intended for »artistic consumption?« A biography hung on a gallery wall as a piece by a conceptual artist is a »candidate for appreciation« perhaps, but it is also an artwork. What makes the difference between the artistic biography and the non-artistic one? What is the difference between treating the brown spiral as art and treating it as nothing but a joke or an insult?

One way out of the problem would be to introduce a distinction between artistic appreciation and other kinds of appreciation. As suggested already, this would be an arduous, if possible, chore since no obvious distinction volunteers itself.

There is no conspicuous type of »appreciation« common to the *Mona Lisa*, Duchamp's *Fountain*, and Barry's piece, but absent from all non-art. Traditionally, a uniquely *aesthetic* (perceptual) appreciation was thought to mark the difference. Dickie denies that a special aesthetic experience exists.[14] I am inclined to say that even if it does exist, it is not something which pertains only to art objects. Here we confront the old problem of separating aesthetic experiences of nature from aesthetic experiences of art. The impediment to discovering any difference is that aesthetics is fundamentally about the perception of aesthetic qualities, not about art, and hence is not equipped with resources for characterizing specifically artistic endeavors.

5. What is left of the Institutional Definition once we exercise reference to artifactuality and appreciation?:

A work of art is something upon which some person or persons acting on behalf of a certain social institution (the artworld) has conferred the status of work of art.

As it stands now, this refined form of the Definition is circular: an artwork is something granted the status of artwork. Dickie recognizes that his definition is circular, but argues that it is not viciously circular since the circle is mediated by his discussion of »the historical, organizational, and functional intricacies of the artworld.«[15] The circle is indeed informative since it displays the material vacuity of the indexical concept 'artwork.' To be an artwork is like being thought about by someone; artworks share no common properties or even a network of similarities, but only a »place« in the artworld. The question we must return to now is whether Dickie's notion of status conferral accurately designates how something achieves a place in the index of artworks.

6. In making the pieces P_{ij}, I do not engage in an explicit act of conferral; rather I avail myself of a versatile convention for making artworks which is widely countenanced by artists today. This convention might be termed the »Specification Rubric,« and its general form is »I hereby specify the piece (I am now making) to be _____,« where the blank can be filled in by a specification of anything whatever as the piece. Methods of specification are varied, but they all are used to »create« and identify specific pieces. The Rubric established a piece-making or piece-specifying convention, and not a status-conferring convention. The difference can be seen in the number of distinct actions required to achieve conferral and specification. A conferral happens in two stages. First, the item on which status is going to be conferred needs to be specified, then the actual conferral of status can take place. When art is created, however, a single act of specification appears suf-

[14] Ibid., passim. [15] Ibid.: 28.

102

ficient for »imparting arthood.« I hesitate at using the word »impart,« because the kind of specification involved in making art differs from that preceding the act of conferral. Status conferral commences with the identification of a thing which does not yet have the status it will be given when the conferral takes place. For art, on the other hand, the specification does not usually isolate something which *will be granted arthood;* rather the specification isolates *the piece.* Art status is gratuitous. The question »What is the piece?« and, once the piece is discerned, the question »So what?« totally eclipses the question »Is it art (yet)?«

Artworks are created, not by christening things to be art, but rather by specifying pieces. Arthood is not a property something can have without its being *a piece, an* artwork. One can make a piece without explicit conferral, but one cannot confer art status without explicitly making (specifying) a piece. Endowing something with a status is not enough; one must create by bringing a new piece into existence. The artist does not »make this X into an artwork,« he »makes (creates) this artwork Y,« where »Y« tells what the piece is.

The weakness of the conferral model for arthood is shown in the way it singles out artworks extensionally. Consider Dickie's analogues for art-status conferral:

My thesis is that, in a way analogous to the way in which a person is certified as qualified for office, or two persons acquire the status of common law marriage within a legal system, or a person is elected president of the Rotary, or a person acquires the status of wise man within a community, so an artifact can acquire the status of candidate for appreciation within the social system called »the artworld.«[16]

In all of Dickie's examples, the conferral of status occurs within an extensional context. If Harry Haller is certified or elected, and if Harry Haller happens to be the loneliest man in the country, then it is true that the loneliest man in the country is certified or elected. Artworks, on the other hand, need to be designated intensionally. To see why, suppose that at 1:36 P.M. on the 15th of June, 1969, Robert Barry was not thinking about anything he knows. Then the following two declarations made by Barry will be equivalent:

(1) I hereby confer art status on everything I know but am not at the moment thinking — 1: 36 P.M., 15 June 1969, New York.
(2) I hereby confer art status on everything I know.

If Barry was, for example, daydreaming at the specified moment, (1) and (2) should establish the art status of the same entity and one merely duplicate the other. However, (2) cannot be used by Barry to create the piece discussed earlier. This is because »Everything I know but am not at the moment thinking . . .« and »Everything I know« specify two different *pieces.*

[16] Above: 25.

The former piece contains reference to a specific moment in time, while the latter does not, and this could be a major artistic difference.

Moreover, two (or more) different pieces can be housed in the same extensional entity. Duchamp painted »The King and Queen Surrounded by Swift Nudes« on the back of a canvas on which he had already painted »Paradise.«[17] One artifact, two artworks. A conferral of status is not refined enough to take notice of the difference. This point could be taken a step further. Suppose Andy Warhol makes a piece he specifies to be »All the things Robert Barry knows but was not thinking about at 1:36 P.M., 15 June 1969.« If arthood is a matter of conferral, Warhol cannot make his piece since Barry has preempted him. But Warhol can make his piece and it is different from Barry's. For one thing, it is Warhol's, not Barry's. For another, the two pieces were created at different times. Most important, the two works of art can hardly avoid having entirely different meanings. The interpretation of one will be read in the context of Barry's *oeuvre,* the interpretation of the other in the context of Warhol's.[18]

Dickie might attempt to take account of these problematic cases with appropriate reference to the »set of aspects« mentioned in his definition. The role of this set of aspects is somewhat unclear in Dickie's argument. He says in his definition that the set of aspects has conferred on it the status of candidate for appreciation, but he frequently speaks as though it is the artifact itself which receives the conferral, as he does in the last passage quoted. Moreover, he seems to use »conferral of arthood« and »conferral of status of candidate for appreciation« interchangeably. In any event, Dickie would presumably try to differentiate the Warhol piece from the extensionally equivalent Barry piece by saying that different *sets of aspects* of the same entity (All the things Barry knows...) receive a conferred status, thereby allowing two works to have a common basis. The weakness of this gambit is that it would tend to violate Dickie's model of status-conferral. The sets of aspects singled out to differentiate the two artworks would have to refer in some way to the particular circumstances of the purported »status-conferral.« In other words, the aspects which separate the Warhol and the Barry works are determined in part by the fact that one was done by Barry and the other by Warhol. This means that *what* receives the conferred status would be identified through details of the individual acts of conferral. And then it begins to look as though we don't

[17] See MARCEL DUCHAMP, catalogue for the show organized by the Philadelphia Museum of Art and the Modern Museum of Art (1973): 248. It is interesting that the »paintings« are upside down with respect to each other, so that not both can be shown properly at the same time.

[18] A. Danto gives a similar example in »The Artworld«, above: 15f.

have a genuine conferral of status, but something else. Dickie's examples of conferral all forbid this type of peculiarity. At one point he likens art-making to christening. What or who is christened in no way depends upon the particulars of the christening act itself — upon whether, for example, the individual is christened by one person or another, or whether he is christened at one time or another. Moreover, once christened is enough. Persons are christened, not aspects of persons; a person cannot be christened again under some other aspect unless a different status is conferred. Christening has an extensional logic. In response to »Who was christened?,« any reply extensionally equivalent to a true response will fit. This is not true of questions such as, »What is the artwork?« or »What became an artwork?« Dickie's failure to note this distinction makes his theory incapable of explaining an important difference

Some may find it strange that in the nonart cases discussed, there are ways in which the conferring can go wrong, while that does not appear to be true in art. For example, an indictment might be improperly drawn up and the person charged would not actually be indicted, but nothing parallel seems possible in the case of art. This fact just reflects the differences between the artworld and legal institutions: the legal system deals with matters of grave personal consequences and its procedures must reflect this; the artworld deals with important matters also but they are of a different sort entirely. The artworld does not require rigid procedures; it admits and even encourages frivolity and caprice without losing serious purpose.[19]

But once the difference between status-conferral and piece-specification are clarified, the laxity of artworld conventions has a simple explanation. Status-conferral is a *changing* convention, piece-specification is a *creating* convention. The point of status-conferral is to award a new status to an antecedently identified entity. Thus the conventions of status-conferral articulate rules to be followed in order to affix the new status to the old entity. If the rules are not followed, the status does not adhere. The purpose of piece-specifying, on the other hand, is to create new entities — new pieces — which need not be isolated and identified prior to their becoming pieces. The conventions of specifying are simply the recognized means of identifying pieces. The reason piece-specifying cannot fail in the way status-conferring can is that once the piece is specified with the appropriate means of specification, it is a piece; but status-conferring requires something beyond specification— a procedure for conferring the status on the antecedently identified (specified) entity. This mechanism of conferral can malfunction. No corresponding fallible procedure is a component of piece-specification.

The Specification Rubric reflects the intensionality of artistic creation by formulating a model for piece-making in-

[19] Dickie, above: 31f.

stead of status-conferring. The following two declarations are not equivalent

(3) I hereby specify my piece to be everything I know but am not at the moment thinking — 1:36 P.M., 15 June 1969.
(4) I hereby specify my piece to be everything I know.

From the fact that someone has created the piece specified in (3), it does not follow that the piece specified in (4) is also a work of art, even if the two are extensionally the same. It may be true of Barry's piece that it is everything he knows, but this cannot be said to be the piece.

A piece usually has an author, an individual denoted by the »I« in (3) and (4). However, the »I« in (1) and (2) simply refers to a role; it makes no difference who confers status if the point is status conferral. Unless we are willing to give up the concept of an author as a person whose intentions are relevant to what we understand the piece to be, something other than status conferral must serve as a model for artistic creation.

To make a work of art is not to christen something art, but to index it under »art pieces.« To do that is to specify a piece within an artistic indexing convention. Indexes list their items intensionally, and artistic indexing conventions provide means for intensionally specifying pieces. These conventions have existed at least since the Renaissance, when our current conception of 'art' was born. When Leonardo took up palette and brush, he did not first make a painting and then christen it art if he liked it. The mere fact that he used the artistic convention of painting on canvas assured that what he specified as the piece would be art. With this convention, the piece is specified when Leonardo stops painting and says »that's it« (as opposed to stopping painting and throwing the thing out or setting it aside for completion at a later time). The history of art since the Renaissance, and especially since Duchamp, has been gradual liberalization of the conventions for piece-specification, until artists embraced the idea that it is nothing other than specification, by whatever means, which assures arthood. This realization freed art of aesthetics by making it unnecessary to specify a piece using aesthetic qualities. Any means of (intensional) specification will work.

The reason Dickie highlights conferral is probably that he has in mind the Readymade as a schematic model of the achievement of arthood, since it seems to strip artistic creation bare of all superfluities. However, it is as *a piece* that any Readymade bears artistic interest, and it is in becoming a piece that any Readymade becomes art. What makes it appear that Duchamp conferred art status on the Readymades is the way they conspicuously reject the aesthetic principle that dictates the coincidence of arthood and created aesthetic qualities. They do this by passing unaltered through the portals of art. But it is not status conferral that makes them art. Their dramatic en-

trance into the gallery is utilized not to make art, but rather to make a point. And that point is that piece-making is an act of specification within indexing conventions. The Readymade is the point in the history of art where the Specification Rubric was openly espoused. The reason status-conferral seems to take place is that the Rubric was supported with an implicit declaration »This is art too.« But this declaration did not make the Readymades art, it simply called attention to the fact that they are works of art by being specified as pieces. It asserted the validity of the Rubric. Duchamp bypassed the indexing conventions superimposed on art by aesthetics. These conventions are, in effect, the media of art which connect physical materials and aesthetic qualities. Duchamp demonstrated that an artist's intention need not be imprisoned in the aesthetic qualities of a medium and that a simple piece-specification convention is sufficient for artistic creation. He didn't confer art status on anything; he avowed new conventions.

7. Dickie's definition, though not explicitly defeated by the matrix of pieces, is implicitly countered by the means of creation employed. If I had conferred status in making »P-One«, it would automatically be true that »5/5« is a work of art. But since I specified a piece, »5/5« is not the artwork I created. A work of art is a piece specified within artistic indexing conventions. This is not a definition of »work of art,« however. It is a description of the current state of artistic institutions. A priori limits cannot be set for creativity, especially when the materials of creation are the concepts and conventions of art itself.

The Institutional Definition of art, which first appeared as a way of getting around the indefinability of art, turns out to be a disappointment, especially for the decider hoping to relieve his uncertainty about the brown spiral notebook. Yet it does highlight important features of the concept 'artwork.' As Arthur Danto says, »To see something as art requires something the eye cannot de[s]cry — an atmosphere of artistic theory, a konwledge of the history of art: an artworld.«[20] This is why, when searching for support in counting Barry's piece as an artwork, I appealed to how it is treated within certain artistic institutions. And this is why I first turned to artistic conventions in trying to evaluate the status of the brown notebook. If I had found a tag stating its title and naming the artist, its role as a member of the show and as an artwork would have been secured. Part of the trouble we have in deciding whether it is art is that there are no clear conventions governing renegades.

1. »Is it art?«
2. So far I have more or less acquiesced in the longstand-

[20] Danto: 16.

ing tradition of aesthetics which accepts the identity of the question »Is it art?« and the question »Is it a work of art?« This crucial presupposition of aesthetic theory has motivated the activity of deciding about the arthood of objects, and it has endowed with meaning the fruitless search for a definition of art construed as a definition of 'work of art.' Now we face the limits of the viability of identifying art with its works. What is at issue is not simply the definition of art, but the validity of aesthetics.

2. In 1735, in the hands of Alexander Gottlieb Baumgarten, aesthetics was christened »the science of perception.« His point was to contrast the aesthetic with the cognitive, perception with knowledge. Since then, »aesthetic« has become almost a synonym for »philosophy of art« and the philosophy of art has become handmaiden to aesthetics. The focal point for philosophy of art under the rule of aesthetics is the perceptual object (or at least the experienced aesthetic object, since literature is not percieved). Accordingly, the work of art (the object experienced) is exalted and philosophy of art centers its investigation on the concept 'work of art,' as if to find out what a work of art is is to find out what art is.

This is the aesthetic assumption deserving exposure: That the essential core of that aspect of culture called »art« exists in works of art so that an answer to the question »What is art?« will describe (or define) a set of entities called artworks. In almost every recent philosophical discussion where the question is raised, we find »What is art?« modulated immediately and without justification into »What is a work of art?«[21] But justification must be given; to allow the shift is to assume that to describe art is to describe a set of items instead of a cultural activity. For aesthetics, the concentration on artworks may not be an impediment since aesthetics studies perception primarily and art secondarily. Aesthetics investigates the perception of aesthetic qualities, and these qualities are neither inherent in nor exclusive to art. Some artworks have no aesthetic qualities, or at least possess them only incidentally. Aesthetic qualities can be found in Duchamp's *Fountain*, but they are incidental to the work of art, as they are to all the counter-definition pieces. Furthermore, aesthetic qualities proliferate in nature, which is why the traditional aesthetic examination of beauty was not confined to art.

3. Philosophy of art must leave aesthetics in order to cope with art which is not fundamentally aesthetic, i. e. which does not choose to create with aesthetic qualities. But even for aesthetic art, artworks are not instances of the concept 'art.' Aes-

[21] This is so common that it hardly needs documentation, even though the shift is usually overlooked. Dickie does it. Weitz does it. R. Wollheim begins his ART AND ITS OBJECTS, N.Y. 1968, this way: »'What is art?' 'Art is the sum or totality of works of art'.«

thetics does not suffer under this assumption because its basic interest lies in aesthetic qualities, and neither in art nor artworks. The reason the artwork becomes salient in aesthetics is that it is conceived to be bearer of aesthetic qualities.

In examining the project of defining art, we have discovered that the two concepts are radically different. Art is a cultural activity like philosophy or mathematics; the concept 'artwork' does not single out a general type of activity or practice, but rather serves to mark off a class of entities. One aspect of art (as an activity) is the production, or if you will, the indexing, of works of art; but artworks are not the sum and substance of art. The concept 'artwork' is subordinate to the concept 'art' since artworks have nothing in common except being granted a certain position through the activity art.

There is a difference between art and artworks, just as there is a difference between philosophy and philosophy books. To study art is usually to study artworks, just as to study Kant's philosophy is usually to study the books he wrote. But philosophy is not defined by telling you how to find the philosophy books in the library or the philosophy lectures in the university. Likewise, art is not defined by explaining membership in the class of artworks.

Now should we try to define 'art' as an activity? Would such a definition be any more interesting or useful than it is in philosophy? It would not produce criteria for deciding about works of art.

4. How important is it to decide about artworks? Gallery owners decide what they want to show, to buy and sell. Art lovers decide what they want to own, what they want to live with. Critics decide what they will and will not discuss. The audience decides what to look at and what to look at again. Artists decide as they will.

5. Once I find out whether the notebook is part of the show, once I find out how it stands with respect to things which are and are not part of the show, what more do I want? Is the notebook art? Is the notebook a work of art?

6. By its works we shall know art. If art is its works there is nothing to know but works. There is more to know than works.

7. Two things can differ in nothing but the presence of arthood. For those who feel uneasy about the lack of any criteria for deciding about art, the following solace is offered: I hereby create a prodigious class of pieces by specifying everything to be art, (x) (x is specified as a piece). What have I done? Vanquished the disorder? No more effort expended keeping track of which pieces of the universe are art and which are not, an especially acute problem when »calling it art« makes it so?

Hubert G. Alexander

On Defining in Aesthetics

From a casual survey of recent writings on aesthetics, one might conclude that the major task (and the major difficulty) lies in the possibility of formulating adequate definitions of such key terms as *work of art, aesthetic object, aesthetic experience,* etc. Much of the distrust of defining appears to date from Wittgenstein's *Philosophical Investigations* with its rediscovery that many common philosophical terms have no clearcut or readily discoverable set of common »essential« traits, but that very often the members of the class of instances designated by a single term have only overlapping »family resemblances.« Applying this notion to aesthetics, both Kennick[1] and Weitz[2] encouraged the belief that the attempt to formulate definitions of the key terms in aesthetics is futile and foolish.

The terms used by aestheticians may be more than commonly vague and difficult to pin down to the satisfaction of the majority of those concerned with these matters, but there is good reason to believe that Kennick and Weitz carried their campaign against definitions too far. Under these circumstances, perhaps a few remarks about defining in general will serve to reorient our thinking about what to expect and what not to expect from a definition.

Can it be that our Western tradition, stemming from Platonism, got off on the wrong foot by expecting too much? The Platonic belief in the reality of ideal entities, which can be understood at least approximately through the techniques of definition, can readily lead to the notion that defining is the best way to come to grips with the real nature of things. Correct definitions on this assumption could be taken as »real« or »true« definitions. On the other hand, it was early realized that definitions are nothing more than an effort to equate the conventional meaning of a given term (the definiendum) with the combined meaning of certain other conventional terms (the definiens). From this point of view, definitions are simply formulae for ascribing certain meanings to conventional names, and definitions are therefore seen to be only »nominal.« A skeptical nominalism has recurrently rejected the notion that universal terms and their definitions can attest to real entities, and has stressed instead the notion that real entities are particulars.

[1] W. E. Kennick »Does Traditional Aesthetics Rest on a Mistake?«, MIND (1958): 317-34.

[2] M. Weitz »The Role of Theory in Aesthetics«, rep. in his (ed) PROBLEMS IN AESTHETICS, N.Y. 1959: 145-56.

But as Western thinkers, at least from the time of Abelard, have observed, either an extreme Platonic realism or an extreme nominalism becomes unworkable. And since definitions must attempt to name some genuine common characteristics of whatever is being defined, they do assume some kind of legitimate status for these common characteristics. If dictionaries are genuinely instructive, as they seem to be, then universals and essences would seem to be legitimate at least in some cases and to some degree.

What causes difficulties with definitions may very well be that we attempt to read some judgment about the kind of reality to be ascribed to the definiendum into the defining statement itself. Confusion on this point should have been allayed by Aristotle's insistence that definitions by themselves »make no assertion of existence or non-existence,«[3] whereas hypotheses do. Definitions do, for Aristotle, seek to lay bare the inner nature (the *to ti ên einai*) of the definiendum, even if the concept is only that of an imaginary being, but they need not assert anything about the kind of reality that might or might not be ascribed to it on ontological principles. Definitions of imaginary objects (centaurs, unicorns, perfect circles, etc.) are just as feasible and meaningful as definitions of ordinary phenomenal objects (beds, trees, human beings, etc.). However, there is no harm in applying the terms »real« and »nominal« to definitions so long as we do not refer thereby to two different kinds of definition, but only to two different possible aspects of any definition — the one having to do with the inner nature of the concept represented by the definiendum, and the other with the suitability of the terms in the definiens.

The terms which we select for a definiens have two rather distinctive functions to perform: (1) they seek to delimit the class being defined from other kinds of things, and (2) they seek to indicate those traits which are considered to be of paramount importance for that class. It may happen that the requirement for delimitation (i. e., for giving as precise necessary and sufficient conditions as possible) is not best served by naming the traits that are deemed most important, or *vice versa*. For example, Aristotle considered it important to distinguish the human animal from other animals by the trait of rationality. Our more physiologically oriented contemporaries have stressed such things as cranial capacity, double-curved spine and erect stature, etc., and those who are interested in the social aspects of man have selected traits such as cultural memory and historical sense. Now, what makes any of these traits important is that they can give clues to other traits, but it must be observed that the adequacy of any definition will depend upon the particular interests of the definer and his particular concerns. It may be that for delimitational purposes,

[3] Aristotle POSTERIOR ANALYTICS: 76b35 (Tredennick trans.).

one set of traits is as good as another; but for importance, the field of interest is the determinant factor.

When looking for delimitational traits, it may be convenient and even necessary on occasion to include such things as functions, causes, effects, or other somewhat extrinsically related items. Robinson, in his work on definitions, would have us distinguish between »analytic« definitions, which aim to analyze (or describe) the definienda intrinsically in their own inner nature, and »synthetic« definitions which depend more upon external relations, such as placing the color blue within certain limits on the color spectrum.[4] But even if we are forced for delimitational reasons to prefer extrinsic or »synthetic« characteristics, the importance of knowing inner traits should also be recognized and satisfied even at the sacrifice of precision.

One last point about definitions should be noted before returning to the problems of defining in aesthetics: viz., we should not expect a definition to be a final or self-sufficient statement, appropriate to all times and all contexts. Definitions are simply abbreviated descriptive statements which seek both to delimit and to give important characteristics so far as this can be done in few words. They are most useful in orienting our thinking toward a particular meaning, and from this point of view serve best when used as the kick-off point for further inquiry. Robinson calls our attention to what he calls »an extremely large demand« made on definition by Santayana in *The Sense of Beauty* when Santayana remarks near the outset of that work that »the definition of beauty in this sense [as just defined] will be the task of this whole book.«[5] But Santayana's remark is quite reasonable when we realize that many definitions — perhaps especially in aesthetics — may need a whole book to explicate and elaborate them.

A more recent discussion of the problem of defining in aesthetics occurs in certain efforts to respond to Weitz's generous condemnation of the practice. George Dickie, for example, essays the task of formulating a definition of »work of art.« Weitz's understandable apprehension over the possibility of discovering universally acceptable precise delimitational definitions in aesthetics had led him to the view that »to understand the role of aesthetic theory is not to conceive it as definition, logically doomed to failure, but to read it as summaries of seriously made recommendations to attend in certain ways to certain features.«[6] Dickie, on the other hand, with a good sense of the usefulness and importance of definitions, proposes a definition of »work of art,« even in the face of full recognition of the variability in artistic tastes from culture to culture and from generation to generation. To surmount this varia-

[4] R. Robinson DEFINITION, Oxford 1950: 98-106.

[5] Ibid.: 162.　　　[6] Weitz, op. cit.: 156.

bility, Dickie offers us a broad non-honorific definition by utilizing Arthur Danto's notions of »artworld« and »candidate for appreciation.«[7] An art work, Dickie says, is »an artifact upon which some person or persons acting on behalf of a certain social institution (the artworld) has conferred the status of candidate for appreciation.«[8] In this way, he gives what appear to be appropriate limits to the class of objects called »works of art,« while recognizing the changing character of the institution termed »artworld.« This »institutionally« oriented definition is a bold attempt to circumvent the high degree of variability in artistic tastes and requirements, especially in the face of the innovations of twentieth century Western art. At first glance, this approach appears to have much merit and promise.

That Dickie is primarily concerned with the delimitational requirements of the more rigorous type of definition is indicated by his concern with borderline test cases. If one wishes to test delimitational precision, borderline cases must be examined with regard to their appropriate inclusion or exclusion. The very first term, »artifact,« which Dickie uses involves a test case. Using Weitz's example of a piece of driftwood brought home and placed on the mantle for aesthetic enjoyment, we are faced with the inclusiveness or exclusiveness of the term »artifact.« If artifacts are limited to human manufacture, then the piece of driftwood should not be considered an artifact, and therefore not a work of art. But we might extend the meaning of »artifact« to include anything with which a human being has mixed his labor, and then allow the mere act of moving the driftwood to a place like the mantlepiece to be such labor. Usually, however, we mean by labor and by artifact something a bit more arduous. Perhaps a little polishing will suffice to convert the driftwood into an artifact and at least potentially a work of art.

Or shall we limit artifacts to objects of *human* manufacture? Shall we exclude chimpanzee and gorilla paintings? Dickie asks. Here the crux of the matter shifts and is curiously made to depend upon the intent of the appreciator; for if such paintings were exhibited in the Field Museum of Natural History, says Dickie, and were therefore not primarily candidates for appreciation, they would not be works of art, but if they were exhibited at the Art Institute, then they would be.[9] Thus, the quality of appreciation of the viewer becomes the determining factor, and not the question of artifactuality. Or should we extend the notion of »artifact« to cover the works of primates? However, if we look for the centrally important idea in the notion of »artifact,« rather than at the borderlines, we find that a degree of purpose and intention or premeditated design comes

[7] A. Danto »The Artworld«, above 9-20, referred to by G. Dickie AESTHETICS, Pegasus 1971: 101.

[8] Ibid. [9] Ibid.: 106, cf. above: 29.

to the fore. Such an implication needs mentioning, even if there may on occasion be thoughtless examples of human production.

We can deal similarly with the other key terms in Dickie's definition, viz., candidate, appreciation, and artworld. The term »candidate,« he tells us, is to be interpreted by analogy with candidates for a degree, or something like a christening.[10] However, we should not consider the »artworld,« which is responsible for the candidacy, as any sort of official or legal intitution, performing an officially recognized ceremony.[11] Candidate,« then is just a useful analogy or metaphor, if not pressed too hard.

»Appreciation« and »artworld« are interdependent concepts, since the appreciator is someone acting in behalf of the artworld. »Appreciation,« we are told, signifies »something like 'in experiencing the qualities of a thing one finds them worthy and valuable.'«[12] This whole concept would have been clearer, however, if Dickie had been willing to incorporate the epithet »aesthetic« in conjunction with »appreciation.« But having discredited theories of special aesthetic attitude, and regarding aesthetic qualities as vague,[13] he apparently rejects adding this term to his definition. Unfortunately there are too many non-aesthetic kinds of appreciation to omit the qualifier »aesthetic,« or else we must limit the meaning of appreciation in a more drastic way than is usual.

Moreover, the notion of an »artworld« seems to require some meaningful sense of aesthetic qualities. What is this sense, how did it emerge, and how can it be correlated with the concept of »institution«? To answer these questions let me construct a hypothesis. If we think ourselves back to the forms of more elemental and simple human communal life, our attention is immediately called to the greater involvement and interdependence of all human activities and interests. What have emerged in recent centuries as »the arts« were simply part of this complex of interrelated activities, placed most often at the service of religion and ritual, though also serving for amusement and entertainment at a less serious level. Drama and poetry, together with the song-dance-mime complex, and even the decorative and graphic forms of expression, were subservient to the ends either of religion or entertainment. In no large sense were the arts capable of being regarded as ends-in-themselves.

In human affairs, however, what starts out as a purely instrumental value tends to become an intrinsic interest. So eventually there developed a conscious concern for the aesthetic qualities of human productions and actions as a separate goal and criterion for judgment. Artists became specialists,

[10] Ibid.: 107. [11] Ibid.: 102f. [12] Ibid.: 105.
[13] Ibid., Ch 5.

and the arts themselves became differentiated more clearly, the storyteller and poet from the musician (although the ancient bard had been both), the sculptor and painter from the architect, and so on. With specialization came a new expertise in the more sophisticated forms of art. The true craftsman developed what amounted to a higher sensitivity to the special qualities of his art, and alongside these separations of interest, the critic and specialist in aesthetics also emerged.

In this sequence of development, the notion of the aesthetic finally became a concern of its own. The qualities first termed »aesthetic« when the term was applied to the science of sensuous beauty by Baumgarten in the eighteenth century had of course been admired and discussed far earlier. In fact, we can safely surmise that there has always been some awareness of a feeling for beauty, no doubt closely associated with feelings of awe and wonder and magic. In Western culture, at any rate, since Classical times, the quality of beauty became strongly associated with the arts as their appropriate goal, probably because of an admiration of humanly achieved perfections of natural beauty, as through the idealized human form in sculpture, or the harmonies and meters employed in the singing of poetic language. To the aesthetic quality of beauty, whether in nature or art, was added the sublime, and later a whole array of others, including the tragic, the comic, the characteristic, the graceful, the pretty, the picturesque, the idyllic, the novel, etc.[14] One might compare these to the aesthetic emotions of the erotic(*sringara*), the heroic (*vira*), the comic (*hashya*), the furious (*raudra*), the wonderful (*adbhuta*), the pathetic (*krauncha*), the hideous (*bibhasta*), and the fearful (*bhayankara*) in East Indian aesthetic theory.[15] Recognition and formulation of such special aesthetic qualities gives evidence of a developing consciousness of the aesthetic as such.

We may grant that the foregoing assortment of qualities is seemingly quite varied and lacking in common characteristics. Modern theories of aesthetics, however, have found some more general conditions of aesthetic appreciation which should be present for the succesful portrayal of any of these qualities. Normally, these conditions include (1) some element of sensory appeal, as in the qualities of an artistic medium itself, (2) a sufficient amount of recognizable formal organization or unity, (3) the suggestion of further or underlying significances incorporating both feelings and cognitive meanings, (4) a sense of appropriateness or harmony among the foregoing, and (5) the ability to evoke an intrinsic admiration sufficiently de-

[14] See, e. g., L. W. Flaccus THE SPIRIT AND SUBSTANCE OF ART, N.Y. 3rd ed, 1941, Pt. IV.

[15] A. K. Sarkar »Hindu Aesthetic Experience: Its Expression in Art, Personality, and Culture«, in ms.

tached from strong practical or cognitive interests.[16] Let me add the qualification that all of these conditions should be present *in some degree,* even though the degree may be quite small in certain cases. For example, a well-decorated and well-shaped vase may have strong sensory appeal, pleasing form, and a sense of appropriateness, but very little suggestion of further emotive or cognitive significance. Or a film, such as Eisenstein's »Potemkin,« may have a heavy concentration on social and moral significance, and a secondary though sufficient infusion of sensory and organizational appeal to remain aesthetically succesful.

By making use of the term »aesthetic,« have we laid ourselves open to Dickie's criticism of this concept? He rejected it not only because it was variable and vague, but more especially because he could find no grounds for any special state of aesthetic attention. I believe we can answer this latter argument rather simply; for the sense of the aesthetic need not be equated with some highly separate and distinctive kind of psychic state for which the evidence is insufficient. Quite adequately for our purposes, it can be regarded as the developed or heightened sensitivity and attentiveness to any of the aesthetic qualities mentioned above and the aesthetic conditions which underlie them.

A more telling reason for the inclusion of the notion of the »aesthetic« in Dickie's definition, however, is the fact that the concept of »artworld« is just as variable, if not more so, and seems to demand the concept of the »aesthetic« to give it a proper sense. Let us see why. First, what is an »artworld«? If wee look at it in various cultural contexts, we quickly become aware of its variability. Take ancient Greek culture, for example. Its »artworld« would include shipbuilders, stonemasons, and accomplished courtesans, as well as poets, painters, sculptors, musicians, orators, etc. These are all *technitês.* But philosophers who, like Plato, were critics and theorists of the arts would have been excluded. Certainly in Western culture today we would include the professional critics and the jurors who make selections for museums as members of the artworld along with the artists themselves. Or where would be the artworld in a primitive society? Would it be all craftsmen and all ritualistic performers taken together? If so, the entire community would be included, for everyone is envolved in some ritual.

Clearly the extent of the term »art« is involved here. We must decide how far along the direction of artistic subservience to other interests we can go in allowing for membership in the artworld. If craftsmen in general are admissable, then why not machinists and assembly line workers today? But such latitude

[16] I develop this point further in »The Paradox of the Universal in Art«, SW J PHIL 5 (1974): 49-58.

does not fit well with Dickie's meaning of the term. However, if we can discover some criterion according to which an artworld can be readily delimited, no matter how changeable the membership, then this concept can still be useful in a definition. Where can we best find such a criterion? The only one that comes readily to mind is that of a dominant aesthetic interest. If so, then the notion of »artworld« requires some notion of the aesthetic.

Futhermore, against those who would find the concept of the aesthetic too vague, there are probably better grounds for finding some uniformity here than in the case of »artworld.« The aesthetic ideal, as it developed in Classical Western culture, had a fairly clear notion of the beautiful as identified with harmony, proportion, balance, and the like. The beautiful for Plato became an ideal worthy of seeking and emulating. It became in fact a guide to morality. Thus, the admiration for the beautiful, and later the sublime, lifts the aesthetic above the ordinary humdrum of life, allowing these qualities to be regarded as superior and somewhat detached ideals to be worshiped as the highest goal of human achievement. We can find something of an analogy if we look at India. There aestheticians from the days of Bharata (5th century) to Abhinavagupta (10th century) dwelt on the eight primary aesthetic e-motions (see above), all of which were aspects of *rasa,* a kind of detached state of aesthetic bliss.[17] And in China, as early as the fifth century, there developed a tradition of the six techniques of painting which stressed above all else the search for *ch'i-yün sheng-tung,* or »tone and atmosphere fully alive« which is the ideal of immersing one's sensitivities into the inner nature of phenomena in order to portray their true spirit.[18]

There are of course some cultural differences in the character of aesthetic ideals, but the very fact that each of these major cultures has sensed the importance of and worked to elucidate such an ideal is enough to indicate that a concept of an aesthetic goal orienting an artworld to its proper task is a very pervasive notion. Certainly the direction and emergence of such a notion constitutes the kind of central pivot needed to give meaningful guidance to what an artworld community or institution should be. So, when we become less concerned about definitional precision and borderline test cases, and turn our attention toward the other function of definition, viz., the discovery of important traits, we find it most helpful to make use of the notion of aesthetic sensitivity and aesthetic quality in defining »work of art.«

One more advantage can be cited for this approach. Melvin Rader recently criticized Dickie's definition on the ground that it offered extrinsic rather than intrinsic conditions (Robinson's

[17] Sarkar, op. cit.

[18] L. Yutang THE CHINESE THEORY OF ART, N.Y. 1967, Ch 7.

»synthetic« rather than »analytic« definitions).[19] Although the line of demarcation between extrinsic and intrinsic conditions is not always clear-cut, it does seem that the inclusion of some mention of *aesthetic* appreciation gives a more intrinsic sense to the term »work of art« than does its omission. At least the character of the artworld is hereby restricted in an appropriate manner.

Whatever we may decide about the relative importance of borderline precision as against internally meaningful core traits in a definition, the conclusion seems inescapable that the effort to formulate definitions within the limits of rigor appropriate to the field of aesthetics is most helpful for better understanding. In this respect, Dickie is certainly right. In my judgment, definitions even in the form of rough delimitations, which also point toward the more significant and important traits implicit in a given term, can serve the function of opening doors to further exploration of these terms, and are certainly not doomed to failure, logically or otherwise.

Gary Iseminger

Appreciation, the Artworld, and the Aesthetic

I. The view that a necessary condition of something's being a work of art is that is has a certain status *conferred* on it by an agent of the institution known as the artworld has been defended most vigorously and explicitly by George Dickie.[1] Now

[19] M. Rader »Dickie and Socrates on Definition«, J AES ART CRIT 32 (1974): 423-4.

[1] At one time, for instance, Dickie proposed the following analysis of the concept »work of art«: »a work of art in the descriptive sense is (1) an artifact (2) upon which some society or some sub-group of a society has conferred the status of candidate for appreciation.« (»Defining Art« AMER PHIL QUART 6 (1969): 254) The »society« he has in mind is what A. Danto has called the »artworld« (in »The Artworld,« above: 9-20). Sometimes it appears that Dickie wants to say that this conferral of status is sufficient as well. He argues, for instance, that the status of being an ARTIFACT can be CONFERRED at the same time as the status of being a candidate for appreciation. (G. Dickie ART AND THE AESTHETIC, Ithaca & London 1974: 44-45, cf. above: 29f.) Otherwise unidentified page numbers in parentheses in the body of the paper and in footnotes refer to pages in thas book.

the question whether or not something is a work of art is not the same as the question whether or not a certain property (feature, aspect) of something is an aesthetically relevant property of it, as is perhaps sufficiently evident from the fact that there are properties of works of art which are not aesthetically relevant (the color of the back of a painting) and aesthetically relevant properties of things which are not works of art (the delicacy of a flower).[2] So it is a further step to argue, as Dickie also appears to do, that a necessary condition of a property's being aesthetically relevant is that it has a certain status conferred on it in accordance with the conventions which govern (indeed, constitute) the artworld.[3] In this paper I want to explore this extension of the »institutional analysis« from art to the aesthetic and to contrast it with an alternative account of the way in which the institutions of the artworld are related to the aesthetic.

II. Some terminology and examples due to John Searle will help us to see just what is involved in the claim that aesthetic

[2] Dickie's discussion of aesthetic relevance is described, following M. C. Beardsley AESTHETICS, N.Y. 1958: 16, as a search for the »aesthetic object.« This term seems to me potentially misleading to the extent that it suggests the different question whether or not there is some (possibly non-physical) entity, different from, say, the piece of canvas with the paint on its surface, and having its own unique »ontological status.« Terms like »aesthetic property,« »aesthetic concept,« »aesthetic feature,« and the like, may also mislead in suggesting Frank Sibley's project of attempting to distinguish between properties which can only be recognized by an exercise of »taste,« conceived of as requiring something besides normal »eyes, ears, and intelligence,« and other properties. (See F. Sibley »Aesthetic Concepts« PHIL REV 68 (1959): 421-450) But there is only a contingent connection, if any, between aesthetic properties conceived of in this way and aesthetic properties conceived of as, roughly, those which are relevant for appreciation and criticism. (See R. Meager »Aesthetic Concepts« BRIT J AES 10 (1970): 303-322) It is the latter set of properties with which, following Dickie, I am concerned. Accordingly, I shall speak for the moment of aesthetically relevant properties, though later I shall introduce the notion of an aesthetic state of affairs.

[3] This thesis is not as clearly stated by Dickie as it might be, but it is clear that he wants to extend his »institutional analysis« from the concept of a work of art to the concept of the aesthetically relevant (what he calls the »aesthetic object«). See especially 11-13 and 179-181. The extension is signalled by the revision Dickie makes in his definition of a work of art, a revision which »embeds« (13) the institutional theory of the aesthetic object in the institutional theory of the work of art: »A work of art in the classificatory sense is (1) an artifact (2) a set of aspects of which has had conferred upon it the status of candidate for appreciation by some person or persons acting on behalf of a certain social institution (the artworld).« (above: 23) Following Dickie I shall call the thesis that a necessary condition of a property's being aesthetically relevant is that it has this status conferred on it by an agent of the artworld the INSTITUTIONAL THEORY or the INSTITUTIONAL ANALYSIS of the aesthetic; this should not be allowed to obscure the fact that the alternative I shall sketch involves the institutions of the artworld in other ways and may involve other institutions in this essential way.

relevance is a conferred status and will also provide us with a different model to range against the institutional analysis.[4]

Searle speaks of institutions as »systems of constitutive rules,«[5] that is to say, rules which »constitute and also regulate an activity the existence of which is logically dependent on the rules.«[6] Where such rules exist, they give rise to a category of »institutional facts,« whose existence »presupposes the existence of certain human institutions.«[7] That something has a status which is conferred (for example, that someone is President of the United States, that two people are husband and wife, that a certain piece of wood is the king in a game of chess) is an example of such an institutional fact, for the idea of the conferral of status seems to carry with it the idea of institutions which (formally or informally) authorize people (the Chief Justice of the Supreme Court, clergymen or Justices of the Peace, referees) to confer status.

Institutions may function, however, in ways other than by conferring kinds of status which are impossible without them. After asking us to imagine chess being played in different countries according to different conventions (»e. g. in one country the king is represented by a big piece, in another the king is smaller than the rook«), Searle asks us to consider a different sort of case:

Imagine a society of sadists who like to cause each other pain by making loud noises in each others' ears. Suppose that for convenience they adopt the convention of always making the noise BANG to achieve this purpose. Of this case, like the chess case, we can say that it is a practice involving a convention. But unlike the chess case, the convention is not a realization of any underlying constitutive rules. Unlike the chess case, the conventional device is a device to achieve a natural effect. There is no rule to the effect that saying BANG COUNTS AS causing pain; one can feel the pain whether or not one knows the conventions. And pain still can be caused without employing any conventions . . .
The point of the analogies is that the noise case illustrates what it is for a practice to have a conventional mode of performance, without having constitutive rules and without requiring rules or conventions to perform the act. The chess case illustrates what it is for a practice to have conventional modes of performance, where the conventions are realizations of underlying rules, and where the rules and some conventions or other are required to perform the acts at all.[8]

The kingliness of the piece of wood (but *not* the painfulness of the BANG), then, is a status conferred in virtue of conventions specifying what is to *count as* a king (a pain). The point with regard to the painfulness of the BANG is even stronger, of course. Not only is *this* convention not required for the noise to be painful, but *no* convention is. One can imagine intermediate cases, however, cases where it might not be accurate to say of something which acquires a certain status in a way prescribed by convention that it could acquire that status in the absence of *any* conventions, but it would be accurate to

4 SPEECH ACTS, London & N.Y. 1969. 5 Ibid.: 51.
6 Ibid.: 34. 7 Ibid.: 51. 8 Ibid.: 39-41.

say of it that it could acquire that status *in the absence of any convention governing the acquisition of that status.*

Suppose, for example, that it is conventional in a certain society to insult someone by slapping him or her three times. Suppose also that someone's insulting somebody else is not a totally »non-institutional« process but rather, unlike someone's feeling a pain, presupposes at least the institutions of a minimal social order and a communicable conceptual scheme. Still the status of being an insult does not depend on any conventions or institutions which specify what is to count as an insult. In order for there to be insults, it may be necessary that there be institutions, but surely there need not be institutionalized means of insulting.

Just so, the status of being aesthetically relevant may accrue to some properties of things rather than others only where certain fundamental institutions exist, but these institutions might not be the specifically aesthetic ones of the artworld, and the institutions of the artworld might be related to aesthetic relevance in a way more reminiscent of the insult case than of the chess case. Or, to consider yet another example, suppose, as seems plausible, that the status of being married is a conferred status which can only exist in the context of institutions which specify what is to count as being married, but being in love, though it may depend on *some* institutions and though it may come to be surrounded by conventions to which it has given rise, is *not* a status which can only be acquired in the context of conventions which specify what is to count as being in love. It may be that being aesthetically relevant is, in these respects, more like being in love than like being married.

III. I have already suggested that even if we accept that works of art cannot exist without the artworld, it does not follow that aesthetic relevance cannot. With the distinctions and examples just considered in mind, we may more easily see the *point* of the artworld's conferring the status of a work of art on something if we suppose, quite the contrary, that aesthetic relevance exists prior to and independent of the artworld. Indeed, it seems almost a commonplace to note that aesthetic properties characterize natural objects and that aesthetic states of affairs (as I shall call them) exist independently of the institutions of the artworld. And this fact, if it is a fact, would provide a satisfyingly natural answer to the question of why an agent of the artworld might choose to confer the required status on, say, a piece of driftwood. He could do so, normally, because he *noticed* that it already exhibited certain aesthetically relevant properties.

But it may be that the aesthetic relevance of some property of that piece of driftwood is not conferred on it by the artworld in the same breath, so to speak, as the status of being a work of art is conferred on the piece of driftwood, while aesthetic relevance, for all that, is still impossible apart from these in-

stitutions. In order, then, to see whether or not a case can be made out for understanding the aesthetic as existing independent of the artworld, we shall have to say more about the notion of being a *candidate for appreciation* which is crucial for the institutional account.

IV. Presumably because it is the notion of *candidacy* which makes the theory an institutional one, Dickie says only this about appreciation: »All that is meant by 'appreciation' in the definition is something like 'in experiencing the qualities of a thing one finds them worthy or valuable.'« (pp. 40-41) I want to adumbrate an account of appreciation which expands on this remark and alters it in at least one respect. I shall not argue directly for my proposal; rather, I shall try to explain just what it is and is not meant to cover and to give some idea of why it is framed in the way it is.

Let us say, then, that *someone appreciates a certain state of affairs* (say, a certain picture's being balanced) *when he or she finds value in experiencing that state of affairs.*

(i) It seems appropriate to speak of appreciating a state of affairs (a particular thing's having a property) rather than a thing because it is certain properties or aspects of a thing rather than others which we appreciate when we appreciate it. »What about it do you appreciate?« seems a natural, even inevitable, question. It seems appropriate to speak of states of affairs rather than properties or aspects *simpliciter* as what we appreciate, because it seems clear that it is the property *as instantiated* (the balance in *this* picture, not just the property of being balanced) which we experience and hence appreciate. States of affairs — things having certain properties or aspects (or, if you will, properties as instantiated) are the »objects« of appreciation, not just the picture, not just the property of being balanced, but this picture's being balanced.

(ii) By experiencing a state of affairs I mean something like knowing non-inferentially that the state of affairs obtains. I speak of *knowing* that it obtains because I want to make appreciating a matter which is, in at least one sense, under »objective« control. To put it briefly, we cannot appreciate a picture's being balanced unless it *is* balanced. It may be, of course, that from the subjective side, so to speak, everything is as if we were appreciating a picture's being balanced when the picture is *not* balanced. But that, it seems to me, is not appreciation but delusion. It is to appreciation as false belief is to knowledge. The point of speaking of *non-inferential* knowing is simply to mark the difference between *merely* knowing that a picture is balanced (as, for example, by reading about it in a work by a reputable critic) and *seeing* that it is.[9] To appreciate a state of affairs one must directly confront it.

[9] SEEING that a state of affairs obtains is, of course, far removed from any mere receiving of sense-data. The concept of experience being

(iii) As this example suggests, where a state of affairs is *visible*, experiencing it, and hence appreciating it, entails *seeing* it. Similar remarks could no doubt be made regarding other modes of sensory experience, but I do not mean to *restrict* experience to sensory experience. For it seems to me that the kind of non-inferential awareness of states of affairs I am talking about is possible even with respect to states of affairs which are not perceivable by any of the senses. All that is necessary is that we be able to make sense of a distinction between direct awareness of the state of affairs and inferential knowledge that it obtains.

The sort of example that comes to mind here is one which has brought many aesthetic theories to grief, that of literature.[10] Surely there are, in poetry, for example, relations which, depending as they do on semantic features of the language in which the poem is written, are not available to the senses. We do not see (hear, etc.) the tension set up by the contrasting images in a poem. But it seems equally clear that even here there is the same contrast between merely knowing (say, by accepting upon reflection the views of an astute critic) that such tension characterizes a poem and directly confronting the poem and experiencing the tension in it. The existence of this sort of distinction in cases like this seems to me sufficient to justify speaking of non-sensory experience in connection with them.

(iv) I want to contrast the finding of value with merely liking or enjoying. For one thing, it is clear that we can appreciate works of art where liking or enjoying seems hardly to come into the question. Who *enjoys* the last scene of *Woyzeck,* for example? For another, I think of appreciating, like valuing but unlike enjoying, as involving commitment to claims beyond the merely private and personal.

(v) My account differs from that suggested by Dickie's remark in speaking of finding value in the experience rather than in the thing or its qualities. Thus I do not have to say that someone who *sees* that a piece of paper is a one hundred dollar bill and finds (as who would not?) value *in the piece of paper* is appreciating it. My reason for wanting to avoid calling this a case of appreciation is that I hope something like the notion of appreciation will be able to mark off the domain of the aesthetic. It clearly could not do this if we were forced to say that this was a case of appreciation, for it clearly lies outside that domain. Nor would it help in this connection to rule the case out by saying that the person was not appreciating the piece of paper *aesthetically* or not finding it *aesthet-*

employed here is richer, not poorer, than the concept of knowing that something is the case.

[10] One of Dickie's criticisms of Beardsley's attempt, AESTHETICS: 58, to make perceptibility a necessary condition of the aesthetic is that it does not deal adequately with what is aesthetically relevant in literature (cf.: 156).

ically valuable, for then we would be presupposing some prior understanding of the aesthetic.

The notion of appreciation I have outlined is, then, really a notion of *aesthetic* appreciation, if you like, but it is not the notion of an aesthetic species of the genus appreciation nor is it the notion of an introspectively distinguishable state of mind.[11] It is rather the notion of a certain complex relation between an experiencing, valuing subject and a state of affairs — a relation which can, I think, be characterized without appeal to any prior concept of the aesthetic and which may thus without circularity help us (as indeed Dickie thinks it can help him) answer the question »What makes a state of affairs aesthetic?«

V. The idea that the aesthetic relevance of a state of affairs is conferred upon it does not, of course, follow directly from the use of the notion of appreciation in marking off the domain of the aesthetic. Suppose, for instance, that we said simply that a state of affairs is aesthetic if it is appreciated. Such an account would not entail that the aesthetic character of a state of affairs was conferred upon it, because actual appreciation clearly requires no such conferral of status, no institutions with conventions which say what is to count as appreciating. Like insults and love, appreciation may require that certain fundamental human institutions exist if it is to exist, and it may be that conventional ways of appreciating exist along with appreciation itself, but it surely is not the case that appreciation is impossible in the absence of conventions specifying what is to count as appreciation or without the conferral of the status of being appreciated in accordance with these conventions by an agent of some institution.

There is much to be said against this simple account of the aesthetic in terms of actual appreciation, however, and what can be said against it is at the same time what can be said in favor of complicating it by introducing the notion of candidacy and with it the idea that a state of affairs' being aesthetic is a status conferred upon it. Most bluntly, we must allow for aesthetic states of affairs which are bad, and (perhaps) we must allow for aesthetic states of affairs which are not experienced. Both of these demands seem to force us to distinguish between the aesthetic and the actually appreciated. Talking of *candidacy* for appreciation seems to deal with both of these issues, for doubtless something can be a candidate for

[11] It will be apparent that I am trying to avoid problems which have notoriously plagued attempts to make some such notion as that of appreciation fundamental for aesthetics. Dickie has been a persistent critic of such attempts. (E. g. above: 27f) If I am not mistaken, the account I have given is not subject to any of his strictures, but I shall not argue the point here. I suppose that my project may be viewed as an attempt to restore to their rightful place the »psychologistic and epistemological« considerations from which Dickie has aimed to »free the concept of the aesthetic« (178).

appreciation and be so bad as to remain actually unappreciated (not all candidates are elected) and perhaps someone can confer the status of candidate for appreciation (say by buying a painting and displaying it for sale in his gallery) on a state of affairs without ever looking at it.[12]

But if these are the main reasons for analyzing the aesthetic in terms of candidacy for appreciation rather than actual appreciation, there are other ways of speaking to the same points without introducing the idea of candidacy and hence without introducing the notion that the status of being aesthetic is conferred. Perhaps the most obvious alternative is to say that *aesthetic states of affairs are those which are capable of being appreciated,* or, as we might say, *those which are appreciable.*

To say this, given the foregoing account of appreciation, is to say, first, that they are capable of being experienced. Recalling that we have allowed the notion of experience to extend beyond experience through the senses, we may think that this is not much of a limitation. But it does seem clear that there are entities which are not experienceable and hence not capable of being appreciated, even given this extended account of experience. An example which comes to mind is that of theoretical entities (but not, of course, spatial models of them nor, indeed, the theories which postulate them). So some states of affairs seem to be disqualified from being aesthetic on the grounds that they are in principle unexperienceable; and, of course, there is much which, though not unexperienceable in principle, may be purposely rendered unexperienceable for a given group of people (as what goes on backstage is shielded from the audience). Experienceability and hence appreciability must often be understood as thus relativized to an audience.

The other condition which our account of appreciation places on appreciability, of course, is that the experience of the state of affairs be such that it is possible for someone to find value in that experience. I am not certain whether this is genuinely an added condition in the sense that it rules out cases not already ruled out or not. It will not do to say here, for example, that there are experienceable states of affairs so bad that it is impossible for anyone to find value in experiencing them. Even supposing that this is so, part of the point of moving from appreciation to appreciability was precisely to include the aesthetically bad as part of the aesthetic. That is to say, the claim that it is possible for someone to find value in experiencing a state of affairs must not be construed as implying any favorable judgment, not even the most minimal.[13] It is rather

[12] The reasons just given seem to be Dickie's main reasons for introducing the notion of candidacy. (See 26f above).

[13] I am here asserting against Dickie, then, that appreciability is NOT a vacuous constraint but that it also does NOT involve a value claim. (See 27f above) I do not believe, therefore, that I am interpreting

the claim that the experience in question is capable of being evaluated, is, as we may say, *assessable*. The question then becomes whether any experiences are simply outside the range of evaluation, are completely neutral, so to speak. Candidates suggest themselves such that, if there *are* such experiences, they might plausibly be said to be unassessable. These might include experiences which lack determinate character (the experience of staring at a blank sheet of paper), experiences which are ineffable, experiences which are totally ephemeral. Only a full-fledged account of experience could answer the question whether the assessability of experiences is genuinely an added condition on the experienceability of states of affairs in our analysis of the notion of appreciability and hence of the aesthetic.

VI. I have proposed an account of appreciation and a »psychologistic« and »epistemological« understanding of the aesthetic based on that account which seems to me not to run afoul of Dickie's criticisms of such analyses and to meet the same general requirements which the institutional theory is designed to satisfy. But a consideration of the case of the Chinese property-man will show that the two accounts need not give the same results in all cases.

The property-man in traditional Chinese theater, according to Dickie, »appears on stage among the actors while the play is going on. He arranges properties and scenery and does such things as hold a certain kind of flag in front of the face of a 'dead body' as it walks off the stage.« (p. 166) Now Dickie is inclined to say that the activities of the property-man are not aesthetically relevant to (not part of) the performance (any more, presumably, than the activities of the property-men in traditional Western theater, who do their job behind the scenes or before the performance). But it seems clear that, on my account, these activities (and not just their results) are appreciable by the audience and hence the performance as characterized by them is an aesthetic state of affairs. The institutional theory, on the other hand, enables us to infer from the fact that »a spectator at traditional Chinese theater knows to ignore the property-man and attend to the actors [because he has] ... learned the conventions that govern [its] presentation and appreciation.« (p. 172) that the performance as characterized by the property-man's activities is not an aesthetic state of affairs.

When two accounts differ over cases in this way, no decisive result seems likely to emerge from the pitting of intuitions against one another. Perhaps some of the difficulty in happily giving either answer to the question whether or not the property-man's activities are part of the performance lies in supposing that a clear-cut answer is possible at all. I am inclined to think

the notion of appreciability in the way T. Cohen does in »The Possibility of Art« PHIL REV 82 (1973): 69-82.

that *to the extent that* his activities are appreciable by the audience they are an aspect of the performance. (It is not inept of a critic to complain, for example, about noise backstage.) To the extent that the property-man remains unobtrusive, on the other hand, even though he is in full view, he removes his activities from the realm of what is appreciable by the audience. It is not as if a convention could, by itself, *prevent* his activities from being a part of the performance if he regularly upstaged the (other?) actors.

The case of the Chinese property-man is, of course, a somewhat special one. Dickie also describes some of the conventions of Western theater (raised stage, curtains, house lights, and so on), distinguishing between these »secondary conventions« which »locate the aesthetic object for the spectator« or »conceal nonaesthetic features« and the »primary convention« which »establishes and sustains theater, ... the understanding shared by the actors and the audience that they are engaged in a certain kind of formal activity.« (pp. 173-176) That there are conventions of these sorts is undeniable, but it appears that Dickie wavers on the question of whether or not they are necessary to confer aesthetic status. To speak of »locating« and »concealing« aesthetic or nonaesthetic features certainly seems to suggest that those features have their aesthetic or nonaesthetic character independently of their being located or concealed. Whether or not this is Dickie's view, it certainly seems to be the most plausible way of looking at the matter. The lowering of the curtain is not like a sign saying »Ignore what's going to happen on the stage for the next few minutes.« It is rather a way (a conventional way, to be sure) of making it in general *impossible* for the audience to experience and hence to appreciate what is about to happen on the stage. It is a conventional way of preventing something from being an aesthetic state of affairs, not a convention which specifies that something does not *count as* an aesthetic state of affairs.

At this point it might be conceded that the secondary conventions of theater function not to confer or withhold the status of the aesthetic but rather to make it clearer to the audience what is or is not aesthetic; still, it might be argued, without the primary convention there would indeed be no distinction between the aesthetic and the nonaesthetic.[14] But it seems more plausible to say that it is some primary convention which makes *works of art* possible than to say that such a convention makes

[14] It is not clear to me, though, why Dickie says that the Chinese property-man's activities are rendered nonaesthetic »by the PRIMARY convention of theater presentation« (p. 176, my emphasis). On the one hand, it is not clear how the rather abstractly described »primary convention« COULD do this; on the other, insofar as there IS a convention governing the property-man's activities it seems to be more on a par with the convention Dickie describes as secondary (stage, lighting, and so on).

aesthetic states of affairs possible. It is perhaps clear that there could be no plays without the theater, but is it so clear that there could be no »dramatic« states of affairs? That the institutional account of the work of art is plausible without necessarily lending any plausibility to the institutional account of the aesthetic has been one of the themes of this paper.

VII. The case of the Chinese property-man is, in effect, an argument that the account of the aesthetic in terms of appreciability is too broad. Another case of Dickie's, that of the wire-aided »flying« in performances of *Peter Pan,* can be used to argue that it is too narrow.[15] Dickie imagines a critic who writes of Mary Martin's performance in *Peter Pan,* »Miss Matin gave a perfect portrayal of boyish enthusiasm and displayed a superhuman skill and grace by actually flying about the stage at various times.« (p. 159) Clearly the critic has misunderstood. Dickie goes on:

One must know of the existence of the imperceptible wire in order to understand and assess Miss Martin's »performance« of moving through the air, just as one must be able to see Miss Martin's perceptible facial and bodily movements in order to understand and assess her performance in portraying boyish enthusiasm. Consequently, just as her perceptible facial and bodily movements are an aspect of the object of appreciation and/or criticism the imperceptible wire is also an aspect of the aesthetic object of the performance. (p. 160)

The account I have given of the aesthetic would clearly give, according to Dickie, the wrong result in this case. The institutional account, on the other hand, summed up in the claim that »if one must know of an aspect in order to understand what is presented through a primary convention, then the aspect of the work is also an aspect of the aesthetic object of the work« (p. 179), entails that the imperceptible wire is an aspect of the aesthetic object of the performance.

What has gone wrong here is, revealed by a little reflection on the phrase »object of appreciation and/or criticism.« It is clear that much that critics appropriately say about plays does not involve describing their appreciable aspects, if appreciability is understood in the way I have outlined. The »object of appreciation« consists of fewer aspects than the »object of criticism.« But then we must decide whether or not we want to include criticizable but unappreciable states of affairs (for example Mary Martin's being supported by wires) as aesthetic states of affairs. If we decide that we should not, this alleged

[15] Dickie actually uses it to claim that Beardsley's perceptibility requirement is too narrow. (See 158-163) Even though the experienceability part of my appreciability requirement is a broadening of Beardsley's perceptibility requirement, it is not a broadening of it in any way relevant to this example. If the example shows that the perceptibility requirement is too stringent it shows that the experienceability requirement is too stringent as well.

counter-example to our account of the aesthetic need not trouble us.

One reason not to do so is the fact (recognized by Dickie in his account of the »presentation group,« the »essential core ... without which the artworld would not exist« (p. 36), which include appreciators but not critics) that criticism takes its point from appreciation rather than the other way around. Criticism is an aid to appreciation; appreciation is not raw material for criticism.

Why, then, ought not critics to restrict themselves to pointing out the appreciable aspects of works of art? The answer is that there are ways of facilitating appreciation other than by pointing out appreciable states of affairs, and one way is precisely by pointing out states of affairs which, although themselves unappreciable, would prevent appreciation by an audience which was unaware of them. That there may be such states of affairs becomes clear if we recall the »epistemological« content of the notion of experience which is part of the idea of appreciation. Our mistaken critic is not appreciating Mary Martin's performance because he is wrong about what it consists in; he is not experiencing the state of affairs which actually obtains.[16]

That an unappreciable state of affairs may appropriately be mentioned by a critic does not, then, entail that the account of the aesthetic in terms of appreciability is too narrow. The centrality of appreciation provides us with reasons for restricting the aesthetic to the appreciable, while the epistemological element in appreciation explains the function of critical discussion of the unappreciable. We can happily admit the importance for appreciation and hence for criticism of knowing that Mary Martin is suspended by imperceptible wires without being committed to the view that there are aesthetic states of affairs which are unexperienceable and hence unappreciable.

VIII. The issue which must finally be faced in any attempt to adjudicate between the institutional account of the aesthetic and the »psychologistic« and »epistemological« alternative I have ranged against it is whether art is to be understood in terms of the aesthetic or the aesthetic in terms of art. It is a

[16] It can be a necessary condition, then, of our experiencing a state of affairs (seeing that someone is not flying) that we know something (that the person is suspended by wires) in advance and in some way other than by experiencing it. This is yet another way in which the concept of experience being employed here is a »rich« one. Compare Wittgenstein's remark, involving, to be sure, yet a different notion of experience: »The substratum of this experience is the mastery of a technique. But how queer for this to be the logical condition of someone's having such-and-such an EXPERIENCE! After all, you don't say that one only 'has toothache' if one is capable of doing such-and-such. — From this it follows that we cannot be dealing with the same concept of experience here. It is a different though related concept.« PHILOSOPHICAL INVESTIGATIONS: 208e.

striking fact that Dickie's account is explicitly framed only to distinguish aesthetic from nonaesthetic aspects *in works of art.* (See, for example, pp. 198-200.) Given that the artworld is an institution and that there are conventions of presentation it is not surprising that one can find a convention in the neighborhood whenever one wants to distinguish in a work of art between its aesthetic and nonaesthetic features; given an institutional analysis of the work of art, it is then tempting to suppose that the concept of the aesthetic can be analyzed in an analogous way.

But appreciation surely can take place outside the artworld; indeed, it seems accurate to say that appreciation appears very many centuries earlier in human history than the artworld (and, hence, works of art, understood as having that status only in the context of the artworld). If, then, the aesthetic can be demarcated in terms of appreciation but in a way which does not require the invocation of the notion of the artworld, the central claim of the institutional theory of the aesthetic — that the status of a state of affairs as aesthetic is conferred in accordance with the convention of the artworld — must be wrong. The importance of the artworld lies not in its making the aesthetic possible but rather in its facilitating the aesthetic, by encouraging the production of things whose function is to be appreciated and by providing a suitable context in which they may be appreciated.[17]

Jack Glickman

Creativity in the Arts[1]

What is it to be creative? The answer usually given is that there is a »creative process,« and most writers on creativity have taken their task to be a description of the kind of activity that takes place when one is acting creatively. In the first part of this paper I will argue that that is the wrong way to go about characterizing creativity, that one must attend to the ar-

[17] I am grateful to the editor of this volume and to my colleagues at Carleton and St. Olaf Colleges for their helpful comments on earlier versions of this paper.

[1] A shorter version of this paper was read at the 8th National Conference of the British Society of Aesthetics, SEP 22, 1973. The present essay contains portions of my »Art and Artifactuality«, PROCEEDINGS of the VIIth International Congress of Aesthetics; it also contains portions of »On Creating« — some comments on W. E. Kennick's »Creative Acts«, that were both printed in Kiefer & Munitz (eds) PERSPECTIVES IN EDUCATION, RELIGION, AND THE ARTS, Albany 1970. The argument of the present essay parallels to some extent the argument of

tistic product rather than to the process. In Part II, I argue that their failure to properly distinguish creating from making has led some to suppose, erroneously, that some recent trends in art have celebrated the end of artistic creation.

Douglas Morgan, in reviewing a large number of writers on creativity, provides a convenient account of what I'll call the Creative-Process Theory. He finds that

the »classic« theory of the creative process breaks it down into various stages. From two to five stages are usually thought necessary to describe the process, but the various descriptions bear a revealing community, and I think we may take the »four-step« interpretation as reflecting the consensus:
1. A period of »preparation« during which the creator becomes aware of a problem or difficulty, goes through trial-and-error random movement in unsuccessful attempts to resolve a felt conflict...
2. A period of »incubation,« renunciation or recession, during which the difficulty drops out of consciousness. The attention is totally redirected ...
3. A period or event of »inspiration« or »insight«...the »aha!« phenomenon, characterized by a flood of vivid imagery, an emotional release, a feeling of exultation, adequacy, finality...
4. A period of »elaboration« or »verification« during which the »idea« is worked out in detail, fully developed.[2]

According to Morgan, not only is it »complacently assumed by nearly all investigators that there is such a thing as the creative process — or a class of processes sharing important sets of characteristics, [it is assumed also] that creative processes in art and in science are identical or very nearly so.«[3]

The theory has serious inadequacies. It excludes many instances of creative activity — improvizations in the performing arts, for example, and other instances in which the creating has taken place in a single unreflective burst of energy, as when poets have had a poem come to them all at once. The most objectionable inadequacy of the Creative-Process theory, though, is that what it describes is not at all limited to creative activity. The pattern described fits equally well many instances of genuine creativity and many instances of inept, bungling attempts at creativity. It also fits activities that are not even attempts at creativity: Suppose someone mentions a name that sounds familiar, and I try to recall the person mentioned. Someone asks me, »Do you remember George Spelvin?«. »George Spelvin, George Spelvin,« I repeat, mulling over the name (step

D. Henze's »Logic, Creativity and Art«, AUSTL J PHIL 40 (1962). See also D. Brook & M. Wright »Henze on Logic, Creativity and Art«, AUSTL J PHIL 41 (1963), and Henze's rejoinder in that journal, 42 (1964). So many people have given me helpful criticisms and advice on successive drafts of this paper that I cannot hope to list them all. I am very grateful for their help; I hope they will forgive my not trying to name them all here.

[2] D. N. Morgan »Creativity Today«, J AES ART CRIT 12 (1953): 14.

[3] Ibid.: 12.

1 - aware of a problem). I can't remember, so I put the problem aside, no longer consciously concerned with it (step 2 - incubation). After a while it suddenly comes to me, »Sure, I remember George Spelvin; he's an actor!« (step 3 - the »aha«! phenomenon). Then I begin to remember more, »I saw him as the Chorus in *Romeo and Juliet*« (step 4 - filling in details). Recalling who a person is, given his name, hardly seems an instance of creative activity; yet it fits the description of the creative process.

In criticizing the Creative-Process theory, I might be accused of flogging a dead horse. Most psychologists seem to have abandoned this sort of account of creativity, as have many philosophers. Yet, as I will argue, in many subsequent accounts of creativity the same crucial error persists — the assumption that creativity consists in some distinctive pattern of thought and/or activity. It persists, for example, in Vincent Tomas's theory of creativity in the arts.

Tomas puts the problem this way: when one asks what's meant in saying that an artist is creative or that something is a work of creative art, »one is asking for a clarification or analysis of the concept of creativity as applied to art. One wants to know explicitly the nature of artistic creation — to be given a description of the conditions an activity must satisfy if it is to be an instance of artistic creation rather than of something else.«[4] This last sentence quoted makes it clear that he wants a set of conditions that are not only necessary but also sufficient for an instance of artistic activity to be creative activity.

Tomas begins with the example of a rifleman aiming and firing at a target: the rifleman knows what he wants to do — hit the bull's-eye — and he knows that if a hole appears in the bull's-eye after he fires, he has succeeded. The rifleman knows what he should do to hit the bull's-eye — what position to assume and how to hold the rifle, get the correct sight picture, and squeeze off the shot. If the rifleman fails, Tomas says, he has not obeyed all the rules, and if he succeeds and is congratulated, he is congratulated for being able to learn and obey all the rules.

But when we congratulate an artist for being creative, Tomas says, it is not because he was able to obey rules and thereby do what had been done before. »We congratulate him because he embodied in colors or in language something the like of which did not exist before.«[5] Unlike the rifleman, »the creative artist does not initially know what his target is ... Creative activity in art ... is not ... activity engaged in and consciously controlled so as to produce a desired result.«[6]

[4] In his Introduction to V. Tomas (ed) CREATIVITY IN THE ARTS, Englewood Cliffs 1964: 2.

[5] V. Tomas »Creativity in Art«, ibid.: 98.　　[6] Ibid.: 98.

Yet, Tomas says,

the creative artist has a sense that his activity is directed — that it is heading somewhere... Despite the fact that he cannot say precisely where he is going... he CAN say that certain directions are not right. After writing a couplet or drawing a line, he will erase it because it is »wrong« and try again...
Creative activity in art, then, is activity subject to critical control by the artist, atlhough not by virtue of the fact that he foresees the final result of the activity. That this way of construing creativity reflects part of what we have in mind when we speak of creative art can be shown if we contrast what results from creative activity so construed with what results from other activities that we do not call creative.
Thus we do not judge a painting, poem, or other work to be a work of creative art unless we believe it to be original. If it strikes us as being a repetition of other paintings or poems, if it seems to be the result of a mechanical application of a borrowed technique or style to novel subject matter, to the degree that we apprehend it as such, to the same degree we deny that it is creative.[7]

It is fairly clear, then, how Tomas relates the following three questions: (1) What characterizes an artist as a creative artist? (2) What characterizes a poem, painting, or other work as a creative work of art? (3) What characterizes an activity as artistic creation? Tomas would answer the first two of these questions in terms of his answer to the third: artists, when they work in the manner described, are engaged in artistic creation; a creative artist is one who is able to achieve artistic creation, and a creative work of art is one that results from artistic creation. Tomas claims that although we judge a poem or painting to be a creative work on the basis of qualities of the work itself, such a judgment is possible because the work reveals features of the activity that produced it.

So far, then, Tomas has set forth two conditions an activity must satisfy to be artistic creation: (1) the artist does not envisage the final result of his work, but (2) the artist exercises »critical control.« The first condition, I think, contains a conceptual truth — that if someone knows just what the product of his labors will be, then that product is, in a sense, already created. I'll have more to say about this later. For the present, though, I want to point out only that this first condition does not distinguish the artist who is creative from the one who is not. Tomas allows that a sculptor might know exactly what his sculpture will look like before he begins to work his material, and might even hire someone else to execute his plan. Tomas says that in such a case the creative act is finished: it is the production of the idea, and all that remains is to »objectify the idea« in some material — a matter of skill or work. But for any artist at work, either he does *not* envisage the result, in which case his activity fulfills one of the conditions of artistic creation, or else he *does* envisage the result, in which case he may be objectifying an idea that is the product of a

[7] Ibid.: 99f.

creative act, and so in this case too he may have been creative.
Tomas's second condition raises difficulties, for artists at times produce a work in a single unreflective outpouring of energy. Tomas considers what is supposedly such a case — Nietzsche's writing of *Thus Spake Zarathustra*.

Even if Nietzsche didn't deliberately change a thing, even if all came out just right from the very first line, was there not a relatively cool hour when Nietzsche (and the same goes for Coleridge and KUBLA KAHN) read what he had written and judged it to be an adequate expression of his thought?... If there was such a cool hour and such a critical judgment in Nietzsche's case, this is all that is needed to have made his create ZARATHUSTRA on the view of creation presented above.[8]

Undoubtedly there was a cool moment when Nietzsche and Coleridge looked over their work, but that was after the work was created. According to Tomas, had either Nietzsche or Coleridge not looked over his work after it was finished it would not be a creative work, but since he did look it over it is a creative work. This is paradoxical: the work is the same in either case. And think of a jazz musician improvizing a performance; whether he later happens to judge it adequate after listening to a recording seems totally irrelevant to whether his performance was creative. At any rate, if critical control can amount to no more than looking over the work, it is certainly an easy condition for any artist, creative or not, to fulfill, but it hardly seems necessary.

Tomas sees one other essential factor in artistic creation — *inspiration*.

In the creative process, two moments may be distinguished, the moment of inspiration, when the new suggestion appears in consciousness, and the moment of development or elaboration. The moment of inspiration is sometimes accompanied by exalted feelings.[9]

Inspiration seems to be the sort of thing Morgan called the »aha!« phenomenon; in fact, it becomes quite clear at this point that Tomas's theory is simply a more elaborate version of the Creative-Process theory. Tomas introduces the notion of inspiration to explain the »critical control« in creative activity.

Whenever the artist goes wrong, he feels himself being kicked, and tries another way which, he surmises, trusts, or hopes, will not be followed by a kick. What is kicking him is »inspiration«, which is already there. What he makes must be adequate to his inspiration. If it isn't, he feels a kick.[10]

Tomas comments: »admittedly, the concept of inspiration we have been making use of is in need of clarification.«[11] I agree.

[8] Ibid.: 106. [9] Ibid.: 104. [10] Ibid.: 108.

[11] Ibid. The sort of thing that Tomas is talking about is clarified by Beardsley in his development of Tomas' theory. See M. C. Beardsley »On the Creation of Art«, J AES ART CRIT (1965).

Ordinarily there is no distinction between a good inspiration and a poor one: to say an idea is an inspiration is to say it is a good idea or the right idea; if the idea is a poor one, it is not called an inspiration. But then there can be no characterization of inspiration in terms of the agent's feelings, for on that basis alone one cannot differentiate having an inspiration and having what *seems* to be an inspiration. It is likely that an artist might think he is being creative when he is not. Tomas says that »whenever the artist goes wrong, he feels himself being kicked.« Maybe some artists feel such a kick when they *think* they have gone wrong, but surely there have been a lot of kickless goings wrong in the history of artistic activity. Each of two artists may work in the way Tomas describes, each having feelings of inspiration, each critically controlling his work according to the »kicks« he feels, yet one artist may be creative and the other not be creative at all.

The three conditions of artistic creation that Tomas lays down — not envisaging the result, exercising critical control, and undergoing feelings of inspiration — do not help to distinguish the creative artist from the uncreative one. In what follows, I will try to show that the Creative-Process theory rests on a fundamental misconception about creating.

Tomas realizes that »in discourse about art, we use 'creative' in an honorific sense, in a sense in which creative activity always issues in something that is different in an interesting, important, fruitful, or other *valuable* way.«[12] This I think is correct and crucially important. It is precisely because we do not call an activity creative unless its product is new and valuable that no characterization of creating simply in terms of the artist's actions, thoughts, and feelings can be adequate, for such a characterization cannot distinguish activity that results in a valuably new product from that which does not. Let's take a closer look, then, at what it is that one »does« when one is creative.

In the arts one might create by composing music, writing, painting — i. e. we might say that someone was not only painting but also creating, or not only writing but also creating. It is not that he is doing two things at the same time. If we say that someone is doing two things at the same time — riding a bicycle and viewing the countryside, for example, or reading and drinking coffee — we can imagine our subject doing one of these things without the other. Creating, however, is not an isolable activity. The creator cannot be just creating; he has to be doing something we could describe as writing, painting, composing, or whatever. One does not always create when one paints, writes, or composes; these are means by which one might create. A number of activities sometimes qualify as »creating«.

12 Tomas »Creativity in Art«: 100.

To know whether someone has created, we have to see (or be told about) the results of his work. And the creator himself knows he has created only by seeing what he has done. It is unusual to say »I am creating«; »create« is seldom used in the continuous present tense. I suppose we can imagine a painter, say, who after a bit of especially satisfying work exclaims »I am creating!« but in such a case the creating is not something he is doing at the moment, it is something he has done. If we ask »How do you know you're creating?« he might answer »Just look at what I've painted.« Notice that it makes sense to ask »How do you know you're creating?« whereas it would be silly to ask »How do you know you're painting?« Similarly one might be surprised that he has created, but not surprised that he has painted. We say an activity such as painting, writing, or composing is creating if it achieves new and valuable results; no specific isolable activity *creating* corresponds to the verb »create« as painting corresponds to the verb »paint«.

These considerations suggest that »create« is one of that class of verbs Gilbert Ryle has labeled »achievement verbs«. The verb »win,« for example, signifies not an activity but an achievement. Winning a race requires some sort of activity, such as running, but winning is itself not an activity.

One big difference between the logical force of a task verb and that of a corresponding achievement verb is that in applying an achievement verb we are asserting that some state of affairs obtains over and above that which consists in the performance, if any, of the subservient task activity. For a runner to win, not only must he run but also his rivals must be at the tape later than he; for a doctor to effect a cure, his patient must both be treated and be well again ... An autobiographical account of the agent's exertions and feelings does not by itself tell whether he has brought off what he was trying to bring off.[13]

For a painter, composer or writer to create, not only must he paint, compose or write, he also must achieve new and valuable results; therefore, no description of just the artist's »exertions and feelings« will tell us whether he has created.

If creating were a specific process or activity we would expect that one could decide to create. But artists often try unsuccessfully to create. Given the technical knowledge, one can decide to write, paint or compose, but not create.

If creating were a specific process or activity we would expect the possibility of error. It is easy to *make* something *wrong*. But one cannot create something wrong; either one creates or one does not. But just as winning is not an infallible kind of running, creating is not an infallible kind of making; it is an achievement.

To say that someone created x is often to say that x was, upon being produced, absolutely new — i.e. new to everyone. To say that someone has been creative, though, is to say that the

[13] G. Ryle THE CONCEPT OF MIND, N.Y. 1950: 150.

product is new to the agent. Someone may be creative in solving a math problem, for example, if he devises a solution more elegant and ingenious than the standard way of solving such a problem, even though others may have devised the same solution before. I do not think, though, that ordinary usage supports a hard and fast distinction between *creating*, implying the product is new to everyone, and *being creative*, implying the product is new to the agent. One might say, »Horticulturist *A* thought he had created a new hybrid, but *B* had developed the same hybrid years before.« But one might as well say, »*A* and *B*, independently, both created the same hybrid.« In neither case, though, is there any implication that *A* was less creative than *B*. To say, then, that someone created *x*, *or* that in producing *x* someone was being creative, is to imply that *x* was *new to the agent*. As Kennick points out, if a contemporary of Cézanne working in Siberia and wholly unacquainted with what was going on elsewhere in the art world, produced canvases just like the late canvases of Cézanne, we would have no reason not to describe his work as creative.

Judgments of creativity are implicitly comparative, like saying that a man is tall or short. But the comparison is not unrestricted. A work of art is creative only in comparison with works with which it is properly comparable, i. e. with what the artist might reasonably be expected to have been acquainted with.[14]

Although whether we ascribe the verb »create« depends on the product, not on the activity that produced it, it does not follow that the praise conferred by »create« and »creative« applies only to the product; but in saying that the agent is creative, one is praising him for what he has accomplished, not for having gone through some special process in accomplishing it. This brings us to a crucial difference between the consequences of my view and those of a theory such as Tomas's for answering the following three questions: (1) What characterizes an artist as creative? (2) What characterizes a poem, painting or other work as a creative work? and (3) What characterizes an activity as artistic creation? For Tomas, the third question is primary, and the first two are answered in terms of its answer. On my view the answer to all three depends on the product; it is the product that determines whether we call the activity creating, and also whether we call the agent and the work creative.

The Creative-Process theory has been the dominant theory of creativity during the last half century, and it is hardly surprising that it has been the dominant theory of *artistic* creation, since as such it is a variation on a main theme in the expression theory of art, which because of the influence of Croce, Collingwood, Dewey, and others, has been the dominant theory of art. As the expression theory is usually formulated, good art,

[14] In W. E. Kennick (ed) ART AND PHILOSOPHY, N.Y. 1964: 376.

or »art proper,« comes about only as the result of a certain sort of process — »artistic expression.« But as critics of the expression theory have emphasized, an examination of the process is irrelevant to an evaluation of the product.[15] This, essentially, has been my criticism of the Creative-Process theory. »Creative« is a term of praise, but there is no specific sort of activity necessary or sufficient for producing things of value.

Tomas argued that we judge a work of art to be creative on the basis of properties of the work itself, but only because we take those properties as evidence that the creator went through a certain sort of process. I think Kennick is correct, though, in insisting that we do nothing of the kind. Rather,

we determine whether a work of art is creative by looking at the work and by comparing it with previously produced works of art in the same or in the nearest comparable medium or genre . . .
Anyone can tell at a glance whether two paintings or two poems are different, but not just anyone can tell at a glance which of two paintings or poems is the more creative. To tell this, one must be acquainted with properly comparable works of art and be able to appreciate the aesthetic significance of any artistic innovation, see how it enlarges the range of viable artistic alternatives and thereby »places« what has already been done by putting it, so to speak, in a new light.[16]

It might be objected that Kennick's view, which I am endorsing, confuses *evidence* of creativity with what it *means* to say that someone is creative. But the answer to this objection is clear, I think, when we realize that »create« is an achievement verb and so applies only when something besides the performance of some action is the case. Although a patient's recovering his health is evidence that the doctor cured him, it is also the criterion for ascribing the verb »cure« to what the doctor did. To cure someone *means* to make him well as a result of treatment. I suppose that in some sense a valuably new artwork is »evidence« of creativity, but more than that, we apply the verb »create« only when the results are new and valuable, since creating *means* producing what is valuably new.

Tomas considers the possibility that being creative is simply producing what is valuably new, but he dismisses that possibility with the following argument.

Do we want to mean by creation in art MERELY the production of a work that not only is different but is different in a valuable way? In that case, it would follow that a computer would be no less creative than Beethoven was, if it produced a symphony as original and as great as one of his, or that a monkey could conceivably paint pictures which were no less works of creative art than Picasso's . . . So conceived, artistic creation is not necessarily an action, in the sense of this word that involves intention and critical control, and the traditional distinction between action and mere movement is obliterated.[17]

[15] See, e.g., J. Hospers »The Croce-Collingwood Theory of Art«, PHILOSOPHY 31 (1956).

[16] W. E. Kennick »Creative Acts«, op. cit.: 225.

[17] Tomas, Introduction: 3.

Concerning Tomas's claim that if monkeys and machines create works of art, then »[1] artistic creation is not necessarily an action . . . and [2] the traditional distinction between action and mere movement is obliterated,« the first conjunct of the conclusion seems to follow from the premise, but the second one does not. If machines can create artworks then it seems true that artistic creation is not necessarily an action, but it does not follow that there is no distinction between action and mere movement.

But more to the point, to say that someone is creative is to say that he is creative in some specific way. There are creative painters, creative teachers, creative businessmen, creative mathematicians. We might say of someone creative in a number of ways that he is a creative person, or creative in general, but we can in such instances enumerate the various ways in which he is creative.

Now can a monkey be as creative as Picasso? The proper reply is »As creative a *what* as Picasso?«. As creative an *artist*? Only if it is allowed that a monkey can be an artist. Similarly, if we are to make any sense of the question »Is a monkey at a typewriter who produces a sonnet identical with one of Shakespeare's as creative as Shakespeare?« it must mean »Is the monkey as creative a *poet* as Shakespeare?« and the answer is clearly No unless it is allowed that a monkey can be a poet. I would think that being a poet at least encompasses (1) knowing a language, and (2) producing and/or selecting an arrangement of »sentences« of that language as meant to be taken in a certain way: hence a monkey cannot be a poet.[18] I am not concerned to argue this point here however. I am concerned only to make clear that on the view I am advancing *if* one allows that a monkey can be an artist or poet, then it is in principle possible for a monkey to be as creative an artist as Picasso or as creative a poet as Shakespeare. If monkeys cannot be artists or poets, then neither can they be creative artists or creative poets, no matter what they produce. The same argument applies *mutatis mutandis* to machine behavior.

I think the problem that Tomas raises here is not so much a problem about creativity as about art — whether what is produced by monkey or machine can properly be called art. If it can, then no doubt some such artworks and »artists« are more creative than others. Even if monkeys are not creative *artists*, however, it doesn't follow that it would never make sense to say that a monkey was creative. After all, ascriptions of creativity implicitly compare what's been created to other things of similar kind and provenance. To say that little Johnny is creative is perhaps to say that *for a five-year-old* he is cre-

[18] Whether a monkey can do these things is of course an empirical question. Current experiments in teaching language to chimps may, for all we know, result in some chimp poetry.

ative, and it is not to compare him with Picasso. Similarly one might want to say that Bonzo is more creative than the other chimps if he does paintings with a far greater variety of colors and configurations. But to say this would be only to say that he is a more creative *chimp;* it is not to put him in a class with Picasso, or even with little Johnny.

II. To construe creating, as many have, as a kind of making, is to overlook crucial differences between the concepts *making* and *creating.* Consider the following examples of »make« and »create« in sentences with the same direct object.

> The chef made a new soup today.
> The chef created a new soup today.
>
> The seamstress made a new dress.
> The fashion designer created a new dress.

Although the same noun occurs as direct object in both sentences of each pair, with »make« the noun designates a particular thing, but with »create« the noun is generic. If the chef created a new soup, he created a new kind of soup, a new recipe; he may not have made the soup. But if we say »He made a new soup today,« »soup« refers to some particular pot of soup he prepared. The seamstress made some particular dress, but the fashion designer created a new design.[19] Particulars are made, types created.

Suppose a potter makes a vase and creates a new design on the surface. It may seem that the design is a particular thing, but what was created is a particular design only in that it is a particular *type* of design. If I say he created a new design, I do not mean that what he created are just those lines he put on the surface of the vase. Suppose I make a thousand copies of that vase; I could then show the potter any of the copies and ask, »Did you create the design on this vase?«. The answer in all cases would be Yes. The answer would be No if I asked, »Did you make the design on this vase?«. With »make,« »design« refers to an individual; with »create«, »design« refers to a type. The use of »create« or »make« — one word rather than the other — does not indicate a different sort of process, but a different sort of product (individual or type). Someone might in the *same* process both make a design (individual) and also thereby create a design (type). When we talk about what is created we are not primarily concerned with some particular individual object and its fabrication, rather we are concerned primarily with the idea, conception, or design that that individual object embodies. If I serve you a dish and say it was created by Brillat-Savarin, I do not mean that he has been resurrected and put to work in my kitchen; he developed the recipe.

[19] This distinction is nicely observed in a recent television commercial for sewing machines. The camera takes us to the workroom of a fashion designer who tells us: »I depend on my machines to make the things I create«.

At this point it might be objected that the choice between »create« and »make« does not always indicate a different sort of object: we do not distinguish the kind of »product« (individual or type) when, for example, we say, »He created a disturbance« rather than, »He made a disturbance.« True, but I am concerned only with creating that is *creative*. One can create all sorts of things; before lighting a fire in the fireplace, we heat the chimney to create a draft; we can create a disturbance, or create a nuisance; we create difficulties, impressions, opinion. If someone creates a certain impression, it is no reason to call him creative; he may create the impression of himself that he is uncreative. If someone creates a draft, or a menace, or difficulties, or a stir, it is usually no reason to call him creative. But if a chef creates a new dish, a businessman creates a new way of merchandising, or a painter creates a work of art, these often are reasons to call that person creative. My remarks about the verb »create« (here and elsewhere in this paper) apply only to cases in which the adjective form »creative« is also applicable; this is the use of »create« which, like »creative,« is honorific. The object of »create« when the creating is non-creative is some specific state of affairs rather than some new conception.

I said earlier that there is a conceptual truth contained in Tomas's claim that in creative activity the artist does not envisage the final result of his work. I have argued similarly that creating is producing what is new to the agent. Also when we consider that what is of primary importance in talk of creativity is not the fabrication of some particular object but rather the idea or conception it embodies, this explains Tomas's example of the sculptor. It is now commonplace for sculptors to send the plans for their sculptures to foundries to be executed; in such a case, the sculptor is clearly the creator of the artwork though the foundry makes the work. In the analogous case of an artist who is executing his work himself from a finished plan, the creative part of the work is done, as Tomas says, and what remains is to objectify the idea. (But of course it is not *only* in being creative that one does not forsee the product of one's efforts.)

An issue that's been debated recently is whether natural objects, such as pieces of driftwood, can be works of art. If they can, a curious question arises: who is the creator of such artworks? When Morris Weitz argued in an oft-quoted passage that a piece of driftwood could be a sculpture, and Joseph Margolis vigorously denied this, they put the issue this way: is being an artifact a necessary condition of something's being a work of art?[20] But what really seems at issue in their dispute is whether

[20] »None of the criteria of recognition is a defining one, either necessary or sufficient, because we can sometimes assert of something that it is a work of art and go on to deny one of these conditions, even the one which has traditionally been taken to be basic, namely that of being an artifact: Consider, 'This piece of driftwood is a lovely piece of sculp-

a work of art must have been made by someone and that is another matter. I will now argue that although (1) being an artifact *is* a necessary condition of something's being a work of art, (2) there is no conclusive reason to insist that a work of art must have been made by someone, and so (3) an artist may create a work of art that no one has made.

Most often the term »artifact« is used to refer to an object of archeological or historical interest, such as an ornament, weapon or utensil; obviously something need not be an artifact in this sense, a relic of some defunct culture, before it can be considered a work of art. But »artifact« is used also to refer to contemporary objects; without stretching the term one can speak of automobile hubcaps and plastic dishes as artifacts of our present-day culture. Practically any sort of alteration of the material environment might count as an artifact — a pile of rocks serving as a marker, for example, or a circle of trees planted to demarcate a certain area. Also a single natural object can be an artifact if it has been invested with some important function. Suppose that a stick — one that has not been materially altered, has not been carved or smoothed by any one — takes on magical significance in some culture. The stick, let's suppose, is believed by everyone in the culture to have certain magical properties; it may be handled only by the high priest, and by him only in accordance with certain rituals. Surely such a stick would count as an artifact of that culture; one can easily imagine it, if its use were known, on display centuries later along with the bowls, spears and jewelry of that culture.

Now let's take a hypothetical case. Suppose an artist exhibits pieces of driftwood; perhaps the gallery announces a new conception *Beach Art*. The pieces of driftwood are materially unaltered — i. e. they have not been sanded, smoothed, carved, or re-shaped by anyone. Suppose further that this exhibit is warmly accepted by the artworld, and so the pieces of driftwood acquire the status of artworks. The very fact that the pieces of driftwood would have acquired the status of artworks in our culture would qualify them as artifacts of our culture; i. e. any object accepted as a work of art in our culture would thereby automatically qualify as an artifact of our culture. And since being a work of art of a culture is a *sufficient* condition

ture.'«, M. Weitz »The role of Theory in Aesthetics«, rep in J. Margolis PHILOSOPHY LOOKS AT THE ARTS, N.Y. 1962: 57. »What he says is surely FALSE ... If anyone were pressed to explain the remark, he would of course say that the driftwood looks very much like a sculpture, that it is as if nature were a sculptor, that we could imagine the driftwood actually fashioned by a human sculptor. In making such a remark, we hardly wish to deny what IS a necessary condition for an object's being a work of art, in any sense that is seriously relevant, 'namely, that of being an artifact.'« J. Margolis THE LANGUAGE OF ART AND ART CRITICISM, Detroit 1965: 40.

of something's being an artifact of that culture, it follows that being an artifact is a *necessary* condition of something's being a work of art, a *logically* necessary condition though. Just as the stick's being a magic wand would qualify it as an artifact of its culture, the driftwood's being an artwork would qualify it as an artifact of its culture. The argument so far, then, is that being an artifact is a *logically* necessary condition of something's being a work of art. The question that remains is: can a piece of driftwood (or some other natural object) qualify as an artwork?

As was mentioned earlier, an artist need not *make* the work of art he creates. A sculptor might send the plans for a steel sculpture to a foundry there to be fabricated, and in various other ways an artist may have other craftsmen execute the work of art he creates. What is central to the notion of creating something is the new design, idea, or conception, not fabrication; most often one creates a work of art in the process of executing it, but this is not necessary.

But the artist need not even design the art object. Duchamp displayed as art a urinal and entitled it *Fountain:* he did not make the object nor did he design it, yet he created the artwork *Fountain*. Among Duchamp's other »readymades« was a bottlerack, which became an artwork appropriately entitled *Bottlerack;* it is acknowledged by many as an artwork, and as one *created* by Duchamp. So in many cases the creator of a work of art has not fabricated the art object, and in other cases the artist has not only not made the art object, he has not designed it either. And if the artist need not have made and need not even have designed the art object, then I see no conclusive conceptual block to allowing that the artwork be a natural object.

As far as I know, neither pieces of driftwood nor other natural objects are now universally accepted as artworks. So besides separating the question of artifactuality from that of whether an artwork need have been made, what I have been arguing is that there is no conceptual absurdity in the idea of a work of art created by someone but made by no one. There are not sufficient grounds for ruling *a priori* that pieces of driftwood or other natural objects cannot be works of art, and if they are accepted as such, they would not be that much different from objects already widely accepted as artworks. Already we have artworks that were neither made nor designed by the artist who created them.

The direction of the present argument has been influenced by Arthur Danto's paper »The Artworld.« Also influenced by Danto's argument that »to see something as art requires something the eye cannot decry — an atmosphere of artistic theory, a knowledge of the history of art: an artworld,«[21] George Dickie

[21] A. Danto »The Artworld«, above: 16.

has argued that art's institutional setting makes possible a definition of art in terms of necessary and sufficient conditions. Dickie argues that a work of art can be defined as »1) an artifact 2) upon which some person or persons acting on behalf of a certain social institution (the artworld) has conferred the status of candidate for appreciation.«[22] This is not the place to discuss Dickie's theory in detail, but in order to raise some pertinent issues I'll briefly register some doubts about it.

First, for the reasons given above the condition of artifactuality seems to me superfluous. Also, it is doubtful that the definition sets forth conditions sufficient for something's being a work of art. Consider the tools, tableware, textiles, office equipment, and other functional objects in the Museum of Modern Art's Design Collection. Arthur Drexler, director of the department, says that »an object is chosen for its quality because it is thought to achieve, or to have originated, those formal ideals of beauty which have become the major stylistic concepts of our time ... It applies to objects not necessarily works of art but which, nevertheless, have contributed importantly to the development of design.«[23] Here we have objects — *not necessarily works of art* — upon which someone acting in behalf of the artworld has conferred the status of candidate for appreciation. And granting what Danto says, that to see something as a work of art — or, at least, that to see some things as works of art — requires an atmosphere of artistic theory, it doesn't follow, given such an atmosphere, that even in the artworld everyone will see it as art. The artworld is not monolithic. Some painters and sculptors still balk at calling pieces of driftwood works of art. Their hesitation to call such objects works of art does not stem from a reluctance to value such objects: no matter how exquisite such objects may be, they would say, they are no more works of art than is a magnificent sunset. They know, moreover, the intent with which such objects have been proffered as art, they understand fully the theory of *objets trouvés;* their reluctance to call such objects works of art is their reluctance to *accept* that theory. For them the theory does not establish a sufficiently strong link between found natural objects and the body of acknowledged works of art so that they are willing to classify the natural objects as artworks. I do not wish to discuss the question how widely accepted as art an object must be before it can be said unequivocally to be art. I am not even sure that that is the right question to raise. I want only to register a doubt about Dickie's claim that anything proffered as art is to be classified unequivocally as art no matter the extent of its acceptance. Nowadays it would be simply false to claim that a

[22] G. Dickie AESTHETICS, Pegasus 1971: 101.

[23] Quoted by A. L. Huxtable in »MOMA's Immortal Pots and Pans«, NEW YORK TIMES MAGAZINE, OCT 6, 1974: 74.

Jackson Pollock painting is not a work of art; similarly, I think, with Duchamp's readymades. And perhaps not even pieces of driftwood are a borderline case, although I think they are. In any case, the driftwood dispute is illuminating because it shows that although on Danto's view anything might become a work of art, that doesn't mean *anything goes:* rational argument has a place in formulating and assessing the theory that would extend the concept of art to some new kind of object.

In mentioning Duchamp's readymades I claimed that although Duchamp did not make or design the bottlerack, he *created* the artwork *Bottlerack*. He brought into existence a new work of art (although he did not make a new object). It might be objected that if an art museum director decides to put on display a collection of, say, bottles, or doorknobs or shopping bags, objects not generally considered works of art, and they come to be generally considered artworks, it is not the museum director who is credited as the artist who created them, rather it is the person who designed the objects. And if, in general, the person responsible for bringing about acceptance of x as an artwork is not considered the artist who created x, why should we say it is Duchamp, and not the person who designed the bottlerack, who created *Bottlerack*? But there is a difference between the two cases: Duchamp is creating art and the museum director is only displaying it. Presumably when the museum director decides to put on display doorknobs, shopping bags, or whatever, his gesture is one of calling attention to objects he considers to be already works of art, but ones that have gone unrecognized. But Duchamp and subsequent artists who have transformed mere objects into artworks by signing their names to them have not supposed that there were all these objects, already artworks, lying around unnoticed; they have created those objects artworks. (I purposely choose this locution to parallel the locution »The Monarch created him an Earl.«) (I am not, by the way, assuming that all such creatings are creative.)

The Duchamp case I think supports Danto's contention that »it is the role of artistic theories, these days as always, to make the artworld, and art, possible.«[24] It is not the case, as I take Dickie to be saying, that it is simply the right institutional setting that confers the status »work of art,« but rather it is, as Danto emphasizes, the artistic theory which relates the new object to the existing body of acknowledged artworks. And, I would think, it is because of the specific theory in the context of which Duchamp's readymades appeared that they are artworks.

In writing about the Museum of Modern Art's mammoth Duchamp retrospective, Harold Rosenberg points out that »since their first public appearance, [Duchamp's] creations have

[24] Danto: 18.

possessed an inherent capacity to stir up conflict. Sixty years ago, he entered the art world by splitting it, and he still stands in the cleft.«[25] »[H]e remains the primary target to those critics and artists whose interest lies in restoring art to a 'normal' continuity with the masterpieces of the past.«[26] Rosenberg then sketches the case against Duchamp, one argument of which is the following.

In adopting the ready-made, Duchamp has introduced the deadly rival of artistic creation — an object fabricated by machine and available everywhere, an object chosen, as he put it, on the basis of pure »visual indifference,« in order to »reduce the idea of aesthetic consideration to the choice of the mind, not the ability of cleverness of the hand.« In the world of the ready-made, anything can become a work of art through being signed by an artist... The title »artist,« no longer conferred in recognition of skill in conception and execution, is achieved by means of publicity.[27]

To repeat a point I've already belabored, skill in execution cannot be considered necessary for artistic creation since works of art are so often not executed by their creators. To exclude readymades on that account would entail excluding too much else. And ingenuity, wit, and insight of conception are not necessarily excluded either. Just as some artworks of great technical skill embody the most banal conceptions and others, brilliant conceptions, is there not a range of conceptual skill exhibited in readymades, *objets trovés,* and works of conceptual art? Such art does exclude »ability or cleverness of the hand,« but it does not on that account preclude artistic creation.

Richard J. Sclafani

The Theory of Art

I. The Theory of art is at least as old as Plato. Yet, surprisingly little attention has been given to problems concerning the nature and justification of theories of art. This contrasts significantly with moral theory, e. g., whose nature and justification have often, if not always, been treated as central to proposed theories of morality. It is for this reason this is a somewhat unorthodox fashioned paper. It begins with a critique of a well-known program for moral theory — John Rawls' »Outline of a Procedure for Ethics«.[1] For reasons which will

[25] H. Rosenberg »The Art World«, THE NEW YORKER, FEB 18, 1974: 86.

[26] Ibid.: 88. [27] Ibid.

[1] J. Rawls »Outline of a Decision Procedure for Ethics«, PHIL REV 60 (1951): 177-97, hereinafter referred to as (OP, xx).

become clear, this program is of more than passing interest for the theory of art. Rawls' »Outline« not only comprises the anatomy of his major work, *A Theory of Justice*,[2] it also provides a useful framework through which certain problems in the theory of art can be profitably treated. Broadly speaking, this piece can be thought of as a study in the comparative anatomies of moral theory and art theory. Of course, studies in comparative anatomy are bound to turn up structural differences as well as structural similarities. This will certainly be the case here. The stages of this study will compare and contrast Rawls' views on the nature of moral theory with the views of two philosophers particularly sensitive to parallel concerns in the theory of art — R. G. Collingwood and Arthur Danto. To this end it will be necessary to examine some well-known views of Thomas Kuhn on the nature of scientific theory insofar as they bear upon moral theory and the theory of art.

II. It is clear from the outset of TJ that Rawls' conception of the nature of moral theory is an integral part of the particular theory of morality developed in his book. He begins his work with »Some Remarks About Moral Theory« and ends with »Concluding Remarks on Justification.« We can begin to answer the question »What is a theory of art?« by considering first what Rawls has to say about a theory of justice (morality). It must be stressed, however, that the following account is preliminary and that considerable revision may be required.

For Rawls, a theory of morality is not unlike a theory in any other area. A theory of morality aims to explain, help us better understand, etc., a given body of factual data. In this case, that data is what Rawls calls the considered moral judgments of competent judges. A successful moral theory is one which provides a set of principles which when applied in concrete situations most adequately explicate the judgments we ordinarily make. Rawls puts it this way

There is a definite if limited class of facts against which conjectured principles can be checked, namely, our considered judgments in reflective equilibrium. A theory of justice is subject to the same rules of method as other theories (TJ, 51).

Although Rawls uses expressions such as »considered moral judgment,« »competent judge,« »reflective equilibrium,« and »explication« in quasi-technical ways, he appears to have a largely non-technical, common sense notion of »theory« in mind when he discusses the nature of a moral *theory*. While Rawls' quasi-technical apparatus certainly needs to be examined, initially this non-technical notion of a theory seems appropriate for his purposes. Spinoza's experiment notwithstanding, a moral theory cannot consist of definitions, axioms, theorems, etc.,

[2] Cambridge 1971, hereinafter (TJ, xx).

to be somehow projected onto our everyday moral affairs. Rawls sums up this point by saying

Definitions and analyses of meaning do not have a special place: definition is but one device used in setting up the general structure of a theory. Once the whole framework is worked out, definitions have no distinct status and stand or fall with the theory itself. In any case, it is obviously impossible to develop a substantive theory of justice solely on the truths of logic and definition. The analysis of moral concepts and the a priori, however traditionally understood, is too slender a basis. Moral philosophy must be free to use contingent assumptions and general facts as it pleases. (TJ, 51)

On a common sense level, the purpose of a moral theory is to achieve and impart explanation and understanding of our moral sentiments, powers, judgments, behavior, and insofar as they bear upon our moral life, our institutions. The term »theory« will be used frequently throughout this paper. For the most part, it will be used in this informal way. When, in connection with the views of other writers, the term is used differently, the differences, which will often be crucial, will be carefully noted.

Since a moral theory cannot proceed *a priori*, and since substantive knowledge of those human interests which give rise to the need to make moral decisions is required of any theorist, all moral theories, Rawls' included, are bound to be fallible, subject to revision, and even replaceable (cf. TJ, 52). Questions about meaning and truth in moral theory cannot be answered by appealing to consistency and coherence alone. In order to evaluate the adequacy of a moral theory one must know how it proposes to solve concrete moral problems such as individual rights *vs.* common good, political and economic equality, etc. For Rawls, conceptual analysis and linguistic investigation have a central place in moral philosophy, but the essential concerns of a moral theorist cannot end here. He also seems committed to the view that moral theory exerts an active influence on our everyday moral affairs, enabling us to determine what is and is not just, what we ought and ought not to do, etc. (PO, 178) If this view seems familiar and relatively clear, it is important to note that Rawls may neither wish to nor be able to sustain such a position within the general framework of his theory. These matters will be attended to shortly.

III. Before discussing Rawls' position further, we can begin an account of art theory by noting some striking parallels between his conception of a moral theory and Collingwood's conception of a theory of art. In the Preface to *The Principles of Art* Collingwood says

I do not think of aesthetic theory as an attempt to investigate eternal verities concerning the nature of an eternal object called Art, but as an attempt to reach, by thinking, the solution of certain problems arising out of the situation in which artists find themselves here and now.[3]

[3] Oxford 1938, hereinafter (PA, xx).

Collingwood, like Rawls, is hardly interested in Aristotelian real definitions, and like Rawls, he does not begin with Aristotelian first principles. For Collingwood, a theory of art begins with facts — not recondite facts, but facts well known to any person with sufficient experience of the subject matter of his book

The order of facts to which they belong may be indicated by saying that they are the ways in which all of us who are concerned with art habitually think about it, and the ways in which we habitually express our thoughts in ordinary speech (PA, 125).

Whose thoughts and opinions does Collingwood have in mind? He adresses his book to the person ». . . whose experience of the subject matter has been sufficient to qualify him for reading books of this kind . . .« (PA, 125); to all those who are »properly qualified to judge . . .« (PA, 87) matters of the sort dealt with in his book. Collingwood appears to have in mind a rather select class of people sufficiently educated in the history and practice of art. He appears to be interested in accounting for what might best be called »the considered aesthetic judgments of competent aesthetic judges.« But Collingwood is acutely aware that art, like language, owes its existence to society as a whole. While relations between art and society are complicated in ways that are difficult to unravel, it is clear that given his general conception of art, Collingwood must provide an account of the relationship between the beliefs of ordinary people on aesthetic matters and those considered aesthetic judgments upon which his theory of art is based. In turn, this necessitates an account of the relationship betweeen those considered judgments and his theory itself. As we shall see, Rawls must provide parallel accounts of the relationships between the beliefs of ordinary people on moral matters, the considered moral judgments of competent judges upon which his theory of justice is based, and the theory itself.

Roughly speaking, Collingwood regards the aesthetic beliefs of ordinary people as a cluster of loosely related thoughts and opinions which are unclear and unsystematic as they stand. The first task of the art theorist is to sort out those aesthetic judgments arrived at as the result of informed consideration from those which are merely the product of unreflective opinion. It may then be possible for philosophers to articulate principles of art upon which these considered judgments are based. This sorting out process obviously runs the risk of circularity, however, so more will need to be said about such key notions as »considered aesthetic judgment« and »competent aesthetic judge.« Indeed, this rough account of the relationship between ordinary discourse, considered judgments, and philosophical theory needs considerable refinement for both Collingwood and Rawls.

For Collingwood, the problem ». . . is to clarify and system-

atize ideas we already possess; consequently there is no point in using words according to some private rule of our own, we must use them in a way which fits onto common usage« (PA, 1). The articulation of a theory of art must be consequent to this. His requirement that a theory of art leads to judgments which are publicly justifiable promises several possible advantages. If principles of art can be educed in accordance with the considered aesthetic judgments of competent critics, then not only will we be in a position to engage in informed criticism of commonly held aesthetic views, but we will also be in a position to apply these principles to new problems and new movements in the arts. Such developments may call for emendations of various sorts in our theory of art, but this is only to be expected given our enlarged experience of aesthetic possibilities. The justification of proposed principles of art will be a matter of multiple considerations in mutual support. Their justification will rest upon an entire conception of art and the relative success with which they help to organize our considered aesthetic judgments. This conception of justification is highly similar to Rawls' conception of justification (TJ, sec. 9 & 87).

A corollary of the view of justification which Rawls and Collingwood adopt is that in order to construct a theory of morality or art, in order to educe principles of justice or art, in order to define key terms as they occur in moral and aesthetic judgments, it is not enough simply to be able to recognize instances of the things in question when one comes across them. Rather, one must know their relations to other things as well, and if one's knowledge of those other things is vague, the proposed theory might be worthless. For Rawls, justice must be seen in its multiple relations to politics, economics, psychology, sociology, decision theory, etc. It is little wonder that Rawls regards his theory as »primitive,« »gravely defective,« and »incomplete.« For Collingwood, art too must be seen in its multiple relations to religion, science, morality, history, and especially, to language. Only then can we approach an adequate understanding of art, whether it be as artist, audience, critic, historian, or theoretician (PA, vii).

IV. We can begin a critical discussion of Rawls' conception of a theory of morality and apply the results, *mutatis mutandis*, to Collingwood's conception of a theory of art. To do this it will be necessary to cite Rawls' familiar characterizations of the concepts of »competent judge,« »considered moral judgment,« »explication,« and »reflective equilibrium.« A competent moral judge is characterized as a person of normal intelligence with adequate factual knowledge of the world in which moral action takes place; a person who is reasonable insofar as open-mindedness, willingness to change one's opinions in the light of new facts, etc. characterize reasonableness, and who shows a sympathetic understanding of those human interests which give rise to the need to make moral decisions (OP, 178-180).

Rawls then defines a considered moral judgment in terms of the conditions under which it is made (OP, 181-183). He lists seven such conditions, but for purposes of this discussion, they needn't be repeated. For in the end, these conditions carefully select those judgments most likely to be made in accordance with the intuitions and habits of thought and imagination of a competent judge (OP, 183).

It is important to ensure that Rawls has avoided the trap of circularity in characterizing the concepts of »competent judge« and »considered moral judgment.« On the face of it, he appears to avoid this trap. A competent judge is not defined in terms of the particular principles he holds, nor the particular judgments he makes. Moreover, the seven defining conditions of a considered judgment guarantee the non-arbitrary and morally neutral quality of a competent judge. The concepts of »competent moral judge« and »considered moral judgment« are thus correlative. So there is a *prima facie* case for thinking that Rawls has not defined these concepts in a circular manner. Whether or not this case can be sustained, however, will depend upon further aspects of his theory to be considered below. For now, we note that Rawls' account of the concepts of »competent moral judge« and »considered moral judgment« allows him to introduce the concept of an »explication.« A set of moral principles »explicates« a set of moral judgments if any competent person, applying these principles consistently and intelligently in particular cases under review, would arrive at a set of judgments identical with the set of considered judgments of competent judges (OP, 184).

This preliminary account of Rawls' conception of moral theory can be completed by examining the concept of »reflective equilibrium.« Rawls frequently compares his method in ethics to that of the inductive logician

In the latter study [inductive logic] what we attempt to do is to explicate the full variety of our intuitive judgments of credibility which we make in daily life and in science in connection with a proposition, or theory, given the evidence for it. In this way we hope to discover the principles of weighing evidence which are actually used and which seem to be capable of winning the assent of competent investigators. The principles so gained can be tested by seeing how well they can resolve our perplexity about how we ought to evaluate evidence in particular cases, and by how well they can stand up against what appear to be anomalous, but nevertheless settled, ways of appraising evidence, providing these anomalies exist (OP,190).

Rawls wishes to formulate and later justify principles of justice in a manner similar to the way in which an inductive logician might formulate and justify principles of inductive logic. It is commonplace, however, in inductive logic and science, that discrepancies arise between principles derived from a given body of factual data and some of the judgments we come to make about that data. In such situations, we can alter the

principles, the judgments, or both, depending upon what the particular case seems to call for. Rawls finds this to be the case in ethics as well

By going back and forth, sometimes altering the conditions of the contractual circumstances, at others withdrawing our judgments and conforming them to principle, I assume we shall find a description of the initial situation that both expresses reasonable conditions and yields principles which match our considered judgments duly pruned and adjusted. This state of affairs I refer to as reflective equilibrium (TJ, 20).

This procedure of »going back and forth« indicates that, for Rawls, the starting points of a moral theory are relatively, not absolutely, fixed. Rawls puts this point another way by noting that we might well wish ». . . to change our present considered judgments once their regulative principles are brought to light . . . a knowledge of these principles may suggest further reflections that lead us to revise our judgments« (TJ, 49). In both theory and practice, Rawls believes that »Ethics must, like any other discipline, work its way piece by piece« (OP, 189). Because principles and judgments are mutually emendable, our awareness of our own moral positions can always be enlarged, made more acute, and so on. Reflective equilibrium ensures the extensional openness of both the class of competent judges and the class of considered moral judgments. It also indicates in its own way Rawls' apparent commitment to the view that moral theory exerts an active influence on everyday moral thought.

V. Rawls' position on the nature and justification of a theory of morality gives rise to several problems not all of which will be treated here.[4] This discussion will focus on the cluster of problems generated by Rawls' conception of the relationship between a philosophical theory of morality and ordinary moral thought. The first problem within this cluster is providing an adequate account of the relationship between the considered moral judgments of compentent judges and the moral beliefs and opinions of ordinary people. The general form of this problem can be stated as follows: On the one hand, Rawls wants to say that the class of considered moral judgments must be grounded in and checked against the beliefs, attitudes, sentiments, intuitions, sensibilities, etc., of ordinary people. On the other hand, he admits that there is no guarantee that the considered judgments of competent judges will always coincide with what he calls »the common moral thought of mankind.« To see this problem in more precise terms it will be helpful to compare Rawls' position to the position of another moral philosopher in the same tradition in which Rawls sees himself working.

In *The Groundwork of the Metaphysics of Morals* Kant re-

[4] For an excellent survey of these problems see C. E. Harris Jr. »Rawls on Justification in Etics«, SW J PHIL 5 (1974): 135-44.

peatedly insists that his theory of morality expresses no more than is already contained in ordinary moral discourse. Yet, when it comes to explaining the precise nature of the relationship between the dictates of the Categorical Imperative and ordinary moral reason, Kant resorts to what is essentially an *ad hoc* metaphor:

In studying the moral knowledge of ordinary human reason we have now arrived at its first principle. This principle it admittedly does not conceive thus abstractly in its universal form; but it does always have it actually before its eyes and does use it as a norm of judgment.[5]

Kant never says exactly what it means for ordinary moral reason to have his principle »actually before its eyes.« Nevertheless, it seems plausible to interpret him as saying that the Categorical Imperative enters into moral reasoning as a norm of judgment in a manner similar to the way in which *modus ponens, modus tolens*, etc. enter into deductive reasoning as norms of validity. Ordinary moral reason could no more function without the Categorical Imperative than deductive reason could function without laws of logic of the sort mentioned above. This is not surprising since Kant regards moral philosophy as an *a priori* science.

Suppose we now ask of Rawls whether or not common moral thought always has his principles of justice before its eyes. How shall he answer this question? Given his conception of moral theory, two quite different sets of responses seem possible, each of which generates its own special problems. As we shall see, it is far from clear that these different sets of responses are compatible with one another, and making them compatible might result in a considerable weakening of Rawls' position.

One way in which Rawls might respond contrasts significantly with Kant's position. Kant sees his principle of morality »operative« or »at work« in common moral thought. In Kant's view, ultimately there cannot be a conflict between the dictates of the Categorical Imperative and common moral thought. This is guaranteed for Kant by the *a priori* validity of his moral principle. Rawls, however, specifically denies that his principles of justice possess any *a priori* validity whatsoever, and he explicitly maintains that conflicts between his theory and common moral thought are not only possible but inevitable. So unlike Kant, who sees his moral principle as a constitutive element of common moral thought, Rawls would like to maintain a clear separation of the three principal elements in his theory: (1) common moral thought; (2) the considered judgments of competent judges; (3) the theoretical account of those judgments which includes his principles of justice.

Given the general framework of Rawls' theory, there is an

[5] Trans. H. J. Paton, N.Y. 1964: 71.

important reason for this. If his principles of justice were already operative in common moral thought, in rendering considered moral judgments competent judges could not fail to resort to these principles. But the class of considered moral judgments must be neutral with respect to theoretical principles of justice since, for Rawls, it is upon these judgments that principles of morality are based. Unless Rawls maintains a strict separation of the three principal elements in his general view, the non-circularity of his position would be severely compromised. Thus, Rawls' theoretical apparatus, including his principles of justice, must be understood as primarily explanatory and not constitutive of common moral thought. On this reading of Rawls' position, moral theory must be regarded as merely a mirror, albeit many-faceted, of common moral thought.

Can Rawls sustain this strict separation of principal elements and thereby ensure the non-circularity of his program? Other aspects of his theory raise serious obstacles to this end. Rawls says explicitly that moral theory ought to enable us to determine what is and is not right, what we ought and ought not to do, etc. The concept of reflective equilibrium calls explicit attention to the interworking of moral theory and everyday moral thought insofar as considered judgments and ethical principles, both of which are ultimately grounded in common moral thought, are mutually emendable. On the face of it, the concept of reflective equilibrium appears to be a relatively simple and straightforward way of characterizing the relationship between moral theory and common moral thought.

It is by no means clear, however, that the relationship between moral theory and common moral thought can be this simple and straightforward for Rawls. On Rawls' view, moral theory explicitly incorporates complex economic and mathematical considerations as they emerge in economic and mathematical theory. He says, for example,

A correct account of our moral capacities will certainly involve principles and theoretical constructions which go much beyond the norms and standards cited in everyday life; it may eventually require a fairly sophisticated mathematics as well. This is to be expected since on the contract view the theory of justice is part of the theory of rational choice. (TJ, 47)

What is meant by an »account« in this passage? If the concept of reflective equilibrium is to play the role Rawls assigns it, an account cannot be simply a theoretical explanation of our moral capacities, for a theory of morality is supposed to actively influence everyday moral affairs and not just explain our thoughts and actions concerning moral matters.

What is the nature of this influence? What sort of relationship is there between the theory of rational choice, for example, and common moral thought? Rawls does not deal with

these questions directly. He does, however, offer an analogy which suggests a way in which they might be answered.

A useful comparison here is with the problem of describing the sense of grammaticalness that we have for the sentences of our native language. In this case the aim is to characterize the ability to recognize well-formed sentences by formulating clearly expressed principles which make the same discriminations as the native speaker. This is a difficult undertaking which, although still unfinished, is known to require theoretical constructions that far outrun the ad hoc precepts of our explicit grammatical knowledge. A similar situation presumably holds in moral philosophy. (TJ, 47)

Rawls thus implies that characterizing our sense of justice requires theoretical constructions that far outrun the *ad hoc* precepts of our explicit moral knowledge. Presumably, economic and mathematical constructions are among these theoretical devices.

No doubt, common moral thought does involve complex psychological, political, economic, etc. factors. And no doubt, the presumptive principles which characterize our moral capacities must have a complex structure. Does this mean, however, that economic and mathematical theory, insofar as they are encompassed by moral theory, have an active influence on common moral thought? On the basis of his analogy between linguistic theory and moral theory, Rawls seems committed to the view that common moral thought is, at least in some ways, theory dependent.

This point can be made as follows: One result of completing the task in linguistic theory of adequately accounting for the sense of grammaticalness we have for the sentences of our native language will be a refinement of that sense of grammaticalness. This means that at least some revisions in our present judgments concerning grammaticalness are to be expected. Indeed, only the emergence of certain theoretical equipment in linguistics has made it possible to make certain grammatical discriminations which are simply beyond the reach of what Rawls calls our explicit grammatical knowledge.[6] Cannot the same be said for certain moral judgments given Rawls' conception of moral theory? Rawls says that a more adequate theory of justice is bound to call for various changes in our considered moral judgments. Insofar as a theory of justice incorporates economic and mathematical theory, it would seem that only with the aid of economic and mathematical devices in moral theory can certain moral judgments be made. This means that having a theory of justice would make certain moral judgments possible. It also means that a considered moral judgment for Rawls might well involve complex economic and mathematical theory — theory which his account of morality explicitly incorporates — theory which ordinary people could

[6] This point was made clear to me in discussions with Z. Vendler.

hardly master, and which could hardly be present (even in inchoate form) in the judgments they now make since much of it is yet to be constructed. If this is true, competent judges will have to master more and more technical economics and mathematics in order to render considered judgments. And the gap between competent judges and ordinary people might be considerably broadened, issuing a corresponding broadening in the gap between considered judgments and common moral thought.

On this reading of Rawls' position, the strong separation of moral theory and common moral thought cannot be sustained. Rawls seems forced to admit that his theory of morality, including his principles of justice, are, after all, in some ways »operative« in common moral thought (however different the nature of their operation may be from Kant's principle). This suggests, among other things, that the notion of theory appropriate in Rawls' case is not as simple and straightforward as it first appeared, that a more esoteric notion of theory seems appropriate — a notion more familiar in discussions of theory dependence in the philosophy of science.

VI. It has been noted that Collingwood addresses *PA* to those who are »properly qualified to judge«. A competent aesthetic judge can be characterized as a person of normal intelligence, tolerably familiar with the history and practice of art; a person who is reasonable, as shown by a readiness to receive and contribute to new movements in the arts, revise judgments in the light of new developments, etc., and who has a sympathetic understanding of those human interests which give rise to the creation and evaluation of works of art. Considered aesthetic judgments of competent aesthetic judges should help to make clear what is expressed in the linguistic practices of which, as speakers of the language, we are already masters. So Book I of *PA*

...is chiefly concerned to say things anyone tolerably acquainted with artistic works knows already; the purpose of this being to clear up our minds as to the distinction between art proper, which is what aesthetics is all about, and certain other things which are different from it but are often called by the same name (PA, vi).

Moreover, the distinctions in question are, in theory, something objective

In principle, the question whether this piece of verse is a poem or a sham poem is a question of fact on which everyone who is properly qualified to judge ought to agree (PA, 89).

But is the problem actually this simple? Is discriminating works of art from other things simply a matter of articulating and employing distinctions already embedded in ordinary art discourse, even for those »properly qualified to judge«? Several considerations suggest negative answers to these questions. As was noted in Rawls' case, there is no *a priori* reason to sup-

pose that considered judgments and common thought will always coincide. Nowhere has this been more evident than in painting and sculpture since World War II. Considered aesthetic judgments concerning Abstract Expressionism and certain strains of Pop Art have repeatedly clashed with common aesthetic opinion. This is nothing new. Similar clashes occurred at the turn of this century with the advent of Post-Impressionist art. They occurred with Impressionist art itself. In general, these clashes seem to occur whenever a firmly entrenched artistic position is being challenged by a group of apparent revolutionaries (the Delacroixs, the Monets, the Cézannes, the Picassos, *et al.*).

By no means, however, are these clashes confined to the arena of considered judgments *vs.* ordinary aesthetic thought. They occur within the class of considered aesthetic judgments as well. Royal Cortissoz, the art critic of the Herald Tribune in the Post-Impressionist era, wrote: »The farce will end when people look at Post-Impressionist pictures as Mr. Sargent looked at those shown in London, 'absolutely skeptical as to their having any claim whatever to being works of art'.«[7] At the same time, an equally prominent critic, Clive Bell, was arguing vehemently for the artistic enfranchisement of these pictures.[8] History has overwhelmingly favored Bell's position. But this does not in itself constitute grounds for arguing that Cortissoz was not a competent judge. As Rawls seeks to make clear, a competent judge cannot be defined in terms of the substantive principles he or she holds or the particular judgments he or she makes. Such a definition would result in a circularity fatal to any theory. It would be nearly impossible to show that a critic of Cortissoz's rank and reputation was not competent, and it would be clearly inappropriate to argue incompetence on grounds of subsequent historical development.

The possibility of conflicting considered judgments among competent judges raises serious problems for both Collingwood and Rawls. For if a theory of art or morality is supposed to explicate the considered judgments of competent judges, the question arises, »Against which set of considered judgments is the adequacy of a theory to be tested?« This problem is compounded by historical complexities. Stuart Hampshire has pointed out that Rawls' theory of justice would hardly explicate the considered moral judgments of Plato or Aristotle.[9] Yet, these philosophers must be regarded as highly competent judges. Collingwood explicitly recognizes that his theory of art

[7] R. Cortissoz »The Post-Impressionist Illusion« as quoted in P. Ziff PHILOSOPHICAL TURNINGS, Ithaca 1966: 33.

[8] C. Bell ART, N.Y. 1958. See esp. Ch. II, »Aesthetics and Post-Impressionism«.

[9] S. Hampshire »A Theory of Justice«, rev. article, THE NEW YORK REVIEW OF BOOKS 3 (1972).

would not explicate the considered aesthetic judgments of these philosophers. In fact, he regards his theory as a significant improvement upon what he calls the technical theory of art which dominated, in his view, the entire pre-eighteenth century era. Although claims of historical relativity should be scrutinized with great care, insofar as considered judgments of competent judges seem to vary considerably from era to era, art and morality can be characterized as historically relative for Collingwood and Rawls. This is a point of major significance for Collingwood and Rawls, for given their view of philosophical theory, if aesthetic and/or moral judgments change from era to era, then theories of art and morality must change along with them.

Whether or not the apparent facts of historical relativity seriously damage Rawls' position and whether or not he can adequately account for the apparent changes in considered moral judgments and moral theories are questions not to be dealt with here for the following reason: whether or not the problem of historical relativity damages Rawls' position on moral theory, it does not damage at all Collingwood's position on art theory. It is taken as commonplace that considered aesthetic judgments do vary from era to era, that we fully expect these changes to take place, and that we wholeheartedly welcome them. How uncharacteristic of art activity it would be if Picasso painted like Rembrandt, or if Shakespeare wrote like Sophocles. And how uncharacteristic of art criticism it would be if our aesthetic sensibilities and our considered aesthetic judgments were not altered by the achievements of different artists in different historical periods. It is perhaps a fundamental difference between morality and art that the idea of moral relativity is intuitively repugnant while the idea of artistic relativity, in the sense indicated, is intuitively indispensable.

Against which set of considered aesthetic judgments is the adequacy of a theory of art to be tested? On a Collingwoodian account, a highly provisional answer to this question is: the set of considered aesthetic judgments which most adequately supports and is mutually supported by concurrent theories of art in particular historical eras. Hence, without an adequate theoretical exposition of the ordinary art discourse of a given period, it is unlikely that we would be able to make the requisite distinctions, formulate the appropriate considered judgments, etc. which enter into the discrimination of art from non-art. Thus, Collingwood devotes Book II of PA to a philosophical exposition of the terms and distinctions employed in his preliminary account of art in order to show that the conceptions they express support and are supported by his theory (PA, vii).

VII. The account of the relationships between art theory, considered aesthetic judgments, and ordinary aesthetic thought suggested above need further elucidation. Moreover, it raises new problems, such as the problem of conceptual change, which

will have to be dealt with by anyone endorsing a position similar to Collingwood's. Danto has begun to develop a version of the position under discussion,[10] which can be used to elucidate what has been said so far. It also provides a focal point for specifying in precise terms the problems which surface when this view of art theory is carefully examined. Finally, Danto's work suggests some ways these problems might be met, although these suggestions will be found wanting.

Like Collingwood, Danto believes that theories are indispensable to the task of rendering considered judgments. He says,

but telling art works from other things is not so simple a matter, even for native speakers, and these days one might not be aware that he is on artistic terrain without an artistic theory to tell him so. And part of the reason for this is that the terrain is constituted artistic in virtue of artistic theories, so that one use of theories, in addition to helping us discriminate art from the rest, consist in making art possible. (AW, 10)

The claim that theories make certain phenomena possible is by now well familiar in the philosophy of science. Since it is relatively new to aesthetics, however, it will be necessary to discuss two examples which are intended to show what Danto has in mind.

The first example has already been mentioned — Post-Impressionist paintings. Cortissoz was not alone in his scathing indictment of the pictures of Van Gogh, Picasso, Matisse, Braque, etc. Kenyon Cox, a prominent *fin de siècle* critic wrote about cubism,

...the real meaning of the Cubist movement is nothing else than the total destruction of the art of painting...Having abolished the representation of nature and all forms of recognized and traditional decoration, what will the 'modernists' give us instead?[11]

Why were critics such as Cox and Cortissoz so vehement in their refusal to countenance Post-Impressionist pictures as art? One tempting answer is that they regarded representation or imitation as a necessary characteristic of art, and saw Post-Impressionist art as non-representional or non-imitative. But this answer will not do for critics like Cox explicitly recognized that a Turkish rug or a tile from the Alhambra, and many other forms of traditional decoration, although without representative purpose, nonetheless posses intrinsic artistic merit. Furthermore, while some Post-Impressionist pictures, e. g. some of Kandinsky's works, were non-representational, most others, including such major works as Cézanne's »Mount Sainte-Victorie« series and Picasso's »Les Demoiselles d'Avignon« clearly were representational, although it is certainly true that they

[10] A. Danto »The Artworld«, above 9-20; »Artworks and Real Things«, THEORIA 39 (1973): 1-18. Hereinafter (AW, xx) and (AR, xx), respectively.

[11] K. Cox »The 'Modern' Spirit in Art« quoted by Ziff op. cit.: 33f.

did not represent or imitate in a traditional fashion. Thus, Cortissoz clearly recognizes representation in Van Gogh's drawing when he says, »The Laws of perspective are so strained. Landscape and other natural forms are set awry. So simple an object as a jug containing some flowers is drawn with the uncouthness of the immature, even childish, executant.«[12] And of Matisse he wrote, ».. . whatever his ability may be, it is swamped in the contortions of his mishappen figures.«[13]

Remarks such as these make it tempting to think that the issue was largely a matter of taste. No doubt, Post-Impressionist art did not suit the tastes of traditional critics. But if this were the only explanation available for their refusal to recognize these works as art, much of what is significant and fundamental to both traditional and modern painting would be lost. One could scarcely find an art history textbook nowadays which did not discuss the fundamental differences between traditional and modern painting with respect to such things as perspective, use of color, distortion, etc.

Danto's view of the role of theories in art suggests an interesting way to characterize such fundamental differences and the ultimate achievement of art status on the part of Post-Impressionist pictures. He finds that the Imitation Theory of Art (IT), which dominated aesthetics from Plato through the nineteenth century, is an extremely powerful theory explaining much about the causation and evaluation of artworks. As the position taken by traditional critics such as Cox and Cortissoz suggest, however, in terms of the IT, it was not possible to see the works of Picasso, Matisse, et al. as works of art. Since this was neither a question of holding representation to be a necessary characteristic of art, nor was it simply a matter of taste, a different explanation altogether for this sort of phenomena seems indicated. According to Danto, to see these pictures as art what was called for was

... not so much a revolution in taste as a theoretical revision of considerable proportions, including not only the artistic enfranchisement of these objects, but an emphasis upon newly accepted features of accepted art works, so that a quite different account of their status as artworks would now have to be given. (AW, 11)

At the core of Danto's »theoretical revision« is the claim that art need not be understood as unsuccessfully imitating real forms, but rather, as successfully creating new ones. Danto calls this new theory of art the Real Theory (RT). And again, in one form or another, the RT can be seen at work in practically any history of art written today.[14] Danto goes on to say that the RT ushered in a whole new way of looking at art,

[12] Cortissoz op. cit.: 35. [13] Ibid.

[14] See, e. g., the popular text by H. W. Janson HISTORY OF ART, Englewood Cliffs 1962.

such that we now have countless numbers of paradigm cases for teaching the use of the expression 'work of art' which would have ». . . sent our Edwardian forebears into linguistic apoplexy« (AW, 11).

On an account of the Danto/Collingwood sort there is a striking parallel between the structure of certain developments in the history of art and the structure of certain developments in the history of science. There is often a reluctance to accept new theories to explain new phenomena because a well-established or widely-acclaimed theory is being threatened. Of course, older theories are never abandoned all at once. Typically, various attempts will be made to rescue them from imminent demise by the introduction of auxiliary hypotheses, such as that the artists in question are egoistical or incompetent. Cortissoz's indictment of Van Gogh is a typical case in point. Gradually, however, if auxiliary hypotheses and other such devices fail, and the new phenomena persist in demanding explanation, a new theory emerges which includes all of the old theory's strong points, but accounts for the new phenomena as well. Although it has been just briefly summarized, an interesting consequence of a theoretical shift of this sort is brought out in Post-Impressionist art. Echoing Dewey's famous remark,[15] Danto notes

As a result of the new theory's acceptance, not only were Post-Impressionist paintings taken up as art, but numbers of objects (masks, weapons, etc.) were transferred from anthropological museums (and heterogeneous other places) to MUSEES DES BEAUX ARTS, though as we would expect from the fact that a criterion of the acceptance of a new theory is that it accounts for whatever the older one did, nothing had to be transferred out of the MUSEES DES BEAUX ARTS — (AW, 11)

Danto's position on art theory resembles in significant ways the position of Kuhn on scientific theory. In an important commentary on science and art, Kuhn makes a point very similar to Danto's

Though contemporaries address them with an altered sensibility, the past products of artistic activity are still vital parts of the artistic scene. Picasso's success has not relegated Rembrandt's paintings to the storage vaults of art museums. Masterpieces from the near and distant past still play a vital role in the formation of public taste and in the initiation of artists to their crafts.[16]

Kuhn goes on to draw a contrast between art and science in this respect

Few scientists are even seen in science museums, of which the function is, in any case, to memorialize or recruit, not to inculcate craftsmanship or enlighten public taste. Unlike art, science destroys its past. (C 407)

[15] J. Dewey ART AS EXPERIENCE, N.Y. 1934: 48f.

[16] »Comment«, COMPARATIVE STUDIES IN PHILOSOPHY AND HISTORY (1969): 407; hereinafter (C, xx).

At this point it will be helpful to consider a rather different kind of example which illustrates in its own way Danto's claim that theories make art possible.

In a movement of inadvertent prophecy, Kierkegaard unwittingly raises the possibility of abstract expressionist art. One of his alter egos of *Either/Or* tells us

The result of my life is simply nothing, a mood, a single color. My result is like the painting of the artist who has to paint a picture of the Israelites crossing the Red Sea. To this end, he painted the whole wall red, explaining that the Israelites had already crossed over, and that the Egyptians were drowned.[17]

Imagine this »artist« exhibiting this »painting« in 1843 when *Either/Or* was first published — the age of Ingres, Delacroix, Daumier, etc. Surely, it would have been dismissed as a joke, a fraud, or worse. Yet, pictures such as these are clearly possible nowadays — questions of merit aside — and so are their logical opposites, namely, monochrome canvasses which defy any literary interpretation whatsoever.

Such an object could not have been art in 1843, for in 1843 it would have been impossible, on Danto's position, to have a painting of X which did not represent X in terms of obvious resemblance features, and it would have been impossible for there to be a painting which was not about, did not depict, etc. something real or imaginary. Today, we no longer demand literary or pictorial content in painting. If Danto is right, the way has been paved for us by the theoretical revision which began with what art historians now call the Post-Impressionist Revolution, and the subsequent developments in twentieth century painting. The gap between the Monets and the Rothkos had to be bridged by the skill and ingenuity of the Picassos and the Pollocks. In 1975, we appear to be in a position to formulate questions about art, make critical aesthetic judgments, etc., which would have been meaningless, perhaps self-contradictory, in the nineteenth century.

VIII. Danto's position is deceptively appealing. It seems to accord with accepted opinion in art history. It invokes a prominent and engaging tradition in the philosophy of science. And it operates at a level of generality both sweeping and powerful in scope, thus satisfying a craving natural to both philosophy and art history. Nonetheless, Danto's position on the nature of art theory faces serious difficulties which may turn out to be insurmountable. One difficulty centers around an ambiguity in his use of the term »theory«. By »theory« Danto does not mean anything so narrow as what Plato produced in *The Republic,* Reynolds in *The Discourses,* Collingwood in *The Principles,* etc. Rather, he has in mind something much broader and much more general than any of these. It could not be simply for the sake of »the exigencies of logical exposition« that

[17] S. Kierkegaard EITHER/OR, Garden City 1959, I: 28.

Danto speaks of *The* Imitation Theory of art, for he is concerned with a general conception of art and not with what Plato, Aristotle, Reynolds, or any other theorist might have produced at some particular time. Thus, Danto characterizes the *Real Theory* in very general propositions such as, »Art is not to be understood as unsucessfully imitating real forms but as sucessfully creating new ones quite as real as the forms which the older art had been thought, in its best examples, to be creditably imitating« (AW, 11); and art is to be thought of as making ». . . non-imitations which are radically distinct from all heretofore existing real things« (AR,4).

It is clear that something like the RT is not a specific theory in anything like the way in which *The Poetics, The Principles,* etc. are theories. The expressions Danto uses to characterize this »theory« are expressions such as »A whole new mode of looking,« »A modification of perception,« »A way of seeing something as something,« etc. It would be natural to add to this list expressions such as »A perspective,« »A guiding factor in the practices of artists, critics, historians, theorists, etc.,« »A Kunstweltanschauung,« and perhaps, given the affinities Danto's position bears with the Kuhnian tradition in the philosophy of the science, »A paradigm«.[18]

In the commentary mentioned earlier, Kuhn underscores the importance of his discovery of certain parallels between art activity and scientific activity. He says

A belated product of that discovery is the book on SCIENTIFIC REVOLUTIONS . . . Discussing either developmental patterns or the nature of innovation in the sciences, it treats such topics as the role of competing schools and of incommensurable traditions, of changing standards of value, and of altered modes of perception. Topics like these have long been basic for the art historian but are minimally represented in writings on the history of science. (C, 403)

At approximately the same time he was making these remarks, Kuhn was composing the Postscript to the second edition of SR. Because he had used the term »paradigm« ambiguously in the first edition, and because this ambiguity became the source of significant criticism of his position on the nature of science and scientific change, Kuhn distinguishes two senses of the term »paradigm« in this Postscript

On the one hand, it stands for the entire constellation of beliefs, values, techniques, and so on shared by a given community. On the other, it denotes one part or element in that constellation, the concrete puzzle-solutions which, employed as models or examples, can replace explicit rules as a basis for the solution of the remaining puzzles of normal science. (SR, 175)

It is Kuhn's first sense of »paradigm«, which he calls »socio-

[18] THE STRUCTURE OF SCIENTIFIC REVOLUTIONS, Chicago 1962, 2nd ed.; hereinafter (SR, xx).

logical,« that seems immediately and especially relevant to Danto's notion of »theory,« for this is the sense of »paradigm« which, as Kuhn explicitly indicates, has to do with »modes of perception,« »perspectives,« and the like. Unfortunately, it is far from clear that this sense of »theory« or »paradigm« is of much explanatory value for Danto or Kuhn. Kuhn, in fact, seems to recognize this in his Postscript when he acknowledges that the second sense of the term which he distinguishes is »philosophically deeper.« The lack of explanatory effectiveness of the sociological sense of »theory« or »paradigm« becomes evident when we ask if an art theory (or paradigm) in this first sense is anything we can clearly identify. On the one hand, the answer is a deceptively straightforward yes. After all, look at any art history text for an account of the Post-Impressionist period. Not only do we see a theory (paradigm) operating here, but a theoretical revision (paradigm shift) as well. On the other hand, the issue is far more difficult than appearances lead us to believe. What we can identify are particular artists, works, exhibitions, etc. which seem to fit into a certain historical perspective we construct from a distance of half a century of unprecedented artistic experimentation.

Did something like Danto's RT emerge, become entrenched, and guide art activity in the Post-Impressionist period in a way which justifies his claims of »theoretical revision«? Although a full treatment of this question will not be attempted, it is clear that it is extremely difficult to answer, for it involves simultaneously complex issues of a historical and a conceptual sort. On the historical side, there is an ever-present danger of circularity which Danto must avoid. The problem can be stated as follows: A theory, in his sense, is what a given art community shares (e. g., the community of Post-Impressionist artists, critics, and so forth); and a theory is what makes possible the artistic enfranchisement of works produced within a community, (The »artworld«). Conversely, however, what a given art community shares, what makes the work of practitioners within a community possible, is a theory. It becomes clear that an artworld, must be identifiable independently of its theoretical or paradigmatic structure. Only then is it possible for theories or paradigms, in Danto's sense, to be articulated in a non-circular way by doing such things as carefully examining the works of art, works of criticism, etc. produced within a given artworld.

Identifying art communities in a non-trivial way is not as easy as first appearances might suggest. It takes considerable expertise to sort out the multiple historical factors which give rise to and come to define (at least in part) a given period of art. Moreover, the empirical techniques required of an art historian are often highly complex, involving archeological, anthropological, philological, and even scientific laboratory procedures. The task of identifying art communities also requires

considerable critical ability. Careful critical analyses, especially of pivotal works such as Botticelli's »The Birth of Venus,« Monet's »The Picnic,« Picasso's »Les Demoiselles d'Avignon,« etc. are indispensable to this task. Without extensive critical analyses the relevant similarities and dissimilarities among works of different artists in different periods would simply escape us. This fact suggests an interesting application of Kuhn's second, »philosophically deeper« sense of »paradigm« to art. If paradigms are thought of as accepted concrete examples of scientific achievement, then it will be particular works of art, and not the styles, theories, etc. they may exemplify which will best serve as paradigms for the art historian. If it should turn out to be ultimately impossible to adequately specify theories or paradigms in the first »sociological« sense, perhaps art communities could still be talked about in terms of their individual achievements. In fact, Kuhn believes that it is ultimately impossible to specify the nature of the shared elements which supposedly distinguish one scientific or artistic theory (paradigm) in the sociological sense from another (C, 412). Clearly, however, this issue cannot be settled *a priori,* and it cannot be settled without a careful examination of the essential differences between art and science of which Kuhn is well aware.

Certain strains of intellectual and social history, as well as certain psychological and sociological studies, are also relevant to identifying art communities. Detailed studies of the role of various institutions in moulding the art activity of a given era are perhaps only now being fully recognized for their potential value in helping us understand and appreciate art movements. The psychology of perception in the hands of writers like E. H. Gombrich sheds considerable light on questions and problems with which art historians have long been concerned (although it is by no means easy to find philosophical value in such studies). And such subjects as the opportunity for professional communication, dissemination of information, climate of opinion, and other bits of research in the sociology of art are now being given special attention, (cf. SR, 176). A similar discussion of the community structure of the artworld is strongly indicated. Without such a discussion, it might appear that Danto has forced an interpretation on the development of art at the turn of the century which does not accord with the actual history of that period, and that he has vastly oversimplified what was surely an extremely complex era vis-a-vis art perspectives. The possibility that Danto has opted for sweeping historical generality where painstaking specificity is indicated is a problem which looms ever larger in his program.

Thus far, only historical difficulties have been mentioned in identifying art communities. There are conceptual problems as well. It seems clear enough that non-representational art did gain a foothold in this century (excluding the sorts of non-

representational decoration already mentioned). And it appears that something like Danto's RT can be seen at work in the emergence and entrenchment of non-representational art. But the theoretical accounts, explanations, justifications, etc. for this phenomenon vary enormously. Non-representational views of art received very different theoretical fomulations at the hands of Bell-Fry, Collingwood, Dewey (albeit unwittingly), to mention just a few prominent writers. Were all of these theorists articulating the same non-representational paradigm? If not, which of them most closely approximates Danto's theoretical revision (RT)?

This point can be illustrated more clearly if we turn to a remote historical period which is far more easily identifiable and not nearly as complex as twentieth century art — namely, the Golden Age of Greek Art. Surely the Greeks subscribed to a mimetic conception of art. But what does it mean, exactly, to to say that art is imitation? Is it Plato's or Aristotle's account of imitation which best articulates the Greek way of looking at art? Can we actually identify anything like »the Greek way« of looking at art? If we can, the identification will have to be made without recourse to the paradigm of mimesis in order to avoid the obvious problem of circularity. And we must bear in mind that however dissimilar their accounts may be, both Plato and Aristotle must be regarded as highly competent judges.[19]

[19] Again, whether or not anything like »the Greek way« of looking at art can be identified is a question which cannot be settled A PRIORI. But the procedures for answering are relatively clear. The job requires a detailed analysis of both the ordinary art discourse and the considered aesthetic judgments of competent critics generated by the works of this period. IN CASU, this task requires philological expertise. G. Else's important study ARISTOTLE'S POETICS: THE ARGUMENT, Cambridge 1954, can be taken as a model for this sort of investigation which seems appropriate. In order to explicate the Greek concept of imitation, Else examines varieties of uses of that term and its correlates and varieties of things which a broad cross-section of Greek writers regarded as mimetic. He then attempts an elaborate philosophical analysis of the concept of mimesis in the context of working out the structure of the argument which he sees in the POETICS, and concludes that Aristotle's account most adequately articulates the Greek concept of mimesis (which has been identified without recourse to the POETICS or the REPUBLIC per se).

Of course, this is no guarantee that Else's analysis will go unchallenged. Fundamental disagreement on a philosophical or philological level is always possible. And it is always possible to argue that a conflicting theory of mimesis, Plato's e. g., accounts for the considerate aesthetic judgments of at least some competent Greek writers more adequately than does Aristotle's. (Similarly, it could be argued that a laissez-faire conception of justice more adequately explicates the considered moral judgments of some persons Rawls would have to regard as competent moral judges, more adequately than the principles of his own theory). It must be emphasized, however, that the possibility of conflict and disagreement notwithstanding, it sometimes happens that views of the sort Else and Danto articulate gain general acceptance, as evidenced by the fact that an assimilation of their general conceptions of their

This survey of the problems and issues central to the theory of art can be brought to a close by considering one further problem faced by a view of the Collingwood/Danto sort — the problem of conceptual change. Danto says that a Warhol Brillo box could not have been art at the turn of the century. He likens this »could not« to flight insurance in the Middle Ages and to Etruscan typewriter erasers (AW, 18). The reason for this is that at the turn of century, the required theoretical background of the RT had not yet emerged. When Danto says »could not have been art« he is saying that the accepted meanings of »art« and its correlates, which would have been dependent on an IT background for their meaning in the last century would not have sanctioned using »art«, »work of art«, etc. to talk about something like a Brillo box. Two points of major significance for the Collingwood/Danto type of view follow from this: (1) The meanings of »art« and its correlates are theory dependent. (ii) The meanings apparently changed when the IT-RT revision took place.

But how are these changes to be characterized? For one thing, it is extremely difficult, perhaps impossible, to say how meaning is related to perspectives, or to »seeing something as something«. And it is equally, if not more difficult to say how ways of seeing change, shift, get revised, emerge, become entrenched, etc. The problem is especially acute for Danto and Collingwood, for the meaning change which allegedly take place must be explained without recourse to the influence of the theories or paradigms which are supposed to exhibit the structure of these changes. No doubt, varieties of historical, sociological, psychological, institutional, and other causal factors enter into meaning changes and paradigm shifts on such a view. But causal explanations alone cannot account for standards of correct and incorrect linguistic usage. Some sort of logical account of meaning and meaning change is called for. And this sort of account must go beyond the ordinary measures of deductive and inductive reasoning.

To illustrate what is meant by a »logical account of meaning«, we can contrast Collingwood's account of shifts in »constellations of absolute presuppositions«[20] with Danto's account

subject, the distinctions generated by those conceptions, the methods of analysis employed in arriving at conclusions of major importance, etc. becomes a standard part of the education of anyone proposing to work in the field. It is safe to say that Nietzsche's BIRTH OF TRAGEDY has acquired this status (to cite one important philosophical example). Whether or not Else's study of the Greek KUNSTWELTANSCHAUUNG or Danto's IT-RT revision account will gain such acceptance cannot be determined in advance. Only when all of the implications of their proposed analyses are examined in detail can a full assessment be made.

[20] Roughly, Collingwood's concept of »constellations of absolute presuppositions« is equivalent to Kuhn's notion of »paradigm« in the sociological sense — Kuhn himself uses the notion of a »constellation of beliefs, values, etc.« in a highly Collingwoodian way.

of what happens when a »theoretical revision« takes place. In reply to the question »Is a shift in absolute presuppositions merely a change of fashion or taste, or is it something different?« Collingwood makes the following observations which are crucial enough to be quoted at length

A »change of fashion« is a superficial change, symtomatic perhaps of deeper and more important changes, but not itself deep or important. A man adopts it merely because other men do so, or because advertisers, salesmen, etc., suggest it to him. My friend's formula »If we like to start new dodges, we may«, describes very well the frivolous type of consciousness with which we adopt or originate these superficial changes. But an absolute presupposition is not a »dodge« and people who »start« a new one do not start it because they »like« to start it.

People are not ordinarily aware of their absolute presuppositions, and are not, therefore, aware of changes in them: such a change, therefore, cannot be a matter of choice. Nor is there anything superficial or frivolous about it. It is the most radical change a man can undergo, and entails the abandonment of all his most firmly established habits and standards for thought and action. Why, asks my friend, do such changes happen? Briefly, because the absolute of any given society, at any given phase of its history, form a structure which is subject to »strains« of greater or less intensity, which are »taken up« in various ways, but never annihilated. If the strains are too great, the structure collapses and is replaced by another, which will be a modification of the old with the destructive strain removed; a modification not consciously devised but created by a process of unconscious thought.[21]

Collingwood's causal description of the processes involved in shifts of absolute presuppositions are highly insightful and reveal a good deal about his historicist position on the nature of conceptual diversity and conceptual change. Unfortunately, his remarks do not amount to a logical analysis of such shifts. This is not because his description is largely metaphorical, or because terms such as »unconscious thought« are hopelessly vague. It is because he says almost nothing about how a given term which occurs with a certain meaning in one set of presuppositions — »work of art«, e. g. — comes to have a different meaning in another set of presuppositions. And he says almost nothing about the appropriateness of advancing reasons in support of replacing one set of presuppositions with another.

Danto has an intriguing account of style matrices which suggests quite another alternative, and which might be used to help exhibit the structure of the theoretical revisions with which he is concerned. He claims that a necessary condition for something to be a work of art is that at least one »pair of artistically relevant predicates« be applicable to it. Such a pair consists of two predicates which he calls »opposite predicates«, such as »representational« and »non-representational«, »expressionist« and »non-expressionist«, etc. (AW, 18f) He calls these pairs of predicates »opposites« rather than »contradictories« because as they are usually understood, contradictory precates apply to all objects, whereas »opposites« apply only to

[21] ESSAY ON METAPHYSICS, Oxford 1940: 98n.

some. It is not true, e. g., that all objects are either expressionist or non-expressionist, but it is true that all works of art are either expressionist or non-expressionist on Danto's view. Thus, pairs of opposite predicates behave like contradictory predicates when applied to certain classes of objects only — to works of art for example.

Danto uses this logical apparatus to set up a matrix of artistic styles. This can be constructed, such that we get a truth-table like matrix, see AW, 19. Since each row determines an available style given the active critical vocabulary available at a given time, theoretical revisions in the artworld might be thought of in terms of adding new columns of art-relevant predicates and their opposites. As is the case with propositional truth-tables, the addition of a new column, in this case an art-relevant predicate, increases the number of available styles by 2^n. A rather fascinating point follows from this construction:

... suppose an artist determines that H shall henceforth be artistically relevant for his paintings. Then, in fact, both H and non-H become artistically relevant for all painting, and if his is the first and only painting that is H every other painting in existence becomes non-H, and the entire community of paintings is enriched, together with a doubling of the available style opportunities. It is this retroactive enrichment of the entities in the artworld that makes it possible to discuss Raphael and DeKooning together — or Lichtenstein and Michelangelo. (AW, 20)

As fascinating as Danto's account may be, it leaves largely untouched the problem of meaning and meaning change in the artworld. How, e. g., does a pair of predicates become artistically relevant? By fiat? By Picasso speaking ex-cathedra? By mounting emotive force? By rational choice? Danto does not, and perhaps cannot, answer these questions. Yet, they are crucial to his position.

Another problem raised by this matrix account is the problem of distinguishing between style and theory, in Danto's sense of »theory«. It has been noted that there are good reasons for Danto to steer clear of talking about specific theories of art such as Plato's or Collingwood's, and to talk of »theories« in the looser sense instead. But this raised difficult problems. Now it may well be the case that the same sorts of considerations which drove Danto from talk of particular theories to paradigm-theories now move him from talk of paradigm-theories to styles. As Kuhn points out, »Both 'style' and 'theory' are terms used when describing a group of works which are recognizably similar. (They are 'in the same style' or 'applications of the same theory'.)« (C, 412) But a familiar problem awaits Danto at this turn. It is extremely difficult, and perhaps impossible, to specify the precise nature of the elements which supposedly distinguish a given style or theory from another. And if this task is accomplishable, it might best be accomplished not by examining styles or theories in themselves, but by critical analyses of particular achievements (paintings,

sculptures, etc.) »in the style of« or »exemplifying the theory« in question. Once again, this points in the direction of Kuhn's »philosophically deeper« sense of »paradigm«.

Colin Lyas

Danto and Dickie on Art

In recent years a number of writers, notably Arthur Danto and George Dickie[1] have made remarks that have been referred to as »The Institutional Theory of Art«. What is involved in these remarks, though often of great importance, is not always clearly discernible. In what follows I shall try to disentangle what seem to me to be the important points from the sometimes confusing surroundings in which they occur.

I. In the course of objecting to Weitz's claim that artifactuality is not a necessary condition for something's being art, Dickie writes:

Any theory of art must preserve certain central features of the way we talk about art. (A, 104).

One of the themes of Danto's work is an attack on a view, possibly implicit in the assertion that I have quoted from Dickie, of what a philosophical account of art should be.

This view, correctly called 'Socratic' by Danto runs roughly as follows: I and other native speakers have mastered the term 'art' and its cognates. Our mastery, in part at least, is a matter of our having »internalized« rules which tell us what conditions must be met before we can apply the term 'art' to this or that object. The (complex) task of a Socratic 'theory' of art is to extract from our use, these principles that we have mastered, »showing forth« as Danto puts it, »what we already know, wordy reflections of the actual linguistic practice we are masters in« (AW, 10). Such an enquiry will issue in assertions such as »When we use the term 'art' of a thing we imply that this or that feature is present.« The test of such a theory (representation of rules of use) is, as Dickie suggests, whether it *does* match our use. Danto neatly sums the matter up thus:

It is of course indispensable in Socratic discussion that all participants be masters of the concept up for analysis, since the aim is to match a real defining expression to a term in active use ... This is precisely what the adequacy of the theory is to be tested against, the problem being to make explicit what we already know. It is OUR use of the term that the theory means to capture (AW, 9f).

[1] A. Danto »The Artworld«, above 9—20, hereinafter referred to as »AW«, and »Artworks and Real Things«, THEORIA 39 (1973), hereinafter »AR«. G. Dickie AESTHETICS, N.Y. 1971, hereinafter »A«.

The view of philosophical endeavour contained in this account is not uncommon in modern philosophy. The issues it raises are highly complex and it would involve too long a digression to deal with them here[2]. Instead I wish to comment upon Danto's objections to this 'Socratic' procedure as a method in the philosophy of art.

In the characterization of Socratic procedure that I have just quoted, Danto correctly observes that it assumes an agreed use, *our* use, the principles of which the Socratic analysis is perspicuously to represent in what Danto calls »a theory«. The existence of this pre-theoretic agreement must be assumed, since that is what the theory seeks to explain and it is that against which the theory is tested.

To this account Danto makes the objection that given modern developments in art we can no longer assume, as we must if we are to use the Socratic procedure, that native speakers know and agree, prior to any theorizing, how to use the term 'art'. Indeed they may now need a theory to tell them what is art and what is not. Thus Danto writes:

Telling art works from other things is not so simple a matter even for native speakers, and these days one might not be aware he was on artistic terrain without a theory to tell him so. So that one use of theories consists in making art possible (AW, 10).

There is an element of truth in Danto's claim that a »theory makes art possible«. This may be put as follows: Those who at various times have used the term 'art' have wished to use it of some things and to withhold it from others. The reasons they give for applying it and withholding it reveal their rules for the use of the term, and these rules of application might, I suppose, be called a 'theory'. In that sense of 'theory' it seems to be a necessary truth that theories make art possible for us. For unless we have such rules we will be unable to say what is art and what is not. To concede *that*, however, is not to admit anything that will undermine the Socratic procedure. It is true for *any* use of the term 'art' that that use is possible only if there are rules (a 'theory') for that use. So it is true for any use of the term 'art', (ancient or modern) that if we are to be clear as to what it is to use that term, then we must, in Socratic fashion, lay bare the rules internalized by those who use it.

Danto does not seem to me, then, to have shown that modern art is different in that a theory makes it possible to call it 'art'. It is possible, however, that despite appearances he did not wish to show this but rather to show (i) that the theory of art (rules of use for the term 'art') since Post-Impressionism are not those which governed the use of that term prior to Post-

[2] On this see, for example, the articles in my PHILOSOPHY AND LINGUISTICS, London 1971.

Impressionism and in consequence that (ii) reflection upon the earlier use of the term 'art' will not reveal what those are up to who now use that term of such things as modern New York painting. Reflection on the earlier use will to be sure turn up a body of rules (a theory of art). (Danto calls it »Imitation Theory«). However, those who use the term 'art' of Post-Impressionists (Van Gogh, Gauguin and Cézanne) and of modern New York painting employ a different, explicitly formulated theory of art. That is to say they have different rules in terms of which to decide what is art and what is 'significant' about it. This being so, native speakers, operating with the older theory of art, still encapsulated in their language, will not be able to understand why certain things are now called 'art'. They will only come to see that certain things *are* now art if they learn the new theory (rules of use) according to which those things *are* now called 'art'.

If this is Danto's story, then he is not so much raising difficulties for the Socratic method of analysis, namely, the method whereby we discover a theory of art by revealing the principles underlying the use of the term 'art' by this or that group. For that method will be needed if we are to understand why people call, say, modern New York painting 'art'. Rather he is attacking the belief that the use of the Socratic method on the vernacular of those native speakers who are heirs to an older view of art, can tell us about the new art, or even help us to see that it is art at all.

II. Let us now look more closely at the claim that the view of art implicit in the vernacular of native spakers has been replaced by a new and more explicit theory in accordance with which new sorts of things are called 'art' and old sorts of things are called 'art' in a new way. This claim is an extremely complex one. It rests first upon some historical claims, namely (i) that a certain set of rules (Imitation theory) was implicit in the vernacular of native users of the term 'art', (ii) that another theory (dubbed 'RT' by Danto), not in use prior to Post-Impressionism, *is* the new theory according to which people now decide whether something is art.

Discussion of these historical claims will be a complex matter — a matter not aided by the fact that Danto gives no very clear account of »Imitation Theory« or of its supposed replacement. I do not here propose to undertake those enquiries necessary to verify or falsify the claim that the present rules of use for the term 'art' differ from the rules (theory), prior to Post-Impressionism, for the use of that term[3]. Rather I wish to show that there is a possible inconsistency in Danto's exposition. For he tells us that art since Post-Impressionism is adjudged to be art by criteria (theories) different from those in terms of which

[3] On this matter see R. Sclafani »Artworks, Art Theory, and the Artworld«, THEORIA 39 (1973).

the old art was adjudged to be art. Thus he says that to get Post-Impressionist paintings accepted as art

> required ... a theoretical revision of rather considerable proportions, involving not only the artistic enfranchisement of these objects but an emphasis upon NEWLY SIGNIFICANT FEATURES of accepted art works so that QUITE DIFFERENT ACCOUNTS of their status as art works would now have to be given (AW, 11, my italics).

He speaks too of a »whole new mode of looking at paintings old and new«. But although he *says* this I shall show that where he does characterize the new art he does so in terms of features that arguably have figured, even prior to Post-Impressionism, as features believed to be characteristic of art.

III. By way of approach to this matter let us begin with Danto's native plain speaker, christened by him 'Testadura'. It is to such bafflements as Testadura's when confronted with, say, a painted tie, a can opener, a paintstreaked bed, facsimiles of Brillo cartons piled high in neat stacks, (all Danto examples), that Danto's essays are in part directed. He wishes to tell Testadura »what makes it art?« (AW, 17).

If Testadura *is* baffled by the fact that people call such things 'art' then two ways of relieving his bafflement suggest themselves. One is to show him that those who call these 'art' are using the term 'art' in a different sense from him. Alternatively one might hope to show him that they are using the term in the same sense, so that things *he* recognizes as relevant features in a work of art are, contrary to first appearances, present in the works in question.

Sometimes Danto seems to have the first of these in mind, as when he talks of one theory of art »replacing« another so that »quite different accounts« have to be given. Since the meaning of the term 'art' is given by giving the principles governing its use (its 'theory') to say that modern art now falls under a different theory seems to suggest that the term 'art' is used of modern works by virtue of different rules of application. And *that* might seem to suggest that the term 'art' as used of modern New York painting does not mean what it does when used of earlier works. I do not think however that Danto can mean this. For he wishes to claim that there is a theoretical revision of the term 'art', and the term 'revision' here suggests some continuity between the term 'art' before the revision and the term 'art' after it. In the first sort of reply to Testadura, however, we get not so much revision of the term 'art' as its 'ambiguation', namely, a linguistic slackening that comes about when one term, whose use has hitherto marked the presence of certain features, is now used to mark the presence of quite different ones.

Of course the second line of reply to Testadura that I suggested is equally unpromising for Danto, although, as I shall argue later, this is arguably the reply that he makes. For if

Danto explains the new art to Testadura in terms of the features that Testadura already counts as relevant features of art, what becomes of the claim that modern art is art in a quite different way?

Danto, then, seems to need some middle ground between equivocation and univocity in the use of the term 'art'. Sometimes he suggest the following line. Up to a certain time people call things 'art' if they exhibit some one or other of a set of features A,B,C,D,E. After that time they call things 'art' if they exhibit some one or other of an expanded list of features A,B, C,D,E,F,G,H, ... There being an overlap in the two lists of features it begins to make sense to speak of »conceptual revision«. That Danto does have this account in mind is suggested by his talk of »adding art relevant predicates« (elsewhere called »newly significant features«). He writes

suppose an artist determines that H shall henceforth be artistically relevant for his paintings. Then in fact both H and non-H become artistically relevant for ALL paintings ... and the entire community of paintings is enriched (AW, 20).

Now one difficulty here, as we shall see, is that Danto either does not give examples of »*newly* significant features« or gives examples that, although significant, are not new. And of course unless one does show that features *have* been added since Post-Impressionism, claims that the term 'art' has undergone some conceptual revision or enrichment, are as yet empty. For the present however, let us examine this 'enrichment' account as a *possible* line of reply to Testadura.

On this account one says to Testadura 'you are baffled by the new art because you call works of art 'art' because of features A,B,C,D,E, these new objects are called 'art' not merely in terms of these features but also because of further features F, G,H, etc.' Now, however, Testadura seems to have something like his former reply. Why, he might ask, since they *are* different features, treat F,G,H, etc., as features of *art*, in the sense in which I, Testadura, use that term. Either they are 'added' because they are already implicit in the principles according to which I call something 'art', in which case whence this talk of »conceptual revision,« or they are arbitrarily tacked on. If these features are just arbitrarily tacked on, having no essential relationship to the features in virtue of which I call something 'art', then again we seem to have the ambiguation rather than the revision of the term 'art'.

There are various possible replies to this but I shall concentrate on one that derives from Danto and Dickie, and which runs as follows.

There is, and has long been in existence something called 'the artworld'. Confining ourselves to paintings and sculptures, there are, and have long been, activities such as painting on things, carving or modelling them, framing them, putting them

on pedestals, hanging them on walls and in other ways exhibiting them. There are schools for instruction in these activities, galleries for institutionalized exhibition of works, markets where they are bought and sold. Objects existing in this milieu are called 'art', though this is a designation with no value connotations.

Suppose now that at a certain period of time people have come to praise objects existing in this milieu for the possession of some one or other of the set of features F_1, F_2, F_3, \ldots Then this set will be the set of features in terms of which a thing that is a member of the artworld is *praised* as art. Suppose, then, that new works appear in galleries and exhibitions and that people notice that these new works have a valuable feature F_n in terms of which artworks have not hitherto been praised. They praise these new works for possessing this feature. Under the influence of these new works old ones are re-examined and that new feature is found in them also. People then praise the old works as well as the new ones for the possession of this feature. If all this happened we could imagine thinking that an enrichment had occurred in the concept of art.

On this account F_n may be quite unlike the other features in terms of which we have hitherto valued members of the artworld. However, we can now answer the question why we should call it an artistic feature granted it *is* unlike. What unites the new feature and the old ones as value features of *art* is that they are all value features of something that is art by another criterion, i. e., by virtue of membership of the artworld.

IV. We have, then, extracted these views from Danto:

(I) An item in the artworld, hitherto valued for features F_1, F_2, $F_3 \ldots$ may come to be valued for F_n. Such an addition enriches the concept of art.

(II) Post-Impressionist painting and modern New York painting is called 'art' in an enriched sense, that is to say, the set of features for which it is praised is larger than that for which earlier works were praised.

Of these I shall discuss (II), for (II) appears to remedy the somewhat speculative schematic nature of (I) by suggesting that *examples* can be given of features that have quite recently enriched the concept of art.

I can approach my difficulties with (II) by noting that there are in principle at least two ways in which new art might be said to be original. It might first be said to be orginal in that it draws attention to a feature F_n, that is not one in terms of which works have hitherto been valued. Alternatively the work might be original in that although it exhibits qualities in terms of which we have always valued art, it does so in a different sort of way.

It should be clear that only the truth of the claim that a work exhibits the first sort of originality would support assertions that a conceptual revision has taken place, i. e., that the cata-

logue of features in terms of which we honorifically call something art has been enriched. The claim that the latter sort of originality has been displayed justifies only the assertion that the catalogue of kinds of *works* has been enlarged (i. e. that different ways have been found to exemplify familiar value features of art).

My own suspicion is that although he needs to show, and thinks he has shown, that, say, New York painting has the first sort of originality, Danto has shown only that it has the second. Hence he has not made out his claim that a conceptual revision has taken place.

Before I come to my reasons for saying that Danto has shown only that the new art finds new ways of embodying familiar features, let me give two reasons why this sort of originality is more likely than that more radical originality in which a work exhibits hitherto unremarked value features.

First, given the volume and variety of art, and the volume and variety of the interest that has been taken in it over many centuries, it seems to me to be *prima facie* unlikely that newly significant value features will emerge in terms of which we might praise something as art. (This seems to me not to foreclose upon the possibility of originality in art as long as new ways of embodying familiar value features can, as they do, appear). Secondly, I suspect that history is on my side in taking this view. Whenever there appears a new way of doing things, whether it be the Strozzi altar piece, Manets *Olympia*, Ibsen's *Ghosts*, Stravinsky's *Rite of Spring*, Wordsworth's and Coleridge's *Lyrical Ballads*, or many others we might cite, then the unaccustomed eye in confused and derision often results. Then, after a settling down period (seldom very long), we become aware of the continuities between the new art and the old. We praise the 'new' art for such things as wit, grace, intensity, balance, courage, sensitivity, daring, and the like, terms in which the old art, too, was praised. Any originality we salute is the originality of the means by which these value qualities of art have been captured.

V. I wish now to substantiate the claim that Danto does not cite newly significant features in terms of which art is enriched, but, arguably, shows the enrichment to be a matter of finding original ways of embodying familiar qualities.

I remark, first, that in the earlier paper, »The Artworld«, Danto is in many ways unforthcoming with examples of newly significant qualities in terms of which art has in recent times been enriched. He certainly offers the schematic claim that to add a feature to the list of qualities for which art is praised is to enrich art (a claim that I, for one, am not inclined to deny). Thus he writes:

It is not easy to see in advance which predicates are going to be added

or replaced by their opposites, but suppose that an artist determines that H shall henceforth be artistically relevant for his paintings ... the entire community of paintings is enriched. (AW, 19f).

And although we would expect him to tell us what new value feature is brought to our attention by such a paradigm of the new New York art as the Brillo boxes, he writes only that

Whatever is the artistically relevant predicate in virtue of which they gain their entry, the rest of the Artworld becomes that much richer in having the opposite predicate available and applicable to its members (AW, 20).

As I have remarked this is to make the somewhat speculative claim that art might be enriched by the addition of newly significant value features. In order to show that a conceptual revision has taken place (rather than that it *might* do so) Danto has to give examples to show that this enrichment has occurred.

There are, however, some more precise-looking remarks that Danto makes about the distinctive newness of the new art. First he tells us that it is new in that it is art by virtue of a new theory called 'RT' which has replaced the traditional theory that he calls »Imitation Theory«. Of RT he writes that »according to it artists were to be understood not as unsuccessfully imitating real forms but as successfully creating new ones«, »new entities as giant whelks would be.« (AW, 11 & 12) Whether the view that the artist creates new entities *is* original to Post-Impressionism and its successors I do not know. Complex historical enquires of a sort explicitly eschewed by Danto would be needed to establish that. More to the point is the fact that we have not been told what it is about these new entities that leads people to call them *art*. As Danto himself wrote in a later article, »What makes us want to call 'art' what by common consent is reality« (AR, 4) and he asks, »the nagging question whether all unentrenched objects are reckoned to be artworks, e. g. the first can opener« (AR, 5). Let us turn then to those remarks in which he does try to explain why these new things are *art*.

One view emerges with great force from those remarks. This is the view that items of the new art are often *quasi-speech* acts, i. e. statements, comments, protests, affirmations and the like. (I have called these »quasi-speech acts« because in the arts we are considering, viz. 'New York painting 1961-1969' (AR, 1), the vehicle for the speech act is not usually words).

Danto says such things as this:

Picasso's strategy in pasting the label from a bottle of Suze on a drawing [is] SAYING AS IT WERE that the academic artist concerned with exact imitation must always fall short of the real thing, so why not just use the real thing (AW, 17, my italics).

In that paper too he speaks as though a crushed Brillo box might be 'a *protest* against mechanization' and an uncrushed

box might be 'a *bold affirmation* of the plastic authenticity of the industrial' (AW 17, my italics).

Later in AR he writes:

»Picasso USED the necktie to MAKE A STATEMENT . . . part of what Picasso's statement is about is art (AR, 10, my italics).

and:

Art is a language of sorts in the sense at least that an art work SAYS something (AR, 15).

and:

A fake pretends to be a statement but is not one. It lacks the required relation to an artist. That we should mistake a fake for a real work (or VICE VERSA) does not matter. Once we discover that it is a fake, it loses its stature as an art work BECAUSE IT LOSES ITS STRUCTURE AS A STATEMENT (AR, 14, my italics).

Since he believes that works are speech acts of some sort or other we would expect him to believe that works will be valued using the vocabulary we have developed for the praise and censure of such acts. This expectation is fulfilled. In various places Danto indicates that we can call such works 'affected', 'subtle', 'rich', 'witty', 'repetitive', 'self-plagiarizing', and can say of them as we say of statements that they 'show variety' and 'ingenuity'.

There are, then, passages in which Danto speaks of modern works as pre-eminently the performance of quasi-speech acts and of those acts as being assessable as speech acts are. This is not a view that I wish to contest, although as we shall see later it has difficulties.[4] What has to be said, however, is that if this aspect of works *is* to support Danto's claim that a theoretical revision of the term 'art' has taken place, he must show that this aspect of works is one that has become *newly* significant. *That* would be to show that those who, prior to Post-Impressionism, created and responded to works, did not do so in the ways in which Danto says people have created and responded to the new art, namely as statements, assertions, comments, and the like.

To investigate this matter by historical research would be a valuable undertaking. For my own part my feeling is that in showing that modern works are quasi-speech acts, assessable as speech acts are, Danto has not so much shown these works to be totally new departures as to show them to be continuous with works we have long called art, with works that we have taken to be comments upon some aspect or other of the human environment. I have in mind here the fact that even before

[4] Such a view is one that I have myself argued to be true, at least of literary works; see, for example, »Aesthetics and Personal Qualities«, PROC ARIS SOC (1972), and »Personal Qualities and the Intentional Fallacy«, PHILOSOPHY AND THE ARTS: ROYAL INSTITUTE OF PHILOSOPHY LECTURE SERIES, 1971/2, London 1973.

Post-Impressionism people would have taken the Goya war paintings to comment in certain ways upon war, the Dickens novels to comment upon society. Earlier still, as Panofsky argues, a Dürer print might be taken to express a view of the nature of the Eucharist.[5] We can think of many such cases. To this we may add that Danto himself reinforces the view that earlier works have long done what his new works are said to do as when he tells us that the Strozzi altar piece *rejects* »as an act of artistic will, giottesque perspective« (AR, 7) or tells us that Cervantes *Don Quixote opposes* »to the fiction of chivalry the tawdry provincial reality of his country« (AR, 6).

VI. I wish now to show something of the contribution that Danto *does* make to our understanding of the new art. That contribution is not, as I have hinted, to show how the new art dramatically exemplifies a hitherto unremarked quality. Rather it is to show how a much remarked upon feature of many works at many times, their quasi-speech act capacity, finds a new mode of expression in the modern painting of New York.

First, Danto correctly points out that new sorts of materials are used in New York art, 1961-1969, in the performance of their speech act function. The older painters used paint, chalk, ink, etc. For the modern painter

his use of real Brillo cartons [is] but an expansion of the resources available to artists, a contribution to ARTIST'S MATERIALS, as oil paint was, or TUCHE. (AW, 18)

But of course to say that new materials are used in modern painting is not to show that what is made from the new materials had additional artistically relevant predicates applicable to it.

Secondly, Danto observes, wholly correctly, that we will only see what is going on in the new art if we know something of its background, the »atmosphere« that surrounds it. This, however, might amount to various claims.

It may, first, be the claim that we will only know that an item of the new art *is* art if we know something of its provenance. But on Danto's account that is true of the new art only because it is true of art in general. True, unless we know, e. g., that Rauschenberg's painted bed was made by an artist working in an artistic milieu, intending to exhibit the bed in that milieu, and so on, we will not know that it is art. However, as Danto himself seems to suggest, (AW, 18 e. g.) that is not just true of modern art. For example, unless we know that the cave painters of Lascaux did what they did in a certain context we don't know that *their* works are art[6].

[5] E. Panofsky ALBRECHT DÜRER, Princeton 1948, I: 223.

[6] Moreover, if we grant Wollheim's claim that art is an »historical« concept, it will be inevitably true that what we can say of a work, even that we can say it IS a work of art, will be conditioned by our knowledge of its milieu. See his ART AND ITS OBJECTS, Harmondsworth 1970.

This first claim, that we only know W to be a work of art if we know something about the context of its provenance, should be distinguished from the claim that we will only understand *how* it is art against a background of knowledge of art history, theory, and the like. That claim, too, is one that Danto makes and usefully exploits in discussing the new art.

Suppose I do know something is an object in the artworld, and suppose that as such, I expect it, as Danto does, to be some sort of quasi-speech act, a statement or a comment, for example. Then, the claim might be, there is something distinctive about the quasi-speech acts of modern New York painting. This is not merely a matter of the use of novel materials in order to make a statement. It has as well something to do with the *subject matter* of that statement. For, Danto seems to claim, whereas earlier works articulated a response to (made a statement about) such things as war, birth, death, love, time, fate, etc., the new works are a response to (make a statement about) *art* and about the artistic milieu in which they occur. Thus Danto says of the new art such things as »art has become increasingly its own *and only* subject« (AR, 16) and »part at least of what Picasso's statement is about is art« (AR, 10) and »These are paintings of brush strokes« (AR, 16).

Again I would remark that to show that this is so is not to show that a theoretical revision has taken place in the concept of art. The new art *is* like the old in that it has a quasi-speech act aspect, and it is assessed accordingly. What *is* most helpfully suggested is that the new art is new in that it has found a new way of fulfilling the familiar quasi-speech act role. It has done so by finding a novel subject for such statements.

I should observe here the force of saying, as Danto does, »art has become increasingly its own *and only* subject«. The qualification »and only« is important. The older art, to be sure commented on things other than art, e. g. life, death, mutability, and so on. There is also some sense, however, in which this art could also be said to comment albeit often implicitly on its own traditions and its millieu. Art, as Wollheim puts it, is an historical concept. What is done in art is done in the light of what has gone before and may often be treated as a comment on what has gone before. This may happen in many ways. Mozart may wittily *quote* one of his earlier themes in a later work. Gainsborough in his *Blue Boy,* might comment on artistic views prevailing in his time. The Strozzi altar piece, to take an example from Danto, may reject the prevailing giottosque perspective. The Gibbs facade of St. Martin's-in-the-Fields, London, writes *finis* upon the long standing problem of »how to combine a temple facade or portico with the traditional English demand for a west tower«[7]. In *Joseph Andrews* and *Tom*

[7] Wollhiem, op. cit.: 88.

Jones Fielding may *explicitly* address himself to current problems of novel writing.

As much as modern art does, traditional art may contain speech acts about art, and, as much as with modern art, those speech acts will be understood only if the context of the work is appreciated. I have said that in this aspect the new painting of New York and other earlier forms of art come together. What is strikingly different about the new art however, as Danto puts it, is that the artistic milieu is the *sole* object of its comment.

This seems to me to be a useful remark. It links the new art with the old in showing that the new, like the old, had a quasi-speech act content. It shows that the originality of the new art is not that originality that comes from adding a hitherto unremarked feature to the catalogue of features of art, but is rather that originality that comes when a traditional task is accomplished in a markedly different way.

That said some last comments are now in order. First Danto writes:

The distinction between philosophy of art and art itself is no longer tenable and by a curious astounding magic we have been made over into contributors to a field we had always believed it our task merely to analyse from without. (AR, 17)

I do not know that I fully understand this, although I can see some of the temptation to say it. One might argue thus:

Modern art is essentially second order comment about art.
Philosophy of art is essentially second order comment about art.

Ergo, Philosophy of art is modern art.

If that is the underlying current of thought then it is suspect by virtue of an undistributed middle term. If this argument is sound we could as well argue:

Dogs are animals
Cats are animals

Ergo, Cats are dogs.

But since I cannot be sure that I have understood what Danto wishes to say in this connexion I hesitate to ascribe this fallacy to him.

Secondly, it is not clear to me that all modern art or even all New York painting of 1961-1969 is confined to explicit comment on art (although Danto's favored examples may indeed exhibit this feature). Indeed Danto suggests that Testadura might see the Brillo boxes not merely as comments about art but also as »a protest against mechanization« (AW, 17). Even so, he does seem to me to be right to stress how explicitly modern art has developed the innovation of the Duchamp urinal, with its explicit comment on art.

All this being so we need to note that it is one thing to say

that modern art characteristically comments solely upon art and another to say that modern art has in this way initiated an important and durable trend. Miss Meager, for example, has labelled this art »auto-publicizing« and believes that if its trend is followed it will lead to the suicide of art. She writes:

There is limit of tolerance in both artist and public for the interest to be found in the in group excitements of paint surface swearing at paint surface; paint edge cutting paint edge, in the regress of films about films, plays about plays, novels about novels and so on through the permutations.[8]

I can imagine it being said that if art *has* eschewed a concern with the great issues of human existence then so much the worse for art. And if artists *had* to eschew comment on these matters in order to be original then not only may we have reached the terminal point of originality in art but we may have reached the end of art altogether.

I have tried so far to show that Danto makes interesting suggestions about modern art, notably about the way in which it functions as statement or comment. I have tried to show that these suggestions can be made without the need to surround them with talk of theories and theoretical revisions. Not only do these suggestions not support talk of revision of the concept of art, but they tend to obscure the helpful account that Danto does give of the new art, an account that helps us to see how the new art *is* new in finding new ways to perform the familiar artistic tasks of statement and comment.

VII. If Danto's talk of theory revision obscures his helpful account of modern New York painting, it obscures also what I take to be the really significant and far reaching suggestion in his work.

What I find important about Danto's work is that it strikes at two not uncommon assumptions in much recent philosophy of art, namely:

A1: That if F can be truly predicated of a thing W by S only if S knows facts not detectable in W when W is taken in isolation, then F is not really a feature (and hence not a value feature) of W.

and:

A2: If F can be truly predicated of W by S only if S knows facts not detectable in W when W is taken in isolation, then although F may be a feature of W, F is not an artistically relevant feature of W.[9]

Let us begin by conceding that we cannot know from scrutiny of Jim Dine's *Universal Tie* alone (AR, 7) that it makes a certain statement about modern art. Let us concede also that we cannot know from scrutiny of the sounds of the second movement of Nielsen's 6th. Symphony alone that it expresses

[8] »Art and Beauty«, BRIT J AES 14 (1974): 103.

[9] M. Beardsley seems to me to flirt with these notions in various places, e. g. Chapter I of his AESTHETICS, N.Y. 1958. I have detected some of the same current of thought in A. Tormey's recent work THE CONCEPT OF EXPRESSION, Princeton 1971.

Nielsen's bitterness and exasperation at the state of music.[10] Suppose, too we concede that we cannot tell from scrutiny of a work alone that it is authentic or a fake (cf. AR, 12ff). Suppose, finally, we concede that we cannot tell from a poem, taken in isolation, that it is insincere. (To know that we have to know what the poem cannot by definition show, namely that the author's state is not the state expressed in the poem). *If* we concede all these, then by A1 we must conclude that it cannot be a feature of the work that it makes a statement, is an expression of a certain sort, is authentic or fake, or insincere. Nor can values or disvalues emerging from these features be values or disvalues of works. If we now add to all this the claim that to talk *relevantly* about the work is to talk about the features that *it* has, it then further follows from what we have conceded already, that it cannot be relevant for the critic to talk about the work as a statement, as an expression of its creator, as a fake, as authentic, as insincere and, I suppose, as many other things.

Such a line of argument is not, I think, uncommon in the recent philosophy of art. It rests however upon A1, which is often taken as axiomatic. One of Danto's major contributions is to suggest that A1 is *not* an axiom but is, on the contrary, an assumption in need of argument. In doing so he opens again areas of the philosophy of art, notably in expression theory, that have long been thought to be closed off.

A1 expresses the view that only what is derivable from our knowledge of an object taken in isolation can be properly attributable to *it*. Such a view has been attacked in various seminal papers, e. g. Miss Anscombe's »Brute Facts«. One of the motivating forces behind the attack is the insight, stemming in part from Wittgenstein, that often what we can say of an object or situation depends very much upon what we can know or assume of the context or »surroundings« of that object or situation. Sometimes what we need to know is the *institutionalized* surrounding of the object. Thus, that I can say that this piece of wood is a knight, and that I can see it is, depends upon my knowledge of the institutionalized activity of chess playing. I can see what I see only if I know that there is such an institution with such and such rules. The central insight is expressed by Wittgenstein in many passages, notably the following:

Suppose I sit in my room and hope that N. N. will come and bring me some money, and suppose one minute of this state could be isolated, cut out of its context; would what happened in it not be hope? Think for example of the words which you utter in that space of time. They are no longer part of this language. And in different surroundings the institution of money does not exist either.

A coronation is a picture of pomp and dignity. Cut one minute of this proceeding out of its surroundings: the crown is being placed on the

[10] An example taken from Tormey. THE UNIVERSAL TIE is mentioned in AR, 7.

head of the king in his coronation robes, but in different surroundings gold is the cheapest of metals, its gleam is thought vulgar. The fabric of the robe is cheap to produce. A crown is a parody of a respectable hat and so on (INVESTIGATIONS: § 584).

What is impressive is the pervasiveness of the phenomenon that I have mentioned. In so many areas of human life, from the attribution of smile rather than a leer to a face, up to the characterization of an act as murder we rely in our attributions upon assumptions about context, sometimes the highly institutionalized context, of an act, object or situation.

That there are, arguably, descriptions and predications that can be known to be true of things only given some knowledge or some assumptions about the background and surroundings of those things is sufficient to make A1 open to debate and hence to re-open the debate about any of the things excluded, in the way I have earlier indicated, by the use of A1.

Danto makes two uses of the insight that attributions may depend upon a knowledge of surroundings. He first argues that our ability to say *that* something is a work of art may require a knowledge that could never come from staring at its observable properties. Suppose, e. g., someone cannot see why certain unusual things are art. Then

> if he asks us ... to demonstrate through pointing that this is an art work, we cannot comply, for he has overlooked nothing (and it would be absurd to suppose he had, that there was something tiny we could point to and he, peering closely, say »So it is! A work of Art after all!« (AW, 16)

For, Danto claims, »to see something as art is to see something that the eye cannot decry« (AW, 16).

To know that, say, a »ready made« is a work of art we need to know something that we could not gain from staring at it. We need to know something of its provenance, to know, e. g., that it was made to be exhibited in a certain way in the company of other things that we call art. In calling it 'art' we assume such a provenance. Hence our claim is defeated if we discover that the work is a copy or a fake or nothing more than the finger daubing of a chimpanzee. That we can call it 'art', then, is parasitic upon there being an 'institution' called the Artworld. That institution makes it possible for someone to present something to us in a certain context (just as, earlier, I said that it is possible for someone to present us with a knight only because there is an institution called »the chess world«.)

Danto's first use, then, of what may be called »context-dependent attributions« is to argue that our ability to call something art is context dependent. It requires knowledge of something that the eye cannot descry in the work taken in isolation.

There is a second use that Danto makes of the insight that background knowledge may be needed before certain things

can be predicated of a work. He seems to claim that to know what is *in* a work of art (what is truly predicable of *it*) one may require information not available to the observational scrutiny of it. Thus he claims that the ascription of value features to imitative works depends on a knowledge that may not be derivable from them alone, namely the knowledge that they *are* imitations. He writes

it is not unreasonable to insist upon a perfect acoustical indiscernibility between true and sham crow-calls so that the uninformed in matters of art might... be deluded and adopt attitudes appropriate to the reality of crows. The knowledge upon which artistic pleasure (in contrast with AESTHETIC pleasure) depends is thus external to and at right angles to the sounds themselves, since they concern the causes and conditions of the sounds. (AR, 3)

Danto speaks too of the »Menard« phenomenon in which, because of their different contexts, »two art objects... though verbally indiscriminable, have radically non-overlapping and incompatible artistic properties« just as the acoustically interpreted utterance »Beans are high in protein« is, in the context of English, given one interpretation and in the context of Polynesian a different interpretation, under which it means »Motherhood is sacred«.

As well, then, as claiming that knowledge that something *is* a work of art may assume background knowledge, Danto claims that knowledge that a work of art has this or that feature may depend upon background knowledge in a way which is, as I have said, not unfamiliar in the wider context of the human activity of attributing features to things.

I have claimed, then, that what I have called A1, has been responsible for the dismissal as irrelevant of various sorts of comments about works of art. In challenging A1 Danto has re-opened the question of the rightness of such dismissals, e. g., he has re-opened the questions whether it is relevant to say that the work is a statement by its author, or that it is an expression of his attitudes to this or that, or that it is sincere and so on. That these things can only be known to be true of a work if we know what the eye cannot descry in it is not, without further argument, an objection. For there are many cases in which we truly say of a thing that *it* has such and such a feature even though our attribution depends upon background information.

This line of approach, then, is certainly pertinent to a discussion of A1, the assumption that only what is knowable of a thing when taken in isolation is attributable to that thing. Such considerations however, do not allow us to deal with what I have called A2; since it concedes that F may be a feature of W even though S may need information other than that derivable from W to discern it, it is not touched by my earlier objections to A1. For A2 says that even if it is true that some context dependent features *are* features of a thing, still these are not the

sorts of features we should take into account if we are interested in the work itself.

VIII. Clearly unless a reason is given for A2 it will amount only to the arbitrary exclusion of certain features as irrelevant. What reasons are there, then, for it?

One reason which can be dismissed is the following. It might be said that critics should take an interest in *the work itself*. If we can only know of certain features via a knowledge of something other than the work, then we should ignore such features. This, it seems to me, represents a not uncommon mistake. There is a tendency to move from

(1) In appreciation we should only be interested in features of the work itself

to

(2) In appreciation we should only be interested in features discernible in the work when it is taken in isolation

The move from (1) to (2) however, goes only if we assume (A1), an assumption we have queried. From (1) what *does* follow is

(3) If there are some features of the work itself that we can only discern if we have knowledge additional to that which we can get from the work itself, then some appreciation of the work itself relies upon knowledge that cannot be derived from the work taken in isolation.

Thus suppose that to be able to say of a work that *it* is sincere we need to know about the state of mind of its author. Then what follows is that there is a feature, sincerity, that can be attributed to a work only if we have some knowledge of its author. We cannot, however, as Beardsley seems to do *(Aesthetics* p. 29) use that fact *alone* as a reason for claiming that this feature should therefore be ignored by people interested in the work itself. For what would be to assume that only features discernible in the work taken in isolation can be attributed to the work itself, and that, as we have seen, is assumption A1, an assumption in need of argument.

Let us now try a somewhat different line of argument in behalf of A2. Someone might claim that we would be more ready to concede that context dependent features of works are artistically relevant ones if the examples given were clearly features of objects that would be cited by someone interested in them from the point of view of art. Consider, however, Danto's favored example of the speech-act aspect of a work, i. e. the fact that it can be a statement, comment, protest, affirmation, *etc.* Although knowledge that a painting, say, has this aspect is knowledge that requires some background information, it is hard to see why *this* aspect should be of interest to those who are interested in the painting *as art*. Political speeches, psychological analyses *et al.* state, comment, protest and the like, but they are not *art* thereby. Why then should we think this as-

pect to be *artistically* relevant. Better by far that we should avoid involving art with these quasi-speech functions. One way to do that would be to rule them out by deeming only features knowable from the work itself taken in isolation to be relevant to the thing as art.

One principle that is in operation here seems to be the principle that if we are interested in art *qua* art we should ignore features that works of art share with things that are not art. This, however, is too strong, if only because it would eliminate features that a supporter of A2 would not want excluded. Many features, e. g., color, grace, elegance, balance, turbulence of line, sweetness of timbre, to take a few examples, which are detectable in works of art and for which works of art are valued, even when taken in isolation, are also qualities of things that are *not* art, e. g. are features of such naturally occurring objects as willow trees, sun sets, bird songs and waterfalls. If we are to eliminate an interest in the speech act aspect of art because that is a feature present in non-art, are we to eliminate an interest in aesthetic aspect of art because *it* is an aspect that is present in things that are not art?

IX. Although I can think of few reasons for arguing A2, it does have a certain value. For it raises very sharply the question how we decide that a feature (whether or not it is context dependent) is an artistic feature. When, it might be asked, is a comment or statement an *artistic* comment or statement? When are assessments of it as witty, dull, repetitive, perceptive and the like, *artistic* assessments. This is a question that has long taxed me, sharing as I do Danto's belief in the artistic relevance of the speech act dimension of art. The last stage of my discussion of Danto and Dickie is the assessment of an ingenious answer which I think can be derived from their work to the question I have just raised.

To the question »When is a comment, statement, etc. an *artistic* one, and when are its values *artistic* values?«, Dickie and Danto suggest this reply: »When it, and its values, occur in a work of art.« More generally we can try the principle:

(P) If W is a work of art the features of W (and any values dependent on them) are the features of a work of art (artistic features) even if in other contexts they are features and values of things that are not works of art.

Dickie hints at this principle in such passages as the following:

The historical or socially critical context, if any, of a literary work is a part of the work (though only a part) and any attempt to say that it is somehow not part of the aesthetic object when other aspects are, seems strange. (A, 55)

Now if we had a way of identifying a work of art, then we might begin to consider the claim that a feature is artistic when it appears in a work of art (even though it would not be artistic elsewhere).

Here Dickie and Danto invoke what I have earlier, after Danto, called »The Artworld«. Given that institution we can say that for W to be a work of art is for it to be a member of the Artworld I have earlier described.

How does something become a member of the artworld? Here there may be divergences between Danto and Dickie.

Danto speaks as though something becomes a member of the artworld when someone who knows of the artworld, offers it as a member of that world, e. g. by hanging it in an art gallery, sending it to an art sale. To this he adds that not only is it necessary to offer the work in this way but, he seems to say, it is to offer it as making a comment on the artworld.

To call something a work of art then is to assume that it has been (i) entered as such and (ii) that it makes a comment on its artistic milieu. The attribution of artistic status to a thing is, on his account, defeasible. The customs officer who calls a *recherché* brass part of a lawn mower 'art' just to be on the safe side, having no knowledge of art and its traditions, emits an empty noise. So, too, says Danto, the ascription of artistic status to a thing would be defeated should we discover that that thing is the handiwork of chimpanzees or children (AR, e. g. 14).

Although I am not unsympathetic to this line I make one qualification. I suggest that the double condition that is offered by Danto may evidence the conflation of two questions, namely (i) »What makes a thing art at all?« and (ii) »What makes a thing an example of New York art, 1961-1969?«. The first question is, roughly speaking, answered by, »Its being exhibited as art.« This being so then, contrary to what Danto says, we might rightly call a child's painting 'art'. It might be hung on a wall in father's office, or entered in the numerous competitions for children's art. Moreover in being taught to paint the child is being initiated into the artworld. He is encouraged to think of his work as exhibitable. It is therefore, the right sort of thing to call 'art'. The second question, »What makes it New York art 1961-1969?« is answered by »Its being offered as art *and* its being offered as a comment on its artistic milieu (and on nothing else).« In this sense a child's daub, though art, is not *that* sort of art.

What of Dickie? *He* says that an artifact is art when someone has conferred upon it the status of candidate for appreciation. To some extent this overlaps with Danto's notion of offering something as art. Dickie himself suggests this when he says, that this status, »is usually conferred by a single person, the artist who creates the artifact« (A, 103). To confer the status of candidate for appreciation is, then, for someone who knows the artworld to offer it *as* a member of the artworld, by treating it as exhibitable, or, more usually, by exhibiting it.

Again to this something needs to be added. What that is can be seen if we look at Dickie's treatment of such things as readymades, driftwood, and the paintings of chimpanzees, these all

being things that someone might exhibit in a gallery. Dickie writes:

Can't natural objects such as driftwood also become works of art? Such natural objects can become works of art if any one of a number of things is done to them. One thing would be to pick up a natural object, take it home and hang it on the wall. Another thing would be to pick it up and enter it in an exhibition (A, 105)

and

The question whether or not Betsy's [a chimpanzee's] paintings are art depends on what is done with them ... If they had been exhibited in the Chicago Art Institute they would have been works of art. (A, 106)

This reads as if Dickie wishes to say that, merely by being placed in art galleries by people cognizant of art, certain natural phenomena can be art. This, cannot be right on Dickie's own account. For he believes artifactuality to be a necessary condition for something's being art. Driftwood, though, is not an artifact, and Betsy's paintings are only tenuously so.

Dickie then says of the driftwood:

Natural objects which become works of art ... are artifactualized without the use of tools (A, 106)

and of Betsy's paintings he writes, that to put them in a gallery *is* to make them works of art but that:

the resulting works of art are not Betsy's but the work of the person who does the conferring. (A, 106)

The suggestion, then, seems to be that exhibiting a ready-made object (i) artifactualizes it, (ii) makes it art, (iii) makes it the work of art of the exhibitor.

There is, however, a sense of strain in the notion that if I place a piece of driftwood in a gallery I thereby make it art, and moreover, *my* art. And there is sense of strain, too, in the notion that Betsy's pictures become *my* work merely by virtue of the fact that I exhibit them in a gallery.

We can perhaps relieve this sense of strain by adopting Danto's suggestion (a suggestion that may be implicit in some things that Dickie says) that in these cases the artifactual work of art is not the chimpanzee's painting (call it (C)) *simpliciter* nor the driftwood (call it (D)) *simpliciter*. The work of art is some more complex object which might be dubbed »statement-or-comment-on-art-made-by-the-use-of-C-or-D.« This *is* artifactual and, moreover, is something that *is* the artist's in the way in which the driftwood and Betsy's paintings are not.

I am inclined, then, to add to Dickie's claim that an object is a work of art if it is offered as a member of the artworld, the rider »provided in certain cases, e. g. ready-mades and *objet trouvé*, the object is used as part of some more complex whole, responsibility for which can be attributed to an artist.«

Such an account is, like Danto's defeasible. If I find the chimpanzee painting or driftwood were just hung because nice to look at and not as part of some more complex gesture, then I may, as Danto notes (AR, 14f) withdraw the statement that they are art, though I may still value them as pleasing aesthetic objects. Of course very often these sorts of objects are exhibited in such a way as to make it clear that they *are* part of some more complex whole. Duchamp put a *label* on his urinal. A telephone may have the *title* »Self Portrait« or »Vice-Chancellor« or »God«. Betsy's finger daubs may bear the title »Done by Chimpanzee; look around you and despair.« and the exhibition of this whole in certain rooms of an art gallery might be an ironic comment on art. Sometimes there is no label. A pile of gravel in a corner may give us pause. Only then, as I have said, the discovery that it *is* just a pile of gravel awaiting the builders defeats the assumption that it is art by defeating the assumption that it is part of some more complex whole. I may find sermons in the stones, but they are not art unless used by someone to sermonize me.

Suppose then we accept the general line that, roughly speaking, what makes W a work of art is its being offered as a member of a pre-existing artworld. Then there are still difficulties. One which I shall not dwell upon is that although this explains why W may be called a work of art (i. e. by being a member of the artworld), it does not address a deeper question, which can be put as »Why should people have ever formed the concept of art?« In the same way someone might say to me »some who are religious believe in God« and I might ask (as Malcolm does), »why is it that human beings have even formed the concept of an infinite being?« I want to say of my question about the concept art what Malcolm says of *his* question about the concept of an infinite being

this is a legitimate and important question. I am sure that there cannot be a deep understanding of that concept without an understanding of the phenomena of human life that give rise to it.[11]

What we may ask, makes art possible? Is it (*pace* Dickie[12]) that a way of looking at painting, say, should dawn on people? Is it that they must have come to see the possibility of making something for its own sake, as opposed say, to painting on walls as a magical way of increasing the efficacy of the hunt. Such problems, part conceptual and to which historical and socioanthropological evidence may be relevant are, perhaps deliberately, not touched upon by Danto. Yet as I have said they seem to be questions that can be asked, and may even seem to many to be the deep questions in the philosophy of art.

That aside there is a more immediate problem.

[11] N. Malcolm »Anselm's Ontological Arguments«, PHIL REV (1960).

[12] See, e. g., A, Ch 5, for an excellent discussion of his reasons.

I started this section by seeking an answer to the questions »What makes a comment an *artistic* comment?« and »What makes its values *artistic* values?«. An answer might now seem to be »Its being a comment made *via* a work of art«, or, more generally,

(R) F is an artistic feature when F is a feature of a work of art.

I have said that some such view is hinted at by Dickie. As we have seen he can be read as suggesting that historical or socially critical content, e. g., is artistic content if it is part of a work of art. I must here confess that I had not appreciated this when I reviewed Dickie's *Aesthetics*[13], thereby causing him justifiably, to express puzzlement in some correspondence. When I read his claim that a work of art is an artifact upon which someone has conferred the status of candiate for appreciation, my reaction was that one might appreciate something from many points of view (economic, political, religious, etc.). Some of these seemed to me to be of dubious artistic relevance. I was then tempted to ask, »Appreciate from what point of view?«. I could not see how *that* question could be answered in a way that eliminated irrelevant points of view unless one answered it with either (i) »From an aesthetic point of view« (a point of view that Dickie has long treated with suspicion), or with »From the artistic point of view«, which seems to make the account crudely circular. (Circular it might be, Dickie wrote to me, but not in that way!) What I think I failed to notice was that for Dickie »having the status of candidate for appreciation« just meant »being a (potential) member of the artworld«. Once something *is* thus a member it is a work of art and, so the suggestion seems to be, its value qualities are artistic value qualities. Now, however, I think the question 'appreciate from what point of view' that I expressed in the review arises in another way.

Suppose we have the principle:

(Q) W is made a candidate for appreciation by a member of the artworld when he exhibits it in an artistic context (or is prepared so to exhibit it), AND, whatever qualities W has thereby become artistically relevant qualities.

(Q) licences:

(R 1) if W is a work of art any feature of W is a feature of a work of art.

In one sense this must be true, just as it must be true that if the man at the crossroads is the father of Oedipus, then the human qualities of that man are the human qualities of Oedipus' father. Now I ask, does (R 1) license:

(R 2) If W is a work of art and F is a feature of W, then F is a relevant thing to cite when speaking of W AS a work of art.

[13] BRIT J AES 13 (1973): 81-3.

This seems to me to be arguable[14]. That is, it seems questionable to me whether all the features of a thing which is a work of art *are* features that can relevantly be cited when one is interested in the thing in question *as* a work of art. Dickie himself shares this view:

It is clear that it would be silly to take many of the aspects of works of art as parts of the aesthetic object, e. g. the color of the back of the painting. (A, 62)

I suppose we could add to this such things as the mass or (to mention a value feature) the economic worth of the work.

Once, however, we allow that not all features of a work *are* relevant to its assessment as art, we are back with the problem with which we began: how do we decide whether a feature of a work of art, e. g. its speech act aspect, is *artistically* relevant? We cannot now simply reply, »If it is an aspect of a work of art, then it is *eo ipso* artistically relevant« for that is something that Dickie himself denies. *A propos* of this problem he writes

On the basis of what one knows about the various types of art and the conventions or rules which govern them one can come to realize what aspects are the proper aspects for appreciation and criticism. (A, 67)

Since, however, as he himself says, within criticism there are deep divisions as to what is and what is not relevant (think of the debate over intentions), this answer does not advance matters.

One final remark on the problem »when is a feature an *artistic* feature?« I extracted the principle that F is an artistic feature if it is a feature of a work of art from a passage in which Dickie argues, in opposition to Vivas, that historical and socially critical content can be artistic content. As well as the comments I have made on the general view I have extracted from this I wish to comment on the particular way Dickie uses this move in reply to Vivas and to suggest a possible way forward in these matters.

Vivas had said that *The Brothers Karamazov* »can hardly be read as art«, giving as a reason, according to Dickie, that one can scarcely avoid reading it as social criticism. The implied suggestion is that if it is read as social criticism it cannot be read as art.

Suppose now Dickie replies, as he seems to do, that if *The Brothers Karamazov is* a work of art and contains socially critical content then that content is thereby artistic content. We can then reply on behalf of Vivas as follows: since I wish to query whether this book *can* be art given its content it will scarely do to reply that since it is art this content is artistic

[14] See also M. C. Beardsley »What is an Aesthetic Quality?«, THEORIA 39 (1973): 63f, and V. Aldrich PHILOSOPHY OF ART, Englewood Cliffs 1963: 99, e. g.

content. For *my* question is »Is it art, given its content?« and your reply does not address itself to that. Such a reply suggests that the dispute is one as to whether the term 'art' should be applied to a certain sort of content. If this is so, then I suggest the following way forward.

I take it that neither Vivas nor Dickie would deny that things that have been called works of art may exhibit value features of many different sorts. Some are narrowly aesthetic (grace, delicacy, balance, etc.), some are expressive (as when we say that a work is sad, or gay), some record speech-act aspects of the work (as when we say that it states, comments, affirms or protests). Again some of the features, as with *The Brothers Karamazov* have to do with social-critical content.

In saying that *The Brothers Karamazov* cannot be read as art the suggestion might be that the features which make it great, its human content with its implied social criticism, are not the sorts of features by virtue of which *we* usually call things »art«. It is to suggest that as *we* use the term 'art' certain features of a thing are more relevant to our decision to call something 'art' than others. Once the debate reaches this stage, however, the dispute may become in various ways terminological. Dickie may wish to use the term »artistic« of a range of features from which Vivas might wish to withhold the term. For all I know both might wish further to claim that in so using the term »artistic« they use it as most speakers of English do (a dispute that may have to be settled by empirical enquiry). My own view, which I cannot elaborate here, is that what is important is not these terminological matters but the recognition that a work may have many different sorts of qualities (most of which it will share with things not often called 'art'). It is important not to ask what labels can be tied to these qualities, but, given that they are qualities of denizens of the artworld, to ask such questions as how they are and are not related, and how they can be known to be present. In such a way we may come to an understanding of the ways in which we can speak of art. And if we could add to this some account of what has to be the case before we have an artworld at all, then we should have made progress indeed to understanding the phenomenon of art.

X. Those who wrote about G. E. Moore were often confronted with the riposte, »I wasn't intending to do or say *that*.« I have no doubt that Danto and Dickie will at many stages of my exposition be inclined to say that too. If that is so then as well as apologizing in advance for my misconstruals, I should say that I still owe them a debt for what they have made me think, if not what they have managed to convey to me.

Monroe C. Beardsley

Is Art Essentially Institutional?

That those processes and products we broadly call »art« are often inextricably involved and intertwined in social institutions has long been known. It was noted by Plato, in the *Laws* (II. 656 E), where the Athenian Stranger praises Egypt as a land in which music and dancing and visual art were sternly guarded against unsettling innovations, by force of law:

And you will find that their works of art are painted or moulded in the same forms which they had ten thousand years ago; this is literally true and no exaggeration . . . [1]

The researches of modern sociologists, and especially of Marxist social thinkers,[2] have added much to our understanding of the social conditions and consequences of art-activities. And anthropologists have shown how pervasively among the varieties of human society such activities have themselves been institutionalized, either on their own or as segments of religious and other systems. Our awareness of these connections is inevitably intensified by the unprecedented proliferation of satellite and service occupations in our time — for example, those connected with publishers, artgalleries, museums, art commissions, city-planning offices, educational institutions.[3]

But however extended, this institutional implication of art is not in itself a matter for philosophical debate, since it may be considered as merely contingent. What I aim to clarify here, and to discuss briefly, is a somewhat more significant and challenging thesis: namely, that art is not just contingently, but *essentially* institutional.

I. It seems desirable — especially for the (hoped for) benefit of those who are properly suspicious of all essentialist theses, whether affirmed or denied — to begin with a plea for some care in framing a concept of *social institution*. A *social practice* is a kind of recurrent action or activity that is governed or guided by rules and that is recognized by a social group as acceptable because it serves the needs, or at least satisfies the desires, of some members of the group. Some practices may be said to be *institutionalized*, in that they are combined with

[1] THE DIALOGUES OF PLATO, trans. B. Jowett, N.Y. 1937, II: 435.

[2] S. Morawski »Art and Society«, INQUIRIES INTO THE FUNDAMENTALS OF AESTHETICS, Cambridge 1974.

[3] Cf. the papers given at R. Smith's Illinois conference on »The Arts and Career Education«, and published in J AES EDUC 7 (1973).

others to form something like a system, and are carried on by what may be called institutions, in the token sense of this term. An *institution-token* (General Motors, the Unitarian Universalist Society) is a collective entity (with, it may be, changing membership) that is individuated by sets of persistent practices (such as manufacturing cars or holding regular meetings at which certain ceremonies are performed) and by some continuity of what may, in a broad sense, be called sovereignty, i. e., the authority to maintain or alter practices. We may also speak of institution-types (such as the institution of marriage or a legal institution). And particular social practices (such as suttee or divorce or the début) that are institutionalized, in that they are associated with certain institution-tokens, are also commonly called »institutions.«

In a highly amusing account of her attempt to prove the universality of *Hamlet* by recounting its plot to her friends among the Tiv, Laura Bohannon remarks that

Storytelling is a skilled art among them; their standards are high, and the audiences critical — and vocal in their criticism.[4]

Though the storytelling was not organized and ritualized like the ceremonials it replaced when the season of swampiness suspended them, there was a controlling sense of the sort of occasion on which the activity was appropriate, and evidently there were standards of storytelling and of storytelling-criticism. So we may, in the broader sense, refer to storytelling among the Tiv as an institution type.

But merely because an action is an action of a certain sort by virtue of some social convention (including those conventions, if they are properly so called, that govern the use of language in communication), that is no basis for designating the action itself as institutional. Waving good-bye has (in our culture) a conventional basis, but it is no part of an institution. Similarly, if Nelson Goodman is right in holding that a work of art is a character, or class of characters, in a symbol system, that does not entail (in my usage, which I commend to others) that such characters are all institutional objects. Moreover, when we speak of an activity as institutional, it is not enough that the description we give of it be one that has been institutionally instituted. For example, a state legislature may be prevailed upon to pass the sort of law now sought by transplant surgeons and define »death« as the cessation of brain activity (thus protecting the surgeon against criminal charges if he artificially keeps the heart pumping blood to various organs until he can remove them for transplant). The definition of »death« would thus be decided by an institution. But that does not make death an institutional fact, so to speak.

[4] »Shakespeare in the Bush«, THEME AND FORM, eds. M. C. Beardsley, R. W. Daniel, & G. Leggett, 4th ed., Englewood Cliffs 1975: 234.

I suppose here that it is possible and useful to distinguish between those actions (and objects) which are, and those which are not, essentially institutional, in the sense I expect to clarify shortly.

Jones's depositing his pay-check in his checking account is clearly institutional. It could not be performed unless there existed some employing concern and some bank. On the other hand, Smith's hiding his gems behind a brick in his chimney is just as clearly noninstitutional, even if performed with a similar motive. True the chimney may have been built by a construction company, whose activities were CAUSALLY requisite to Smith's action; but its connection with that action is not, as some would say, CONCEPTUAL. In performing his action, Smith had no truck with, made no necessary use of, any institution.

The question before us (which may now be more fully revealed) is how this distinction applies to *artistic* activity, the act of creating a work of art. The Romantic era left us a picture of the artist, still alive in our minds, that reminds us much more of Smith, above, than of Jones. Withdrawn into his ivory tower, shunning all contact with the business, governmental, educational, and other institutions of his society — or perhaps just hidden in his lonely bohemian garret — he works away on his canvas, carves his stone, polishes the rhymes and meters of his precious lyric. Later, of course, he may decide to compromise with reality, to sell, publish, exhibit, or whatever. But until he does so (according to this account) his action is not institutional, nor is what he produces. I have presented the account in somewhat over-colored terms, no doubt; and perhaps I should stress that it is something that I take quite seriously. Of course we cannot deny that the Romantic artist may be supplied electricity by an institution, that his paper or canvas has to be manufactured, that his very thoughts will be (in the word of Jowett-Plato) to some extent »moulded« by his acquired language and previous acculturation. But that is all beside the point, which is (on this account) that he can make a work of art, and validate it as such, by his own free originative power. And it is this claim that has in recent years been explicitly challenged by those who hold that art is (in my words) essentially institutional.

To clarify this term and thesis, we may first draw upon some ideas once suggested by Elizabeth Anscombe, in a brief discussion of what she called »institutional facts.«

For the statement that I owe the grocer does not contain a description of our institutions, any more than the statement that I gave someone a shilling contains a description of the institution of money and of the currency of this country. On the other hand, it requires these or very similar institutions as background in order so much as to be the KIND of statement that it is.[5]

[5] »On Brute Facts«, ANALYSIS 18 (1958): 6.

I prefer to put the matter as follows:

1.1 If the existence of some institution is included among the truth-conditions of »A is an artwork« then artworks are essentially institutional objects.

Notice that I have stated only a *sufficient* condition here, in order to leave room for a second proposal.

I think we may allow a weaker condition for something's being an institutional object, though I can't formulate it very precisely. Suppose we are considering objects of a certain kind, K, and a property, P, that is characteristic of, or normal in, objects of that kind. By which I mean that objects of kind K always have P, unless some special and aberrant conditions interfere; that P is a significant and prominent feature of K's, and is therefore one of the more telling criteria for being a K. Now suppose that among the truth-conditions for the statement »This K has P« is the existence of some institution; then K's are institutional objects, in this extended sense.

1.2 If the existence of some institution is included among the truth-conditions of »this artwork has property P,« where P is a normal property of artworks, then artworks are essentially institutional objects.

The application of condition 1.2 to specific properties may not be very easy or decisive, though some cases are fairly clear. In a society, such as ancient Egypt or Soviet Russia, with an official censorship, every work of art may have to carry the tacit imprimatur of a censor; and since the censor's office is an institution, or part of an institution, that makes artworks institutional objects in that society. But of course it does not make artworks in general into institutional objects — as would happen if, for example, in every society the law required that all artists be licensed or employed by the government. On the other side, someone might hold that all artworks, or at least all those worthy of notice, have artistic form, however simple. Then form would be a normal property of artworks. But that would not make them institutional objects, since the truth of »this artwork has form« does not seem to presuppose any institutional facts.

A more debatable case in between these two clear-cut ones is that of *genre*. And it helps to bring out the way in which disputes about whether art is essential institutional on the second condition will often turn on the question whether a certain property is in fact normal for artworks. Someone might argue, first, that works of art normally belong to some genre or other, and, second, that belonging to a genre is an institutional property, since »a belongs to a genre« has the existence of some institution as a truth-condition. Consider the second claim first. Now if it is to hold, a genre has to be taken as something more than a mere class or kind. No doubt works of art can always be placed in some category along with other works: they are,

say, unrhymed poems, water-colors, works for the piano. But these are not genres. Consider *elegiac poem*, and the following argument: To describe a particular poem as an elegy is to place it in a certain historical or traditional relationship to a body of other poems. The writing of elegies has often been guided by a concept of elegy as being a genre, with certain conventions (though this is of course by no means true of all elegies their authors have called »elegies« — e. g., Rilke's *Duino Elegies*). Then it may be correct to say that elegy-writing is a social practice within a certain literary tradition, and that a society which recognizes that practice contains the institution of elegy-writing. A poet could then conceivably write an elegy without knowing he was doing so, being ignorant of the existence of the genre; but it could not *be* an elegy unless the practice existed.

This argument might be a dubious extension of the term »institution« — if, as I have suggested, we try to preserve a distinction between institutionalized and noninstitutionalized practices. If everybody brushes his teeth, that is a general practice; but this does not make teeth-brushing an institution. The difference between teeth-brushing and, say, the burial of the dead is that the latter practice is associated with various other practices, religious and civil, that give it an institutional character. Still, one could argue that poetic genres (in neoclassical periods) form a loose system: there are epics, comedies, tragedies, pastorals, odes, sonnets, etc. And the practice of composing in each of these genres is an institution in virtue of its association with the practices of the others.

The first claim, however, does not seem to hold. While any work of art can be classified, many works of art do not belong to a genre — if we take genre in a sense strong enough to make the practice of composing in a genre an institution. Even if a poet is writing in blank verse, and knows it, and understands the techniques involved, he is not necessarily being guided by the sense of any pre-existent poetic form. The same is true of the painter and composer. At certain periods, genres may exercise a strong influence; at others, no more than a weak one. In any case, it seems that the property of belonging to a genre is by no means a normal feature of artworks, and therefore cannot serve as a ground for saying that artworks are essentially institutional.

Are there stronger grounds, then, for justifying this thesis? I distinguish three sorts of ground that have been advanced in recent years. Though a good deal has been said of each, and much more could probably be said, I shall be concerned only to sketch them and comment briefly. My aim is not to diminish the importance of all these lines of thought, which have brought various kinds of illumination, but only to cast doubt on the thesis that art is essentially institutional.

II. The most direct version of the institutional thesis, mak-

ing use of condition 1.1 above, is that the property of being an artwork is »conferred« on objects in an institutional way. (I state the conferring view vaguely at the start, so as to leave some refinements open.) To be adequate as an account of art, such a view must present answers to at least these questions:

2.1 On what is the conferring done?
2.2 What is conferred?
2.3 Who does the conferring?
2.4 What constitutes conferring?

It is George Dickie, of course, who has offered the most carefully-worked-out and impressive version of the conferring view, and I shall comment on his version shortly. But I begin by glancing at the version offered independently by T. J. Diffey.[6] Those objects on which the property of being an artwork is conferred are, according to Diffey, those already identifiable as »say a novel or as a play« (p. 151). The range of acceptable presupposed predicates is not specified, so this is not much of an answer to question 2.1. We are not told what sorts of object are excluded, if any. Diffey's answer to question 2.2 is that what is conferred is a »status« — »the status of something as a work of art« (p. 146). Diffey does not explain why being a work of art (but not being a novel or a painting) is a status; it seems to have something to do with being, say, a good novel or a good painting, but discussion of this connection is deliberately set aside (p. 154). Moreover, to explain why something is a work of art by saying that the status of being a work of art has been conferred upon it is not really to tell us much about what sort of thing being a work of art is. So I don't think we have here an adequate answer to question 2.2.

Diffey does discuss question 2.3 in some detail, and in the course of that discussion proposes an interesting distinction. First he says that »this status is conferred by the judgment of the public« (p. 147), drawing the consequence that »Until a work has been submitted to the public it cannot have the status of a work of art« (p. 147). Thus »*a* is an artwork« expresses an »institutional fact,« in Anscombe's sense (p. 147). Now the public is, of course, not an institution, so we may well ask how institutions come into this picture. One way is hinted at, another spelled out more explicitly. The term »submitting« might be given an institutional interpretation — Diffey suggests, for example, that a painting's »public exhibition« (p. 147) is necessary (though not sufficient) for it to qualify as an artwork. If we insist that public exhibition involves recourse to some institution such as an art museum, then »*a* is an artwork« (where *a* is a painting) would have as a truth-condition that »*a* has been shown in an institution.« But it's not clear that Diffey means to go this far; perhaps just hanging up the painting on

[6] »The Republic of Art«, BRIT J AES 9 (1969): 145-56.

a sidewalk would be sufficient. The second, and more promising, argument is that the public includes a subpublic — the »republic of art«, which is what really has the authority to confer artwork status. The problem is to decide »Who are the members of this republic« (p. 150). It contains

Anyone involved with the arts whether as creator, performer, spectator or critic of novels, plays, paintings, music, poetry, etc. (p. 150),

plus others admitted by the original »self-elected« members. If, as Diffey says, the original group qualify as members of the art-republic by setting themselves up as writers, painters, spectators, critics, etc., a curious presupposition seems to emerge. Setting oneself up as a plumber, philosopher, or pawnbroker is apparently not enough to qualify; how, then, does one know whether one's chosen occupation or activity is the right one? I can only suggest that in marking out the range of art-status-conferrable kinds of object, Diffey is tacitly making use of some such criterion as »object of a kind such that it is at least potentially an artwork.« Without such a criterion, I do not see how the classes of eligible entities are bounded; but with such a criterion, the whole analysis would become circular.

I have passed over the claim that most troubles me: that nothing is a work of art until it has actually been submitted to a public. To me this is astonishing; but it helps to bring out, by contrast, the (at least) quasi-Romantic view of art that I cling to. Surely what Monet and Manet and Cézanne created were works of art even before they were exhibited to (and recognized and acknowledged as such by) the artistic establishment. Of course »artwork« has, as Diffey remarks, a »revisable denotation« (p. 149); it is obvious that from time to time it has been applied to different things. But this does not entail that what makes something an artwork is being so called — even by a self-elected or self-elected-elected body of art-republicans. No doubt one task of the aestheticians is to explain how something is a work of art even before it is generally or officially designated as such; but this is just the problem of defining »art,« and any analysis that eliminates this problem seems to me to have a prima facie unacceptability.

Dickie's analysis is a good deal more illuminating.[7] It may even turn out to be right. But I'm still not quite convinced, and I offer a few comments — which, however, touch only on some points in his complex argument, and therefore are far from doing it justice.

Dickie answers question 2.1 very explicitly: the subject of the artwork-property conferring is an artifact, an object made what it is by a human being. (I pass over his further extension

7 »What is Art?«, above: 21-32. Cf. R. J. Sclafani »Art as a Social Institution«, J AES ART CRIT 32 (1973): 111-4; W. L. Blizek »An Institutional Theory of Art«, BRIT J AES 14 (1974): 142-50.

of the class of artifacts; without that extension, the class is at least reasonably well delimited.) More precisely, it is not the artifact as such, but some set of its aspects, on which the conferring is done. Dickie's answer to questions 2.2 and 3.3 are again explicit and significant:

A work of art in the classificatory sense is (1) an artifact (2) a set of the aspects of which has had conferred upon it the status of candidate for appreciation by some person or persons acting on behalf of a certain social institution (the artworld) (p. 23).

What is conferred is the property of being a candidate for appreciation. The second key term here, »appreciation,« I do not pause to query: others have suggested that it is too broad to select the class of artworks unless it is qualified by some adjective such as »aesthetic,« but it is, of course, a fundamental and tenaciously-defended tenet of Dickie's aesthetic theory that no such distinction can intelligibly be made. I do find, however, that »candidacy« is less fully explained than I think desirable for Dickie's purpose. A candidate for appreciation cannot be merely something that is potentially appreciable; such a property, I suppose, stands in no need of being conferred by anyone. A candidate for office is presumably not merely someone eligible for that office, but someone who has taken some preparatory steps toward obtaining it, or who has been given some initial endorsement for the job. His hat is in the ring; he is running. What sort of preparation or endorsement is contained in the assignment of candidacy for appreciation, then? The figurative term suggests that something cannot be appreciated until it has been declared a candidate for appreciation, but surely nothing in the way of an imprimatur is required. A mountain could be appreciated without having been declared such a candidate. Perhaps the difference lies in the mountain's never having been intended for appreciation, or in the absence of any declaration that it *is to be* appreciated (unless someone puts up a sign saying »Scenic Mt. Washington«, at a point where the view is especially appealing — and then the sign might make the mountain a candidate for appreciation).

Dickie's answer to question 2.2 evidently is closely connected with his answers to 2.3 and 2.4. By whom is the candidacy-status conferred? By an agent or agents of the »artworld« —

a bundle of systems: theater, painting, sculpture, literature, music, and so on, each of which furnishes an institutional background for the conferring of the status on objects within its domain (p. 23).

»When I call the artworld an institution,« says Dickie, »I am saying that it is an established practice« (p. 22) — not that there are necessarily institution-tokens corresponding to all these labels (such as the Mystery Writers of America or Ford's Theater), but that sculpturing, writing poems, composing music, etc., are social practices.

One point that gives me trouble is the concept of »acting on behalf of.« I understand what it is for the President of the University, acting on behalf of his institution (or the Board of Trustees) to award the status of being a doctor of philosophy (as in Dickie's example, p. 24). What he acts on behalf of, essentially, is an institution-token, such as Temple University. But the artworld is not made up of institution-tokens — it's not *that* well-organized. Yet if we then switch, as Dickie does, to the broader sense of »institution,« and include general (artistic?) practices, then does it make sense to speak of acting on behalf of a *practice*? Status-awarding authority can center in an institution-token, but practices, as such, seem to lack the requisite source of authority. Perhaps the artworld, as Dickie conceives it, could not confer status.

Dickie's argument, as he has recognized, is in some peril of circularity: artworks are what are given the cachet of the artworld; the artworld consists of people who have something to do with artworks. Nor does he try Diffey's mode of escape. Instead, he accepts the charge, but claims that his circle is large enough to make the process interesting and informative nevertheless (p. 28f). I'm afraid I haven't been able to suppress my disappointment at this outcome: I can't help thinking that if artworks are ultimately defined in terms of themselves, there must be some important piece of the truth that has not been encompassed in the circle.

For further light, we must turn to Dickie's answer to question 2.4. Artistic conferring is not very clear-cut, Dickie concedes (p. 24). Hanging the painting in a gallery or putting on the play or reviewing it, are conferring acts; moreover, if any single member of the artworld »treat[s] *an artifact as a candidate for appreciation*« (p. 25), he acts on behalf of the artworld, and the artifact becomes art. Now if conferring can be done by mere treating (say, by looking at the painting in the hope of seeing something worth while in it), and if the artworld is a society in which there are no Indians, only chiefs, it would seem that Dickie's definition is broad and generous enough to suit anyone. Yet even so, it may be too narrow.

I propose a dilemma. Imagine a busy businessman or financier who has hitherto had no time for poetry (though he may recall reading poems in high school), and who sits down in middle years, under an odd compulsion, and writes his first poem. He also appreciates it — very much. Is it an artwork? Not, presumably, until he can confer the proper status on behalf of the artworld; but he is not yet a member of (at least that segment of) the artworld, since he has not yet composed (or, I am supposing, recently even read) a literary work of art. He cannot represent the artworld until his poem is accredited an artwork. Then does the poem become an artwork only after he shows it to some poet, critic, or constant reader of poetry who can perform the act of conferral? To say Yes, it seems to me, is as

linguistically disturbing as Diffey's requirement of public exhibition; to say No is to breach the definition proposed by Dickie.

III. In our search for theories that may imply the essential institutionality of art, we may turn now to two thinkers who have inquired into the ontological status of artworks and whose conclusions at least point in this direction, since they locate artworks as elements in a larger social, historical, or cultural context.

Dickie's key term, »artworld,« was borrowed, as he remarks (see p. 21), from the first of three highly original and provocative essays by Arthur Danto[8] — though with a shift of reference from a class of paintings to a class of people.[9] The subtleties of Danto's thought cannot be explored here, but some features of his position require consideration.

Danto's original argument can be summarized in two propositions. He first introduces a new sense of »is,« the »is of artistic identification« — the sense in which we point to a painting by Gilbert Stuart and say »That is George Washington« (AW 14f). I borrow from Latin to mark this »is« by »est«.

3.1 For it to be true that A is an artwork, there must be an X such that A (or some of A) est X.
3.2 For it to be true that A est X, there must exist an enabling theory of art.

The concept of »artistic identification« seems to come down to some kind of representation or reference, and in a later version of the argument is supplanted by a concept of »aboutness« — »which something acquires when it is construed as an artwork« (»Transfiguration,« 146). It is aboutness, according to Danto, that keeps a »space« open between the artwork and reality, and prevents the work from collapsing into a real thing — though it seems to me that there must be other ways of doing this, as in the case of music, since I am not yet convinced that all works of art must be about something.

Proposition 3.2 is, however, the relevant one here. Danto expresses it — or expresses the conclusion implicit in the pairing of premises 3.1 and 3.2, — in thought-provoking ways. We can easily grant that »these days one might not be aware he was on artistic terrain without an artistic theory to tell him so.« But Danto goes on to say, »And part of the reason for this lies in the fact that [that] terrain is constituted artistic in virtue of artistic theories, so that one use of theories ... consists in making art possible« (AW 10).

On this view, then, it is a truth-condition of »*a* is an art-

[8] »The Artworld«, above: 9-20; »Artworks and Real Things«, THEORIA 39 (1973): 1-17; »The Transfiguration of the Commonplace«, J AES ART CRIT 33 (1974): 138-48.

[9] Note Danto's usage, above 20.

work« that there exists a theory of art that provides a rationale for saying that »*a* is an artwork« — and the theory is not just a condition of *knowing* that *a* is an artwork. This claim is a form of what might broadly be called »social and cultural contextualism,« but does it make art essentially institutional? That hinges on some questions to which Danto has not yet given answers, though it is much to be hoped that he will.[10] What sort of thing is an »artistic theory,« in this context? Danto tells us something about this, but much is left to our guesswork. Presumably it will be, or include, a principle according to which Warhol's *Brillo Box* is an artwork — but the principle is left unformulated. What does it mean to say that the theory exists? That it is accepted (believed, promulgated) by the artist? the art dealer? A segment of the art establishment? If we insist on a good deal here, the existence of some institution will begin to emerge as a truth-condition of »*a* is an artwork.« But the stronger the claim, the more doubtful it may become — or at least, the more in need of elaborate defense.

It is crucial to our understanding of what kind of predicate »is an artwork« is, according to Danto, that we realize that of two indiscernible objects, one may be an artwork, the other not; and that a particular object may become an artwork at a certain time, though it was no such thing before. Thus »artwork« is not a descriptive, but an ascriptive, term (AR, 11). We can think of artworks, as we think of persons (he suggests),

in terms of privileges, exemptions, rights, and the like. Thus artworks, which happen to contain neckties, are entitled to hang in museums, in a way in which neckties indiscernible from the former are not ... A necktie which is an artwork differs from one which is not like a person differs from a body: metaphysically, it takes two sets of predicates amazingly similar to the P- and M-predicates which PERSONS take on a well-known theory of P. F. Strawson's (AR, 12).

Now, if »artwork« is really ascriptive, one might say, then »*a* is an artwork« does not *have* truth-conditions, so art cannot be, by my definition, essentially institutional. Yet in a not very extended sense it might still be. There are two ways. First, if what is ascribed is a privilege or entitlement of some sort, and the nature of this privilege can only be spelled out with reference to institutions, then the existence of an institution will be a success-condition of the ascription »*a* is an artwork.« Thus Danto suggests that to say a painting is an artwork is to »entitle« it to hang in a museum or art-gallery (though the question remains: *who* is entitled to award this entitlement?) If we build such institution-types as the concert-hall, publishing, drama criticism, etc., into the act of artistic entitlement, art can reasonably be said to be essentially institutional — even if in

[10] Some of these questions have been well raised by R. J. Sclafani »Artworks, Art Theory, and the Artworld«, THEORIA 39 (1973): 18–35.

fact not all paintings are purchased by museums or even hung. For to be an artwork would be to be eligible for institutional treatment.

Second, Danto notes that an ascriptive predicate carries along with it certain defeating conditions which may prevent it from being applied in certain cases. For example, following Danto's example, one might build into the concept of artwork that if the necktie was painted by a child, then even if it is indistinguishable from a Picasso-painted necktie, it may not be called an artwork. But in explaining the exclusion of the child, and in laying down general rules of defeasibility, one might have to bring in, once again, institutions — the child is not an established artist, in the sense that he has never sold a painting, so his work is ineligible to be art. If selling is an institutional action, and is required as a condition of artwork-status ascription, then such ascriptions are institutional.

I believe in the long run ascriptivism will fare no better in aesthetics than it has in ethics, or does (in my judgment) in the theory of persons — though I recognize that the ascriptivity of »is a person« can be persuasively defended. The success-conditions, when they are worked out with care, are hard to keep from turning into what look suspiciously like truth-conditions of non-ascriptive propositions. »It is analytically true,« says Danto, »that artworks can only be *by* artists« (AR, 14). That reads more like a truth-condition for »a is an artwork« than like a rule governing the proper ascription of artwork-status. But is Danto right here? Not, I think, if he means that no one is in a position to create an artwork unless he is already an artist; I would think one gets to be an artist by producing some artworks, not the other way around. Danto suggests that we assign artist-status to the artist and art-status to his work at the same time, and adds that we are not allowed to do this in the case of »Douaniers, children, chimpanzees, counterfeiters« (AR, 14) — or, I suppose, businessmen who set themselves up as amateur poets, as in my example above. I make no plea for douaniers and chimpanzees, but children and amateur poets seem to me to be in a different category; I do not see why they cannot even in principle create artworks, even though they lack the union card. That's like saying that if someone fixes the leaking faucet, it isn't really fixed unless he is a registered plumber.

Joseph Margolis has also made interesting use of an analogy between artworks and persons:[11] both are »culturally emergent entities« which are »embodied« in physical entities, with which they are not identical (p. 33). He also relies on another analogy, that with human actions:

[11] See especially »Works of Art Are Physically Embodied and Culturally Emergent Entities«, above 32-45; cf. KNOWLEDGE AND EXISTENCE, N.Y. 1973: 246.

A man raises his arm to signal; the action has that Intentional property. Apart from human society there is no such action, no more than a movement of the arm; within the conventions of a culture the actions may be seen as such, embodied in the arm's movement ... (p. 39).

It will help us to come to grips with Margolis' ontology of art if we pause to consider the analogue with some care.

In this passage, Margolis characteristically writes as though there were only two descriptions involved, though in fact there are three, even in the passage itself:

4.1 The man's arm's moving.
4.2 The man's raising his arm.
4.3 The man's signalling.

Phrase 4.1 is, as Margolis says, analyzable in merely physical terms; it is the description of an event. Phrase 4.3 describes an action, and indeed one that can only be performed in a social group that has adopted a certain convention, according to which raising one's arm under certain circumstances counts as signalling. Note that the convention states a relationship between 4.2 and 4.3, not between 4.1 and 4.3. What is the relationship, then, among these three descriptions? On my view, they all describe the same event, some properties of which are specified in 4.1, other properties in 4.2 and 4.3. The signalling is just the arm's moving through the agency of the man and in a certain social setting. There is no need to talk of »embodiment,« anymore than there would be to say, e. g., that the world chess champion is embodied in such-and-such an organism: the world chess champion *is* that organism, but considered in one of its social aspects.

Recognizing the identity of 4.1, 4.2, and 4.3 does away, then, with a term which at best is far from clear. »The 'is' of embodiment,« as Margolis calls it (p. 40f) introduces complications that are best avoided if they are unnecessary. It has not been proved, I think, that the arm-movement *cannot* be the same event as the signalling; it occurs at the same time and place.[12] It is not unintelligible to say that the movement is, in the sense of constituting or amounting to, a signalling. Moreover, recognizing this identity also enables us to avoid the error of saying that »Apart from human society there is no such action, no more than the movement of the arm.« Granted that apart from human society there is no such act as signalling; but surely there may be such an act as raising one's arm — *that* is not dependent on society or culture.

Turning now to artworks, we can summarize Margolis' position: The artwork known as the *Pietà* is embodied in a physically identifiable block of marble in the Vatican; it is not identical with the block of marble, but emergent from it.

[12] For a defense of my view, see »Actions and Events: the Problem of Individuation«, AMER PHIL QUART 12 (1975): 263-76.

QUA embodied, a work of art must possess properties other than those ascribed to the physical object in which it is embodied, though it may be said to possess (where relevant) the properties of that physical object as well (p. 35).

As a cultural object it will »exhibit culturally significant properties that cannot be ascribed to the merely physical objects in which [it is] embodied« (ibid). Margolis' argument against saying that the block of marble simply *is* the *Pietà* is that blocks of marble cannot intelligibly be said to have expressive properties such as the *Pietà* has — just as »Stones cannot properly be said to feel anger« (ibid). If it is not merely false, but »inappropriate« to say »This stone is angry,« it does not follow that it makes no sense to say »This physical organism is angry,« or »This block of marble is serene.« Indeed, Margolis later says that when »confronted with a physical object of a suitable sort, I will identify and make reference to a work of art that I take to be embodied in it« (p. 37) — and I confess I do not understand what would make the physical object one »of a suitable sort« for such an attribution unless it has certain formal and/or expressive properties.

When we ask whether Margolis' view of artworks makes them essentially institutional, the answer is not wholly explicit. He speaks of tradition rather than institutions. But it is not clear how much is to be packed into that concept.

But to locate or specify something AS a work of art thus embodied requires as well reference to the artistic and appreciative traditions of a given culture ... Only relative to some cultural tradition ... can anything be identified as a work of art (p. 36).

»Reference« is all very well, but it does not tell us just what we must look for in the tradition in determining whether a particular physical object embodies a work of art. Consider the first examples of op art, and the predicament of the artist and his agent. As yet there was no tradition of op art — except in the sense in which the college is said to have put up a sign reading »Beginning Oct. 1 it will be a tradition that only Seniors can walk on the grass.« Is there even now anything that could be called a »cultural tradition« that makes art of *Brillo Box* — or that excludes it from the artworld? We understand the convention by which arm-raising can become signalling; but it is much less easy to understand (without more help than we are given) the convention by which Brillo box imitating becomes artwork-creating, if indeed that transformation is secured by a convention. For, after all, it is not a convention, but a certain intention, that makes an arm-movement an arm-raising. I think that Margolis' arguments — important and illuminating as they are — have not eliminated the possibility that it is also a certain intention that sometimes makes the act of making a physical object into the act of creating an artwork.

I do not attempt to pursue this suggestion further here, but

I think there is something in it. Suppose it is true, as Ina Loewenberg has argued, that

Something is a work of art if it was intentionally made as such by someone who intends it to be taken as such by observers . . .[13]

No doubt this needs some gap-filling, but it points up a basic contrast between a view like Danto's or Margolis' and what I called the quasi-romantic view. For on this description, art-creating is always in one way like arm-raising (4.2), even if it may also often be at the same time rather like signalling (4.3).

IV. It would be useful and relevant to pursue another line of argument for the essential institutionality of art that would rely on my condition 1.2 and launch itself from some important aesthetic developments in recent years. Though I shall not undertake to discuss this argument, or potential argument, here, I cannot resist alluding to it briefly. We may easily agree, I believe, that the possession of aesthetic qualities (in Frank Sibley's sense) is normal to artworks. If, therefore, the possession of such qualities could be shown to depend directly on the existence of an institution, art would be essentially institutional by 1.2.

I do not know of anyone who has actually worked out this argument, but I discern at least the germ of it in E. H. Gombrich's challenging treatment of expression in art.[14] He argues that »we cannot judge expression without an awareness of the choice situation, without a knowledge of the organon« (*Art and Illusion*, 376). That is, in his example, whether the Mondrian *Broadway Boogie-Woogie* has the aesthetic quality of, say, jazziness depends on (1) the range of different patterns (i. e., other signs) we understand to be within the painter's repertoire, and (2) the range of musical qualities that we understand to be available. There is much more to Gombrich's subtle account than this, of course, but my purpose is only to point out that *if* the very presence of aesthetic qualities in artworks depends on the existence of a social framework of conventional sign-contrasts (the »organon«), and *if* these conventions define an institutionalized practice, *then* art is essentially institutional, by condition 1.2.

Something similar might be said of Kendall Walton's argument for what he calls »categories of art,« whose »standard features« make possible those deviations which (he holds) give artworks their determinate aesthetic qualities.[15] He argues

[13] »Intention: The Speaker and the Artist«, BRITT J AES 15 (1975): 45.

[14] See ART AND ILLUSION, 2nd ed., Princeton 1969, Ch. 11; »Expession and Communication«, MEDITATIONS ON A HOBBY HORSE, London & N.Y. 2nd ed. 1971.

[15] See »Categories of Art«, PHIL REV 79 (1970): 334-67.

that (some) facts about the origins of works of art have an ESSENTIAL role in criticism, that aesthetic judgments rest on them in an absolutely fundamental way. (»Categories«, 337)

Suppose — going beyond Walton — one were to argue that an artwork's being in (or being properly assigned to) a particular category is necessary not only for it to have the aesthetic quality it has, but for it to have any aesthetic quality at all. And suppose that the assignment of category depends on existing or historical conventions that define institutionalized practices. Then this would amount to an argument for the essentially institutional character of art.

As I have tried to suggest, I think of the issue of art's essential institutionality as involving very basic issues in the philosophy of art, and as having significant implications. For there is another form of essentialism that has sustained the main tradition of Western aesthetics and has continuously claimed for art a special cultural status. This is the assumption that there is a function that is essential to human culture, that appears in some guise in any society that has a culture, and that works of art fulfill, or at least aspire or purport to fulfill. The search for this essential cultural function, the wish to discriminate and describe it, has motivated some of the best (and maybe some of the most unfortunate) ideas of disparate aesthetic schools. But the enterprise itself has been taken to be of central philosophical importance. This essentialism was rejected by the followers of Wittgenstein, who said that we may but trace the family resemblances among objects labelled artworks among speakers of ordinary language, and perhaps list some of the criteria that are sometimes used in assigning the label. The institutional theory of art grows out of this movement, it seems to me; it, too, rejects the question »What is art?« in its traditional form, and proposes to substitute the question »Which objects have been assigned the label 'artwork' by the artworld of such-and-such a society?« That's certainly an askable question, but it is no adequate substitute. For when we know what things are called, or not called, »art« by artistic establishments, we still do not know whether there are basic and pervasive human needs that it is the peculiar role of art to serve.

Bibliography,

not including pieces referred to earlier in this volume.

L. Aagaard-Mogensen »Søren Kjørup ÆSTETISKE PROBLEMER« (rev) J AES ART CRIT 31 (1973): 544-6.
— »The Alleged Ambiguity of 'Work of Art'«, PERSONALIST 56 (1975): 309-15.
W. Abell »Toward a Unified Field in Aesthetics«, J AES ART CRIT 10 (1952): 191-216.
M. C. Albrecht, J. Barnett, & M. Griff (eds) THE SOCIOLOGY OF ART AND LITERATURE, London & N.Y. 1970.
J. H. Barnett »The Sociology of Art«, SOCIOLOGY TODAY, (eds.) R. K. Merton, L. Broom, & L. S. Cottrell, N.Y. 1959.
C. Barrett, see W. B. Gallie.
J. Barzun »The Arts, the Snobs, and the Democrat«, OF HUMAN FREE-DOM, Boston & N.Y. 1939.
M. C. Beardsley, see S. Cavell.
— »Esthetic Welfare«, J AES EDUC 4 (1970): 9-20.
S. N. Behrman DUVEEN, N.Y. 1952.
F. K. Berrien »Methodological and Related Problems in Cross-Cultural Research«, INTERNATIONAL JOURNAL OF PSYCHOLOGY 2 (1967): 33-43.
F. Boas THE FUNCTION OF DANCE IN HUMAN SOCIETY, N.Y. 1972.
G. Boas »The Mona Lisa in the History of Taste«, J HIST IDEAS 1 (1940): 207-24.
— »Historical Periods«, J AES ART CRIT 11 (1952-3): 248-54.
T. Brunius »The Uses of Works of Art«, rep. ESSAYS ON ART CRITI-CISM AND THE PHILOSOPHY OF ART, (eds) M. C. Beardsley & H. M. Schueller, Belmont 1967.
— »Theory and Ideology in Aesthetics«, PROCEEDINGS OF THE SIXTH INTERNATIONAL CONGRESS OF AESTHETICS 1968.
S. Burham THE ART CROWD, N.Y. 1973.
C. Butler »What Is a Literary Work?«, NEW LIT HIST 5 (1973): 17-29.
S. Cavell »Aesthetic Problems of Modern Philosophy«, PHILOSOPHY IN AMERICA (ed) M. Black, Ithaca 1967.
— , M. C. Beardsley, & J. Margolis (symposium) »Music Discomposed«, ART, MIND, AND RELIGION (eds) W. H. Capitan & D. D. Merrill, Pittsburgh 1965.
P. Cabanne »Interview: Marcel Duchamp«, THE AMERICAN SCHOLAR 40 (1971): 273-83.
F. G. Chalmers »The Study of Art in a Cultural Context«, J AES ART CRIT 32 (1973): 249-56.
J. Creedy (ed) THE SOCIAL CONTEXT OF ART, London & N.Y. 1970.
B. Croce »Sociological History of Literature«, LA CRITICA (1919).
H. Deinhard MEANING AND EXPRESSION, Boston 1970.
J. Dewey »Art and Civilization«, ART AS EXPERIENCE, N.Y. 1958.
G. Dickie »Is Psychology Relevant to Aesthetics?«, PHIL REV (1962): 285-302.
— »Art Narrowly and Broadly Speaking«, AMER PHIL QUART 5 (1968): 71-7.
— »Defining Art II«, CONTEMPORARY AESTHETICS, (ed) M. Lip-man, Boston 1973: 118-31.
M. M. Eaton »Art, Artifacts, and the Intention«, AMER PHIL QUART 6 (1969): 165-9.
J. M. Ellis THE THEORY OF LITERARY CRITICISM, Berkeley 1974.
S. E. Fish »How Ordinary Is Ordinary Language?«, NEW LIT HIST 5 (1973): 41-54.
W. B. Gallie, C. Barrett (symposium) »Art and Politics«, PROC ARIS SOC S 46 (1972): 103-38.
J. Gimpel THE CULT OF ART, N.Y. 1969.
C. Greenberg ART AND CULTURE, Boston 1961.

A. Harrison »Works of Art and other Cultural Objects«, PROC ARIS SOC 68 (1968): 105-28.

C. Hartshorne »Analysis and Cultural Lag in Philosophy«, S J PHIL 11 (1973): 105-12.

V. Kavolis ARTISTIC EXPRESSION, Ithaca 1968.

G. Keen THE SALE OF WORKS OF ART, N.Y. 1971.

W. E. Kennick »Theories of Art and the Artworld«, in ms.

P. Kivy »How Not to Make a Work of Art«, in ms.

S. Kjørup ÆSTETISKE PROBLEMER, København 1971.

S. E. Lee »The Art Museum in Today's Society«, ARTNEWS 68 (1969): 27, 64-8.

E. M. Levine »Chicago's Art World«, URBAN LIFE AND CULTURE I (1972): 292-322.

J. Margolis »The Myths of Psychoanalysis«, MONIST 56 (1972): 361-75.

— see S. Cavell.

— »Plato, Aristotle, and Danto on the Nature of a Work of Art«, in ms.

— »George Dickie ART AND THE AESTHETIC« (rev), J AES ART CRIT 33 (1975): 341-5.

— ART AND PHILOSOPHY, Eclipse Books, Nyborg & Atlantic Highlands, NJ, 1976.

L. B. Meyer »Universalism and Relativism in the Study of Ethnic Music«, ETHNOMUSICOLOGY 4 (1960): 49-54.

K. Mitchells »Work of Art in Its Social Setting and In Its Aesthetic Isolation«, J AES ART CRIT 25 (1967): 369-74.

M. H. Mitias »Art as a Social Institution«, PERSONALIST 56 (1975): 330-5.

B. Morton »George Dickie AESTHETICS« (rev), J AES ART CRIT 32 (1973): 115-8.

E. Mundt ART, FORM, AND CIVILIZATION, Berkeley 1952.

T. Noble »Notes Towards a Sociology of Literature«, J THEORY SOC BEHAVIOUR II (1972): 205-15.

H. Osborne »Primitive Art and Society«, BRIT J AES 14 (1974): 290-305.

C. M. Otten (ed) ANTHROPOLOGY AND ART, Garden City 1971.

M. Peckham MAN'S RAGE FOR CHAOS, N.Y. 1967.

H. Rosenberg »On the Influence of Theories on Painters«, CRITICAL INQUIRY I (1974).

M. Sachs »Philosophical Implications of the Unity in the Contemporary Arts and Sciences«, PHIL PHENOMENOL RES 34 (1974): 489-503.

A. K. Saran »A Wittgensteinian Sociology?«, ETHICS 75 (1965): 195-200.

R. S. Sclafani »'Art' and Artifactuality«, SW J PHIL (1970): 103-10.

— »George Dickie AESTHETICS« (rev), J PHIL 70 (1973): 303-7.

— »The Logical Primitiveness of the Concept of a Work of Art«, BRIT J AES 15 (1975): 14-28.

R. Scruton ART AND IMAGINATION, London 1974, Esp. Ch 16.

A. Silbermann »A Definition of the Sociology of Art«, INT SOC SCI J 20 (1968): 567-88.

E. Simpson »Aesthetic Appraisal«, PHILOSOPHY 50 (1975).

G. J. Stack »The Being of the Work of Art in Heidegger«, PHIL TODAY (1969): 159-73.

D. Taylor »Anthropologists on Art«, Papers of the 1956 General Studies Anthropology Seminar, 1957: 23-33.

D. Walsh »Aesthetic Objects and Works of Art« J AES ART CRIT 33 (1974): 7-12.

M. Weitz »Open Concepts«, REV INT PHIL 26 (1972): 86-110.

P. P. Wiener & A. Noland (eds) IDEAS IN CULTURAL PERSPECTIVE, New Brunswick 1962, Part II: 93-309.

P. Winch THE IDEA OF A SOCIAL SCIENCE, London 1958.

— »Nature and Convention«, PROC ARIS SOC 60 (1959-60): 231-52.

— »Understanding a Primitive Society«, AMER PHIL QUART 1 (1964): 307-24.

R. Wright THE ART GAME, N.Y. 1968.